Research Guide to the History
of Western Art

Research Guide
to the History
of Western Art

W. Eugene Kleinbauer and Thomas P. Slavens

SOURCES OF INFORMATION
IN THE HUMANITIES
NO. 2

CHICAGO
American Library Association
1982

Sources of Information in the Humanities
Thomas P. Slavens, series editor

Research Guide to Religious Studies by John Wilson
and Thomas P. Slavens

Designed by Harvey Retzloff

Composed by Automated Office Systems Inc.
in Sabon on a Text Ed/VIP
phototypesetting system

Printed on 60-pound Warren's 66, a pH-
neutral stock, and bound in
C-grade Holliston Roxite cloth
by Braun-Brumfield, Inc.

Library of Congress Cataloging in Publication Data

Kleinbauer, W. Eugene, 1937–
 Research guide to the history of Western art.

 (Sources of information in the humanities ; no. 2)
 Includes bibliographies and index.
 1. Art—Historiography. I. Slavens, Thomas P.,
1928– . II. Title. III. Series.
 N380.K56 1982 709 82-6867
 ISBN 0-8389-0329-0 AACR2

CONTENTS

v

PREFACE TO THE SERIES

The purpose of this series is to help librarians, students of library science, and other interested persons in the use of resources in the humanities. The series encompasses art, linguistics, literature, music, philosophy, and religion. These fields share an interest in the creative, aesthetic, and imaginative impulses of human beings and the cultures in which they live. Individuals find joy in music, art, and literature; others thoroughly enjoy discussing linguistics and philosophy; and a basic religious impulse has prompted the quest for emotional and intellectual fulfillment. Scholarship in the humanities has been produced with the goal of enhancing the quality of human life while seeking to understand it more adequately, and those who seek information about the humanities make use of libraries; often, however, they become confused by the large quantities of available materials.

This series, then, is intended as a guide in the search for information in the humanities. The series, as previously noted, consists of six titles covering art, linguistics, literature, music, philosophy, and religion. Each volume is divided into two parts. The first features a survey of the field by a specialist, and the second is an annotated list of major reference works. The survey includes a history of the field, a description of methodology, and current issues and research. The descriptions of issues and research summarize critical assessments of significant monographs, with an emphasis on modern scholarship. They do not cite primary sources, such as the Bible, Shakespeare's plays, music, or art. Rather, the essays focus on the concepts presented in key secondary works. They stress Western subjects and titles; in the case of literature, because of the mass of material available, the essays emphasize English literature. Citations are given in full following each section.

The second part of each volume lists and annotates major reference works. The list relates subject scholarship to bibliography, thus expediting information retrieval.

Many people have assisted in the preparation of this series. They include the Publishing Services staff of the American Library Association, without whose encouragement the series would not have been produced. The collaborators are also grateful for financial assistance from the University of Michigan which granted us the first Warner G. Rice Faculty Award in the Humanities for the purpose of assisting in the preparation of this book. These funds were used to employ Marjorie Corey, Anne Deason, Richard Heritage, Margaret Hillmer, Patricia Kirschner, Karen O'Donnell, and Robert Krupp as research assistants in this project; their endeavors are very much appreciated. We also take pleasure in thanking the professors who wrote the essays. They represent the best of humanistic scholarship in the United States and have made a major contribution to the organization of information in their disciplines.

THOMAS P. SLAVENS

THE FIELD
OF
ART
HISTORY

1

Art History and Its Related Disciplines

Art history is an empirical and intellectual discipline that investigates specific art objects as documents in time and space demanding interpretation and evaluation. As a rule, art historians define a work of art as a man-made object of aesthetic significance that is simultaneously a historical phenomenon. They deal with the visual arts—architecture, sculpture, and painting—as distinguished from literature, music, film, theater, and dance.

The goal of art history is first to place the work of art in history and then assess it in the light of its unique position. Modern art historians strive to analyze, interpret, and evaluate works of art by identifying their materials and techniques, makers, time and place of creation, and meaning or function. They inquire about the who, what, when, where, and why of the art object; often the object itself suggests which of these questions should be pursued. But the function of art history today is not only to make such identifications, but also to relate an individual work humanistically to other works of the same school, period, and culture, while remaining sensitive to its salient aesthetic qualities.

Several genres of art history have flourished since the late nineteenth century. Some resolve themselves in a detailed grasp of the art object. Connoisseurship, the study of materials and technique, and iconography all focus on the immediate work, preparing the way for comparative studies and the study of the development of an artist or artistic movement, or of the transition from one period to another.

Other genres consider the problem of artistic influence and the process of historical change. Iconology, developing from iconography, seeks the meaning of an individual work in relation to other art works. Formalism, beginning with formal criticism, proceeds to ex-

3

amine an artist's oeuvre, schools, or movements in art. Psychological studies and the study of art in society attempt to discover the meaning of the art work in its relation to the artist and his or her world, and also in relation to the more generalized theories of psychology or history. Allied, rather than subordinate, to art history are antiquarianism, art appreciation, archaeology, aesthetics, art theory, and art criticism. All these disciplines study art objects, but differ from art history today in a variety of ways.

ANTIQUARIANISM

Antiquarians deal with antiques, man-made objects of some or considerable age. They are thus often dealing with the same objects as the art historian; however, they also concern themselves with other objects, such as unillustrated rare books, that normally do not interest the art historian. Antiquarians describe, measure, weigh, and catalog antiques, performing tasks that also confront art historians. And, like art historians, they seek to determine whether an object is authentic or fake and the identity of its maker. As a rule, however, antiquarians are unconcerned with problems of interpretation. For example, they avoid problems of subject matter and the social history of the arts, indeed, the artistic personality itself. Generally they are content to present a chronological listing of objects without pronouncing value judgments on them. Moreover, they are often collectors, as are some art historians.

Antiquarianism initially developed in the sixteenth century, and became increasingly popular during the following two centuries. Antiquarians today continue to publish in provincial archaeological journals and magazines dealing with antiques.

ART APPRECIATION

Approaching works of art from a nonhistorical viewpoint, art appreciation stresses the recreative aspect of art and relies heavily on value judgments. It sometimes involves art criticism, especially formal analysis. It can serve as an introduction to the history of art, but remains distinct from it.

ARCHAEOLOGY

Archaeology is the study of mankind's past through its material remains. It includes digging, sorting out, and the chronological ordering of works of art and other material artifacts.

The archaeology of Western civilization is limited to prehistoric and classical or ancient art (through the Roman Empire). Western art history, in contrast, usually excludes prehistoric art but often includes classical art. In the case of the study of the art of classical antiquity, both the archaeologist and the art historian often aspire to establish the correct artistic order of works of art and their chronology, whether it is relative or absolute. In contrast to the archaeologist, however, the art historian is more likely to confront objects for which historical documents survive for the purpose of reconstructing artistic personalities and identifying the subject matter and function of their creations.

The difficulty in distinguishing between the two fields appears in the monumental accomplishment of Sir John Beazley (1885–1970). He studied for decades the thousands of surviving red-figure Attic vases and shards. His work represents the classification of an amorphous and heterogeneous mass of surviving objects not by intuition but by minute study, in this case of the detailed drawing on all vases available. Beazley identified individual artists and demonstrated the influence of one artist on another. His method is analogous to connoisseurship, another field in art history. Rhys Carpenter (1889–1980) sympathetically appraises the nature of archaeology in his essay "Archaeology."

Beazley, Sir John. *Attic Red-Figure Vase Painters.* 2d ed. 3v. Oxford: Oxford Univ. Pr., 1963.
Carpenter, Rhys. "Archaeology." In *Art and Archaeology,* by Rhys Carpenter and James S. Ackerman. Englewood Cliffs, N.J.: Prentice-Hall, 1963.

AESTHETICS

Aesthetics is the branch of philosophy that systematically examines, defines, and assesses the processes and abilities involved in the creation, use, enjoyment, and evaluation of art. To a large extent it deals with recurrent patterns and the validity of the standards of

evaluation. Aestheticians seek to establish categories of thought and systematic definitions to express coherent points of view about the arts. They are interested in the nature of art and in interrelationships of all the arts: music, literature, theater, film, and dance, as well as the visual arts. The term "esthetic" was coined by the German philosopher Alexander Baumgarten (1714–62) in his *Meditationes*. In the eighteenth century, aesthetics was first conceived by English empiricists as a distinct philosophical discipline.

The art historian is interested in the interrelationships of the arts, but only insofar as they elucidate aspects of specific art works. Whereas aestheticians arrange and classify their material and hypotheses according to the theories they illuminate, art historians always deal with objects historically, usually marshaling them chronologically and geographically, and occasionally ideologically.

Definitions of beauty, truth, significance, the nature of art, and the like do not concern art historians. In much of the Western world, especially in the United States and the United Kingdom, art history today is by and large nonphilosophical (in Germany this is somewhat less the case).

An extremely influential figure in twentieth-century aesthetics was Benedetto Croce (1866–1952), who wrote *Estetica come scienza dell'espressione e linguistica generale*. Developing a basic tenet of idealistic metaphysics, Croce urged the unity of the work of art: form and content are inseparable. Every work of art is a unique lyrical intuition: "The total effect of the work of art is an intuition." For Croce, intuition is "knowledge, free from concepts and more simple than the so-called perception of the real." Concomitantly, the art work is an expression of a state of emotion. Since every state of emotion is unique and original, every work of art is also unique and original. For Croce, art is not a physical unity, but purely a matter of the mind; it is a completely internal event: "What is called *external* is no longer a work of art."

According to Croce's epistemological system, the arts cannot be classified or even distinguished, because every work of art is a unique intuition-expression; there is no history of art, only a history of individual works and masters. Masaccio and Donatello cannot be explained by the quattrocento; rather, the quattrocento is explained by them. The artist, his work, and the spectator are identified; aesthetics can only aspire to remove the obstacles to this identification and to evaluate the work as art or nonart. Croce rejects as external and irrelevant to the arts considerations of technique, iconography,

biography, social history, and the history of ideas. Thus his system is a radical monism.

Croce's theory that art is a lyrical intuition dominated aesthetics at the turn of this century and for at least a generation afterwards. Its influence marks the work not only of all important Italian art historians until the Second World War—for instance, Lionello Venturi (1885–1961) and Roberto Longhi (1890–1970), but also of Austrians (e.g., Julius von Schlosser [1886–1938]), American art critics (e.g., Theodore Greene, b. 1897), and even the important American literary critic Joel Elias Spingarn (1875–1939).

Baumgarten, Alexander Gottlieb. *Meditationes philosophicae de nonnvillis, ad poema pertinentibus.* Halae Magdeburgicae: Litteris Joannis Henrici Grunerti, 1735.
Croce, Benedetto. *Estetica come scienza dell'espressione e linguistica generale.* Milan: R. Sandron, 1902. *Aesthetic as Science of Expression and General Linguistic.* 2d ed. Tr. by Douglas Ainslie. London: Macmillan, 1922.
Greene, Theodore. *The Arts and the Art of Criticism.* Princeton, N.J.: Princeton Univ. Pr., 1940.
Longhi, Roberto. *Piero della Francesca.* Rome: Valori plastici, 1927.
Schlosser, Julius von. *Die Kunstliteratur: ein Handbuch zur Quellenkunde der neueren Kunstgeschichte.* Vienna: A. Schroll, 1924.
Spingarn, Joel Elias. "The New Criticism." In *The New Criticism, An Anthology of Modern Aesthetics and Literary Criticism.* Ed. by E. B. Burgum. New York: Prentice-Hall, 1930.
Venturi, Lionello. *History of Art Criticism.* Tr. by Charles Marriott. New York: Dutton, 1936.

ART THEORY

Art theory, closely allied to art history, provides the vocabulary, terminology, and the theoretical apparatus necessary for a scholarly investigation and elucidation of specific works of art. Some theories of art describe the genesis of works of art; others describe the nature of works of art; still others describe the artist. They include art as imitation, as pleasure, as play, as empathy, as communication, as expression, and as quality of experience. Such theories serve art historians as documents for an understanding of individual art objects.

Probably the most fundamental inquiry into art theory and literature about art is Julius von Schlosser's *Die Kunstliteratur.* An indispensable bibliographical reference work and one of the monumental achievements of modern scholarship, this book embraces the history of all writings on art from classical antiquity to about 1800. It exem-

plifies one of the principal areas of inquiry of the Viennese School of
Art History from the mid-nineteenth century until World War II.
Less ambitious, but just as conveniently useful and important, is
Herschel B. Chipp's *Theories of Modern Art: A Source Book by
Artists and Critics,* a judiciously edited and selective compilation of
artists' statements and other documents of modern art in the late
nineteenth and early twentieth centuries. Von Schlosser and Chipp
(b. 1913) both demonstrate that art history leads into art theory as
much as art theory leads into art history.

Chipp, Herschel B., ed. *Theories of Modern Art: A Source Book by Artists
and Critics.* Berkeley: Univ. of California Pr., 1968.
Schlosser, Julius von. *Die Kunstliteratur: ein Handbuch zur Quellenkunde
der neueren Kunstgeschichte.* Vienna: A. Schroll

ART CRITICISM

The proper domain of any one critic is the description, interpreta-
tion, and evaluation of concrete works of art in a single medium of
expression. Like aesthetics, criticism deals with all the arts. Art criti-
cism is a many-leveled activity that comprises the historical, the re-
creative, and the judicial. In all cases it seeks to pronounce value
judgments, an exercise shunned by art history.

Historical and Recreative Criticism

The historical critic and the art historian share the same objectives.
Both disciplines strive to interpret works of art within some historical
framework. The other two modes of criticism, however, differ from
art history. Recreative art criticism determines the unique qualities of
an artist's work and relates them to the values and needs of the
viewer. It is literary expression that often has in itself high artistic
merit. Thus, it transforms one work of art into another. The work of
Walter Pater (1839–94) is a classic example of such criticism. His
Studies in the History of the Renaissance features overwrought but
sometimes imaginative and even eloquent discussions of art and lit-
erature. Pater admitted that he wanted "to see the object as in itself it
really is"; then, by metamorphorical means, he transforms one me-
dium—a painting, for example—into the different medium of a
prose poem. His end product bears no relation to the primary datum
of the art historian. In our century, metamorphorical method in art

criticism is not uncommon; it characterizes the work of the French Existentialist novelist and critic André Malraux (1901–76), whose approach to the visual arts is essentially unhistorical and tends toward a philosophy of pure sensation. It also occurs in some writings of the American art historian Vincent Scully (b. 1920).

Art historians do not neglect language, for they are writers as well as scholars. But they do not find a brilliantly sustained literary style necessary to translate works of art into words. Some art historians have, however, set high standards. The Italian art historian Roberto Longhi maintained that art historical writing is truly a creative act, and his own discourse is often so eloquent and subtle that his scholarship has been classified as literature. Longhi, who was influenced by La Forgue and Mallarmé, possessed the gift of transposing works of art into superlatively well-judged writing, of creating works of art from works of art. Modern Western art historians whose writings have such eloquence include Heinrich Wölfflin, Wilhelm Fraenger (1890–1964), Rensselaer W. Lee (b. 1898), and Sir Ernst H. Gombrich (b. 1909).

Fraenger, Wilhelm. *Hieronymus Bosch: Das Tausendjährige Reich, Grundzüge einer Auslegung.* Coburg: Winkler Verlag, 1947. *The Millennium of Hieronymus Bosch: Outlines of a New Interpretation.* Tr. by Eithne Wilkins and Ernst Kaiser. Chicago: Univ. of Chicago Pr., 1951.

Gombrich, Sir Ernst H. *Art and Illusion: A Study in the Psychology of Pictorial Representation.* New York: Pantheon, 1960.

Lee, Rensselaer W. *"Ut Pictura Poesis:* The Humanistic Theory of Painting," *Art Bulletin,* 22: 197–269 (1940). Republished as a monograph with the same title: New York: Norton, 1967.

Longhi, Roberto. *Il Caravaggio.* Milan: A. Martello, 1952.

———. *Piero della Francesca.* Rome: Valori plastici, 1927.

Malraux, André. *Les Voix du silence.* Paris: NRF, 1951. *The Voices of Silence.* Tr. by Stuart Gilbert. Princeton, N.J.: Princeton Univ. Pr., 1978.

Pater, Walter. *Studies in the History of the Renaissance.* London: Macmillan, 1873.

Scully, Vincent. *The Earth, the Temple, and the Gods: Greek Sacred Architecture.* New Haven, Conn.: Yale Univ. Pr., 1962.

Judicial Criticism

Judicial art criticism evaluates works of art in relation to other works of art as well as to other human values and needs. Applying a set of standards to them, it makes an evaluation. These standards include formal excellence, originality or adherence to tradition, truth or morality, and artistic significance. These standards are ideals, applied whether or not they are appropriate or relevant.

Formal Excellence

Formal artistic excellence provides some judicial critics with a normative criterion. The English critic Clive Bell (1881–1964), for example, evolved the concept of "significant form" to describe the colors, lines, and shapes in a work of art. His concept implied that the work is significant whose value is intrinsic, but he failed to define clearly what form is significant. Bell influenced a number of critics, including Albert Barnes (1872–1951) and John Dewey (1859–1952).

The criticism of Roger Fry (1866–1934), the most important art critic in England during the first third of this century and the "discoverer" of the French post-impressionist painters, focused on the logic, coherence, and harmony of the "pure forms" in the visual arts and tended to ignore or overlook subject matter or content. In *Vision and Design,* he wrote that he "conceived early the form of the work of art to be its most essential quality." In *Cézanne: A Study of His Development,* Fry evaluated painting with almost exclusive reference to its technique and composition.

The most important influence on Fry's purely formal analysis of Cézanne was Heinrich Wölfflin, whose work will be discussed below in connection with formal analysis in art history. Bell's significant form also had some influence on Fry, as did the American Denman Waldo Ross (1853–1935), whose *A Theory of Pure Design* identifies harmony, balance, and rhythm as the three major compositional factors in an analysis of pictures. Ross, in turn, had derived his theory of pure design from German and English writers such as Gottfried Semper, Alois Riegl, and Owen Jones (1809–74), who had dealt with the transformation of natural forms into abstract motifs. Significantly, such thinking about abstract formal relationships coincided with the emergence of the new abstract art of Picasso and Kandinsky, though no direct interrelationship between theory and practice has been demonstrated.

Pure formalist criticism came to dominate art criticism during the 1960s. As a descriptive method it was most rigorously applied to abstract expressionism by Clement Greenberg (b. 1909). In this case, the application of formalism was appropriate, as it dispensed with the very associative elements that abstract expressionist painting itself tried to suppress. The approach was able to develop a descriptive vocabulary wholly relevant to such works, casting a sharp focus on pertinent value judgments.

Greenberg is often regarded as the dean of American art critics.

Art and Culture, an anthology representing his critical activity from 1939 to 1960, puts forth his rather systematic overall point of view. His writings focus on form to the exclusion of content, argue for unity, and tend to reject romantic or expressionist tendencies in art. They also profess a faith in the avant-garde. When referring to the art of Cézanne, Picasso, Braque, Klee, and Matisse, for example, Greenberg writes that "the excitement of their art seems to lie most of all in its pure preoccupation with the invention and arrangement of spaces, surfaces, shapes, colors, etc., to the exclusion of whatever is not necessarily implicated in these factors." His history of later nineteenth- and twentieth-century art discerns two distinct modes, the visual (or colorist) and the sculptural. The first emerges from impressionism, the other from the later art of Cézanne. For Greenberg, the "true avant-garde" resides in the visual mode, exemplified by the work of Monet, fauvism, Matisse, in some works by Pollock and Hofmann, Milton Avery, and in Rothko, Newman, and Still.

The formalist approach to contemporary art also characterizes the writings of other critics, such as Michael Fried (b. 1939), another American. The limitations of this approach have been pointed up by art critic and historian Leo Steinberg (b. 1920). Greenberg's and Fried's formalist criticism can be contrasted to the bewildering multiplicity of viewpoints of writers such as Irving Sandler (b. 1925), whose methodological approach varies from historical to psychological to iconographical to sociological.

Truth, Sincerity, and Honesty

Truth, sincerity, and honesty are epistemic criteria for a second type of judicial criticism best exemplified by the work of John Ruskin (1819–1900), eminent English critic and advocate of British socialism. His writings look at art in its society. *Seven Lamps of Architecture* and *The Stones of Venice* maintain that great buildings are the expressions of their creators, exhibiting a moral quality and exerting a strong influence upon the society in which they exist.

Artistic Significance

The determination of artistic significance or greatness constitutes a third category of judicial criticism. Criteria such as artistic form, technical achievement, interpretation of subject matter, originality, artistic truth, and morality distinguish between trivial or mediocre and significant or great works of art. The way in which a work of art

moves the viewer is another criterion, as it depends upon an artist's insight into creation and life itself.

Such an evaluation of the visual arts was more common in the nineteenth century than it is today, and typifies the criticism of John Ruskin. This approach occasionally marks the criticism of contemporary artists, occurring in newspaper journalism devoted to reviews of the exhibitions of living artists. But it also occasionally characterizes the criticism of scholars. In his published lecture, *What Is a Masterpiece?* Sir Kenneth Clark (b. 1903) contends that "the human element is essential to a masterpiece"; that "the *highest masterpieces are illustrations of great themes*"; that masterpieces are "those large elaborate works in which a painter has put in everything he knows in order to show his complete supremacy in his art"; and that such works must "use the language of the day"—in short, that a masterpiece is "the work of an artist of genius who has been absorbed by the spirit of the time in a way that has made his individual experiences universal."

The concept of masterpiece is used by critics and art historians alike. Its historiography has recently been traced in Walter Cahn's *Masterpieces: Chapters on the History of an Idea.*

Contemporary art historians seldom assume the role of judicial art critics. If art historians make ethical or moral judgments without considering historical factors, they are identified by other art historians as art critics. However, any writer who deals with art created within the last decade or two will probably be called a critic rather than an art historian, as the historical distance between the creation of the work and the writing about it is so small that the writer's evaluation tends to carry a stronger normative tone than would that of an art historian.

In fact, art criticism and art history interpenetrate and complement each other. The art object under investigation suggests an appropriate approach to its interpretation and evaluation; no single method or approach is always applicable or relevant to a given area of inquiry. Better critics and historians alike adopt different approaches at different times, and may even use several approaches to a single work, group of works, or movement. This is true of the currently popular critic Hilton Kramer (b. 1928). Gregory Battcock's *The New Art: A Critical Anthology* likewise illustrates some of the many approaches to contemporary art criticism. Battcock's anthology also describes the work of individual critics like Sir Herbert Read (1893–1968), work that exhibits a flexibility and fluidity of thought difficult

to categorize. Read's *The Philosophy of Modern Art,* for example, displays a synthesis of viewpoints, the individual components of which can be traced back to Clive Bell, Roger Fry, the German aesthetician Wilhelm Worringer, the French art historian Henri Focillon, and the neo-Kantian philosopher and art historian Ernst Cassirer (1874–1945).

Art critics may be trained as artists, philosophers (or aestheticians), art theorists, or art historians. Those with backgrounds in art history adopt the methods and approaches of the field (in particular, formal analysis, the interpretation of symbolic qualities, biography, and the sociology of art) and restrict themselves to the visual arts of the twentieth century.

Perhaps the presence of a historical perspective is decisive. If the critic of contemporary art is cognizant of many trends being pursued by artists, and is capable of interpreting them within an illuminating historical framework—say, a Darwinian, Hegelian, or Marxian mode of thought—then he or she may be regarded as a critic assuming the role of an art historian. Most criticism of contemporary art, at least in the United States and Britain, lacks such a discernible historical base, and therefore cannot be labeled art history.

Moreover, rarely does one encounter a writer on the visual arts who moves easily and with equal perception between contemporary and earlier art; Meyer Schapiro (b. 1904) and Leo Steinberg are two such persons. When a writer champions and promotes contemporary artists, especially younger ones, and conveys his or her view through newspaper columns, art journals, books, museum and gallery exhibition catalogs, and radio and television, that writer can be called an art critic. Art historians avoid such promotion, considering themselves dispassionate and objective.

Barnes, Albert. *The Art in Painting.* Merion, Pa.: Barnes Foundation Pr., 1925.

Battcock, Gregory. *The New Art: A Critical Anthology.* New York: Dutton, 1966.

Bell, Clive. *Art.* London: Chatto & Windus, 1914.

Cahn, Walter. *Masterpieces: Chapters on the History of an Idea.* Princeton, N.J.: Princeton Univ. Pr., 1979.

Cassirer, Ernst. *Individuum und Kosmos in der Philosophie der Renaissance.* Studien der Bibliothek Warburg, X. Leipzig and Berlin, 1927.

———. *Philosophie der symbolischen Formen.* 3v. Berlin: B. Cassirer, 1923–29. *The Philosophy of Symbolic Forms.* Tr. by Ralph Manheim. New Haven, Conn.: Yale Univ. Pr., 1953–57.

Clark, Sir Kenneth. *What Is a Masterpiece?* Walter Neurath Memorial Lecture 1979. London: Thames & Hudson, 1979.

Dewey, John. *Art as Experience.* New York: Minton, Balch, 1934.

Fried, Michael. Introduction to *Three American Painters: Kenneth Noland; Jules Olitski; Frank Stella.* Cambridge, Mass.: Fogg Art Museum, 1965.

Fry, Roger. *Cézanne: A Study of His Development.* London: L. and V. Woolf, 1927.

————. *Vision and Design.* London: Chatto & Windus, 1920.

Greenberg, Clement. *Art and Culture: Critical Essays.* Boston: Beacon Pr., 1961.

Jones, Owen. *The Grammar of Ornament.* London: Day & Son, 1856.

Kramer, Hilton. *The Age of the Avant-Garde: An Art Chronicle of 1956– 1972.* London: Secker & Warburg, 1974.

Read, Sir Herbert. *The Philosophy of Modern Art.* London: Faber & Faber, 1952.

Riegl, Alois. *Die spätrömische Kunst-Industrie.* Vienna: K. K. Hof- und Staatsdruckerei, 1901–23.

Ross, Denman Waldo. *A Theory of Pure Design.* Boston: Houghton Mifflin, 1907.

Ruskin, John. *Seven Lamps of Architecture.* London: Smith, Elder, 1849.

————. *The Stones of Venice.* 3v. New York and London: Smith, Elder, 1851–53.

Sandler, Irving. *The Triumph of American Painting: A History of Abstract Expressionism.* New York: Praeger, 1970.

Schapiro, Meyer. *Modern Art: 19th and 20th Centuries; Selected Papers.* New York: Braziller, 1978.

Semper, Gottfried. *Der Stil in den technischen und tektonischen Künsten.* 3v. Frankfurt: Verlag für Kunst und Wissenschaft, 1860–63.

Steinberg, Leo. *Other Criteria: Confrontations with Twentieth-Century Art.* New York: Oxford Univ. Pr., 1972.

2

Determinants of
Writing Art History

As *historians,* art historians work under the influence of a philosophy of history. Their understanding of the general divisions of history, the nature of historical periods, and the causes of historical change influence their arrangement, classification, and interpretation of works of art. All the data they observe and organize are influenced to some degree by some general historical notion or theory. Their results, drawn from the arts, will either corroborate or conflict with their hypothesis on the nature of history.

As historians of *art,* art historians may be concerned not only with political and social history, but also with cultural history, and with the histories of aesthetics and artistic movements. In order to keep these aspects discrete, art historians employ more periods than other sorts of historians.

PERIODS OF ART HISTORY

General histories of Western art are commonly divided into four eras: antiquity, the Middle Ages, Renaissance and baroque, and modern. (Some historians divide Western art into ancient, medieval, and modern periods, in which case Renaissance and baroque art is found in early modern history.) The four eras are largely mechanical devices of convenience and organization without intrinsic significance.

Each era is then subdivided into shorter phases. Such subdivisions take their characteristics from political, ecclesiastical, social, literary, or artistic aspects of history. No two general histories of art are likely to agree on the number or names of the shorter periods. For example, *Gardner's Art through the Ages,* a popular general history

15

of art, divides the Middle Ages into early medieval art, Romanesque art, and Gothic art and subdivides each phase, in turn, into three or more subphases. By contrast, another popular general history of art, Frederick Hartt's *Art: A History of Painting, Sculpture, Architecture,* divides the Middle Ages into nine sections. Some of the names of Hartt's sections coincide with subsections found in *Gardner's Art...* (e.g., migration art, Carolingian art, Ottonian art). However, the two books disagree on other aspects of periodization: for example, whether early Christian and Byzantine art represent the last phase of antiquity (as in *Gardner's Art...*) or belong to the Middle Ages (according to Hartt).

The names of periods of art history need not correspond to periods in other fields. Period names are of three kinds: political or dynastic (e.g., Carolingian, Ottonian, American Colonial); cultural (e.g., medieval, Gothic, Renaissance); or aesthetic, including some derived from art criticism (e.g., Romanesque, classic, mannerist, baroque). Moreover, historians of nineteenth- and twentieth-century art use the names of artistic movements rather than periods.

Each type of name originally implied a theory about the art it designated. Aesthetic names are the most common period names, but others survive, often with a changing meaning. Art historians no longer accept the original meanings of Romanesque and Gothic, but continue to use them as period names, conventions with new historical boundaries. Conventional periodization provides a continuous system to order works of art, clustering works with significant similarities and differences.

Art historians must clarify and define their use of such period terms, especially when several attitudes and expressions are shown by the art of a single period. The history of late eighteenth-century art is a case in point. After about 1760, many art works in all media began to reflect various attitudes toward ancient Greek and Roman monuments, history and mythology. In scholarship, before the 1960s, such labels as neoclassicism, romanticism, romantic classicism, eclecticism, and "art around 1800" were affixed to these works. No one label conveyed an accurate picture, nor did all of them taken together. One solution to this problem was suggested by Robert Rosenblum (b. 1927) in *Transformations in Late Eighteenth Century Art.* To encompass all the historical revivals in this period, Rosenblum applied the broad concept and name of "historicism," which he adopted from cultural history. Thereby he avoided the confusion arising from the use of terms like romantic classicism and,

concomitantly, emphasized a salient characteristic of the art of this period.

Historians of nineteenth- and twentieth-century art analyze their material not in terms of chronological periods or artistic styles but of artistic movements that overlap chronologically and are substyles of these two centuries (e.g., impressionism, fauvism, cubism, dada, pop, psychedelic). Though none of these movements was dominant or stable enough to be designated a historical period style at any time, each is identifiable by its morphological or ideological continuity. The authoritative Pelican History of Art volume by George H. Hamilton (b. 1910), *Painting and Sculpture in Europe, 1880–1940,* employs the orderly categorization of art according to movements. This didactic approach has limitations, for some modern artists defy easy classification. Many art historians would, for example, probably disagree with Hamilton's placement of Rodin with the impressionists and Henri Rousseau with the expressionists.

Gardner's Art through the Ages. 7th ed. Rev. by H. de la Croix and R. G. Tansey. New York: Harcourt Brace, 1980.
Hamilton, George H. *Painting and Sculpture in Europe, 1880–1940.* Baltimore: Penguin, 1967.
Hartt, Frederick. *Art: A History of Painting, Sculpture, Architecture.* 2v. Englewood Cliffs, N.J.: Prentice-Hall, 1976.
Rosenblum, Robert. *Transformations in Late Eighteenth Century Art.* Princeton, N.J.: Princeton Univ. Pr., 1967.

THEORIES OF HISTORICAL CHANGE

Periodization tells us that historical change has occurred. Two more important problems are (1) the nature of the change and the natures of the art before and after it, clearly and fully described, and (2) the causes of the change.

We have explained, in the last section, how the period names come from several sources. Here we will examine some ways of exploring the differences among periods, and some general theories about the origin of those differences.

Linear Evolutionary Theories

The concept of evolution has been widespread in art history since the middle of the last century. Under the impact of Darwinism, art historians began to conceive of groups of art works as developing slowly and gradually, in a continuous linear sequence from the sim-

plest to the most complex. That sequence was equated with the concept of time, from earliest to most recent. Art historians dealt with works of art individually by their position in the temporal sequence and would interpret their relation to the sequence historically (or stylistically) by reference to the transitions that occurred between the slight variations as well as the gradual modifications represented by the sequence.

One of the earliest persons to apply Darwinism to art history was the German architect and theorist Gottfried Semper (1803–79). In the highly systematized and categorized *Der Stil in den technischen und tektonischen Künsten,* which deals with architecture and the crafts but not painting or sculpture, Semper conceives of art as a biological organism and the history of art as a continuous linear process of development beginning in the remote past and extending into the present. He maintains that style is modified by materials and tools as well as by place, climate, age, and custom. Empirical, genetic, and comparative, his method, his idealism, and his aesthetic materialism colored the thinking of a number of prominent architects and philosophers in Europe.

A far more influential theory of the evolution of art was formulated by the Viennese art historian Alois Riegl (1858–1905), the author of investigations into ancient textiles (*Stilfragen*), late antique art (*Die spätrömische Kunst-Industrie*), and baroque art (*Die Entstehung der Barockkunst in Rom*). Focusing on works of art created during transitions from one period to another whose quality had been deprecated by earlier scholars, Riegl evaluated these works in terms of a continuous evolutionary and progressive process with the binding force of a natural law. Ever since Johann Joachim Winckelmann (1717–68) had published his *Geschichte der Kunst im Alterthums,* the first systematic investigation of art history, writers had viewed the development of art as periods of high achievement followed by periods of decline. For Riegl, transitions from one period to the next were not interpreted as decadent but as single and evolutionary advances. He declared that artistic development in a given period is an internal, autonomous, and genetically progressive process that remains essentially free of external forces, such as functional use, climate, innovations in materials and technique, and society or culture.

Reacting against the aesthetic materialism of Semper and his followers, Riegl held that changes in form are caused by impulses within forms themselves. Thus he introduced the teleological concept of *Kunstwollen,* by which he meant the definite and deliberate im-

pulse on the part of an artist or a period to confront and solve specifically artistic problems. While this concept was based on imprecise terminology and a faulty psychology (Riegl wrongly believed that artists always depict what they see), it represented a shift from a focus on a few external forces shaping the work of art to the creative activity of the individual artist.

To account for the long evolution in art, Riegl formulated two antithetical categories, which he termed "haptic" and "optic." The style of one period progresses from a haptic or tactile mode of perception to an optic or visual one, and the history of art is regarded as a series of pendulum swings between these polar opposites. Riegl argued that the haptic art of the Greeks had given way to the optic art of late Rome; haptic style held sway during the Renaissance as well as in neoclassicism and in post-impressionism, while optic style predominated during the baroque and in impressionism.

Riegl's scholarship, in short, was a landmark in the historiography of art. Like Heinrich Wölfflin, he removed the barrier between major and minor arts, as well as between classic and decadent styles. Riegl's thinking exerted a profound influence on many prominent European art historians, including Max Dvořák, Wilhelm Worringer, Hermann Egger (1873–1949), Hans Tietze (1880–1954), Erica Tietze-Conrat (1883–1958), Paul Frankl, Hans Sedlmayr, Guido von Kaschnitz-Weinberg (1890–1958), and to some extent Henri Focillon (1881–1943), and even Sir Ernst H. Gombrich, all of whom strove to explore Riegl's pioneering ideas further.

Cyclical Theories and Hegel's Spiral Evolution

Cyclical conceptions of historical evolution differ radically from Darwinism and its interpretations, and were fairly common in art historical writing until recent times. One version of the cyclical theory has its counterpart in biology—the fixed life cycle of a single organism embodying birth, maturity, and decay. This theory implies the presence of some kind of vital force generating the cycle and lending it significance. This historical theory is sketched in what is, perhaps, the first Western history of art, that of the Florentine painter, architect, historian, and critic Giorgio Vasari (1511–74). Primarily important as the presentation of biographies and anecdotes of Renaissance artists, Vasari's *Le vite de' più eccellenti pittori scuttori e architettori* contains a cyclical scheme of the unfolding of the arts in which three *età*, or phases of creative evolution, are defined: infancy (the art of Giotto); adolescence (the art of Brunelleschi,

Donatello, and Masaccio); and maturity (the art of Michelangelo). Vasari's cyclical theory implies a historical evolution of art and culture through three determined, and therefore typical, phases.

Vasari's conception of history was not systematically formulated or applied to his biographies. Not until the mid-eighteenth century did a writer on the arts adopt a systematic cyclical theory of history and apply it specifically to art objects (as opposed to artists' lives). That writer was Johann Joachim Winckelmann, the father of modern archaeology, who is sometimes called the first modern art historian. In his *Geschichte der Kunst in Alterthums* Winckelmann contends that "the history of art must teach us the origin, growth, change and decline of art together with the various styles of people, periods and artists, and it must prove these propositions, as far as possible, with the aid of the surviving monuments of antiquity." After marshaling all available evidence, he described a development of ancient Greek sculpture in four stages, proceeding from its earliest origins to its "perfection" in the age of Praxiteles, and its subsequent change and ultimate decline and fall. His views and ideals deeply influenced the Enlightenment, and especially German intellectual thought as seen in Lessing, Herder, Schiller, and Goethe.

The romantic philosopher Georg Wilhelm Friedrich Hegel (1770–1831) formulated a different cyclical theory of history. Abandoning the biological metaphor and the notion of straight-line continuity, Hegel conceived of historical progression based on a spiral movement of human history and dialectical method. His method of thesis, antithesis, and synthesis led him to describe the history of world art in three stages: the symbolical, the classical, and the romantic. He identified the symbolical with Oriental (Asiatic and Egyptian) art, the classical with Greek and Roman art, and the romantic with Christian-Germanic art. He was the first Western thinker whose art historical vistas extended to Far Eastern art as a whole; he thereby made a major contribution to the historiography of art.

For modern Western art history, Hegelianism is important for its impact on Marxist art historians and critics. Under the influence of Hegel's dialectical, single-cycle philosophy of history, Karl Marx (1818–83) formulated a cyclical conception of the idea of secular progress and sketched out some ideas on art. The first Marxist to discuss the arts systematically and rigorously was the Russian critic Georgi Plekhanov (1857–1918), whose study on eighteenth-century French art and society appeared in Russian in 1918 and was translated into English in 1936. This translation spread Plekhanov's views

abroad. More recently, the most prominent Marxist art critics have been the Hungarian György Lukács (1885–1971), the Austrian poet and critic Ernst Fischer (1899–1972), the English novelist and art critic John Berger (b. 1926), and Herbert Marcuse (b. 1898).

Formalist Theories

A far more important and influential approach to the visual arts was formulated by the Swiss art historian Heinrich Wölfflin (1864–1945). His first books (*Renaissance und Barock* and *Die Klassische Kunst*) present formal analyses of the architecture, sculpture, and painting of the Renaissance (especially the High Renaissance) and baroque periods and attempt to identify fundamental differences in the mass of art works of these periods. Thus Wölfflin arrived at a set of five *Grundbegriffe,* or fundamental conceptual tools, to describe the opposed styles of the Renaissance and baroque. Published in his *Kunstgeschichtliche Grundbegriffe; Das Problem der Stilentwicklung in der neueren Kunst,* these polarities may be translated as: (1) the linear and the "painterly"; (2) plane or parallel surface form and recession or diagonal depth form; (3) closed or tectonic form and open or a-tectonic form; (4) multiplicity or composite and unity or fused; and (5) clear and relatively unclear. These five pairs of polar concepts are applied to all media in the visual arts and oppose each other as two modes of vision, as two histories of seeing.

Wölfflin maintained that styles have an inherent tendency to change, and that the development from the Renaissance to the baroque was an internal, logical evolution that could not be reversed. An empiricist concerned with description rather than explanation, he refused to speculate about the causes of this evolution. Whereas Alois Riegl viewed stylistic evolution as an open development, a movement in which there is neither progress nor decline, and in which all styles possess equal value, Wölfflin believed in a dialectical movement between closed cycles, in which the deus ex machina is a kind of self-activating force, operating within artistic phenomena, and intrinsic to the system itself.

The strength of Wölfflin's system is that it is derived from a close analysis of works of art themselves, especially of their morphological structure, rather than from historical theories and metaphysical speculation (though it is true that in the 1880s and 1890s Wölfflin was influenced by the aesthetic theories of the sculptor Adolf von Hildebrand and the philosopher Konrad Fiedler). Wölfflin proceeded from the visual arts to his model, and not vice versa. Moreover,

when he speaks of "classic" and "baroque," his ideas have merely a descriptive rather than normative significance. He contended that his concepts could be employed to define differences in national styles as well as period and artistic styles. In *Italien und das deutsche Formgefühl*, he undertook a comparison of Italian and German art of the years from about 1490 to 1530 and postulated that national concepts of form shaped the art works of these nations through their history.

By excluding the vital analogy of birth, maturity, and decay, as well as all value judgment, Wölfflin presented a refined model of the cyclical organic evolution of development. His model had an immediate and widespread impact not only on art historical scholarship but also on other fields, such as literature (e.g., Oskar Walzel), music (e.g., Curt Sachs), and even economics. But these attempts by scholars to apply the model to their own fields failed, as has been demonstrated by Dagobert Frey (1883–1962) in *Gotik und Renaissance als Grundlagen der modernen Weltanschauung*. These abortive studies also led the German art historian Paul Frankl (1878–1962) to formulate a perceptive and analytical critique of the Wölfflinian model in *Das System der Kunstwissenschaft*. In his *System*, Frankl arrives at antithetical categories, a style of "being" and a style of "becoming," which are defined by reference to the morphological qualities of works of art, and which are subject to a cyclical conception of development.

Wölfflin's model was also marred by internal weaknesses. Early critics recognized that he had overlooked "mannerism," an important phase of Italian art in the sixteenth century. They pointed out that his *Grundbegriffe* cannot be applied to the art of other periods and that the High Renaissance and baroque periods are not as homogeneous as Wölfflin had maintained. They noted that he quite wrongly excluded the possibility of the coexistence of several modes of vision or styles in a single period or even in a single art work. Others regretted his formalist isolation of the art work, observing that he was unconcerned with iconographic or social factors bearing on the creative process.

Though most historians of art today consider Wölfflin's model untenable, they continue to refine and apply his terminology and, especially, his basic morphological comparative approach in their own studies, be they formal, iconographic, or contextual.

The use of antithetical categories to describe change, noted in the work of Riegl, Wölfflin, and Frankl, is a major tendency in German

scholarship of the late nineteenth and early twentieth centuries. It occurs in the writings of other art historians, too. For example, in *Abstraktion und Einfühlung: ein Beitrag zur Stilpsychologie,* Wilhelm Worringer (1881–1965) endeavored to combine Theodor Lipps's theory of *Einfühlung* or empathy with Riegl's concept of *Kunstwollen.* Worringer observes a polar contrast between geometrical (abstract) and organic (empathetic) forms in the whole history of art, Eastern and primitive as well as Western. Abstract aesthetic styles characterize peoples oppressed by nature and involved with spiritual reality, while organic styles characterize peoples who have an affinity for nature and find spiritual satisfaction in it. Worringer identifies the various *Weltanschauungen* that underlie artistic creation as the cause of this opposition of styles. Worringer developed some of the ideas in this book in his *Formprobleme der Gothik.* Attacking the positivist view of Gothic architecture, he defines Gothic as all Nordic art from the Hallstatt period to the baroque of Northern Europe and interprets it as a reaction in that region to the classical values of the Mediterranean. He argues that Gothic style resulted from a peculiar *Kunstwollen* that issued from the psychological traits of Northern man, who was more eager for transcending than for beauty. There is a clear link between Worringer's interpretation of Gothic and contemporary German expressionism.

A different analysis of historical time has been undertaken by the prolific German art historian Wilhelm Pinder (1878–1947). In his *Das Problem der Generation in der Kunstgeschichte Europas,* Pinder is primarily concerned with what he poignantly terms the "noncontemporaneity of the contemporaneous" *(Ungleichzeitigkeit des Ungleichzeitigen),* which in his view is the key to understanding history. For him, as for a number of German and even French writers before him, history is based on the phenomenon of generations. According to Pinder, different generations live at the same time. But since experienced time is the only real historical time (a concept that Pinder had apparently borrowed from Wilhelm Dilthey), these different generations must all in fact be living in qualitatively quite different subjective eras. He wrote, "Everyone lives with people of the same and of different ages, with a variety of possibilities of experience facing them all alike. But for each the 'same time' is a different time—that is, it represents a different *period of his self* which he can only share with people of his own age."

A given historical moment thus will vary in meaning according to the generation in question. Every moment of time is in reality more

than a separate and precise event; it is a temporal volume having more than one dimension, because it is always experienced by several generations at various stages of development. To quote a musical simile employed by Pinder: the thinking of each epoch is polyphonic. At any given point in time, we must always sort out the individual voices of the various generations, each attaining that point in time in its own way. The generations are, as it were, parallel slanting layers running diagonally across pure time; on one of these layers, representing his generation, the individual travels from birth to death. In other words, each historic situation depends on what kind of generations, how many generations, and how old generations actively participate in it.

A further idea posited by Pinder is that each generation builds up an "entelechy" of its own, by which means alone it can really become a qualitative unity. According to him, the entelechy of a generation is the expression of the unity of its "inner aim"—of its inborn way of experiencing life and the world. When seen within the tradition of German and Austrian art history, this concept of entelechy represents the transfer of Riegl's concept of *Kunstwollen* from the phenomenon of unity of artistic styles to that of the unity of generations.

Pinder goes on to say that it is possible for one generation to "infect" the others of the same time, that is, to change them not in their innermost being, their generation entelechy, but in their modes of expression. The character of a period is largely dependent on which generation happens to be the infecting force: youth, middle age, or old age. The entelechy of a generation implies unity of problem, not necessarily of solution; in such a case, we have a "split" age group, as is reflected, he maintains, in, say, works by Monet and Cézanne, Uhde and Gauguin.

The concept of generation entelechy led Pinder to abandon the idea of a *Zeitgeist* that had absorbed the thinking of German art historians before him. The generation entelechies serve to destroy the purely temporal concepts of a period that were overemphasized in the past. The period as a unit has no homogeneous driving impulse, no homogeneous principle of form—no entelechy. Its unity consists at most in the related nature of the means that the period makes available for the fulfillment of the different historical tasks of the generations living in it.

Although Pinder's denial of the existence of an entelechy peculiar to each period means that periods can no longer serve as units in

historical analysis, and that the concept of *Zeitgeist* becomes inapplicable and relativized, other terms customarily used as concepts in the history of ideas remain valid. According to Pinder, in addition to entelechies of generations, there exist entelechies of art, language, and style; entelechies of regional units, or nations and tribes *(Kulturraum);* even entelechies of the individuals themselves. In this regard Pinder avoids simplification. Methodologically, he undertakes a comprehensive analysis of all factors determining a given situation.

For Pinder, then, historical change is based on the interplay of constant and transient factors. The constant factors are civilization, nation, tribe, family, individuality, and type; the transient factors are the entelechies of generation, art, language, style, and the like. He maintained that "growth is more important than experience ('influences,' 'relationships') . . . that the life of art, as seen by the historian, consists in the interactions of *determining* entelechies, *born* of mysterious processes of nature, with the equally essential frictions, influences, and relations *experienced* in the actual development of these entelechies."

With his idea of the "non-contemporaneity of the contemporaneous," as well as his concept of entelechies, Pinder ultimately seeks to establish measurable intervals in history, and to use this formula of generations in order to discover birth cycles exercising a decisive influence on history. As to the length of generations, Pinder is not dogmatic. The length varies, and in periods of great creative activity or of unrest generations tend towards shorter duration and quicker change. A period of 25–30 years seems normal, but in the last analysis Pinder cannot refrain from considering this at least an approximation to the length of a genealogical generation. But he does not stress this point, and he allows for irregular breaks in the system.

The most debatable point in his construct is his notion of the genesis of generations. His generations are not shaped by common experience or other sociological factors, but born as predestined entelechies; thus, they cannot be submitted to causal analysis.

The relative ages of the various arts are important to Pinder. The four arts with which he is principally concerned arise and develop in this order: architecture, sculpture, painting, music. (For him, literature belongs to a different realm of human productivity, one that includes philosophy, religion, and the human sciences, all of which use words as their medium of expression.) In a given period the various arts may have a certain time coloring in common, but with different age shades; or they may be parallel, but on different age

levels, each art having its own entelechy, the innate laws of which it follows at the same time it participates in the general intellectual and artistic development. Thereby he seeks to account for why the arts are not always following the same level of development, why some lag behind others at a given point in time.

There is only one counterpart in American scholarship to such theoretical considerations of the arts as those of Riegl and Wölfflin, George Kubler's *The Shape of Time: Remarks on the History of Things*. The theory expressed by Kubler (b. 1912) evolved under the influence of anthropological theory, concepts of the history of science, biology, glottochronology, and in some measure mathematical and philosophical inquiry. It responds to problems posed by ancient American art and what he terms the dehumanization of anthropological archaeology. Kubler's theory seeks specifically to describe change in the visual arts while radically enlarging the scope of art history. He advances the thesis of a linked succession of human productions, including art objects, that are distributed in time as early and late versions of the same action. Kubler emphasizes continuous change in the flow of human materials: "The aim of the historian, regardless of his speciality in erudition, is to portray time. He is committed to the detection and description of the shape of time."

Offered as an alternative model to the static stylistic categories of a Riegl or a Wölfflin, Kubler's model is based on the fundamental concept of changes occurring in long durations of different morphologies. Through his concepts of linked solutions and formal sequences, Kubler "discards any idea of regular cyclical happening on the pattern of 'necessary' stylistic series by the biological metaphor of archaic, classic, and baroque stages." He replaces biological with historical time and, like Wölfflin, is concerned more with the description than the explanation of the change of objects in time.

In the last fifteen years, several writers have dealt with the concept of progress and development in the arts. For example, in her *Progress in Art,* Suzi Gablik advances a novel thesis on art history heavily indebted to the Swiss experimental psychologist Jean Piaget's work with children and to his insights on cognitive modes of development. Gablik's inquiry rests on her contention that because artists have moved away from representational concepts of space and time and toward a more abstract and formal treatment of space-time parameters, the history of art necessarily reflects a progression. In her view, art progresses along a path defined by genetic epistemology, since, in

the light of the laws of developmental psychology, perceptual patterns of behavior precede cognitive ways of looking at the world. Accordingly, art history is inextricably tied to increasingly complex structures of thought patterning. Her thesis is that "historical development in art reflects a changing relationship between man and the environment and that the evolution of human cognition has led to changes in the way in which we experience and represent the world." At once provocative and questionable, Gablik's thesis avoids making value judgments of the art it analyzes; its scientific approach tends to ignore the ethical, social, cultural, and historical forces surrounding the work of art.

Berger, John. *Permanent Red: Essays in Seeing.* London: Methuen, 1969.
———. *The Success and Failure of Picasso.* Baltimore: Penguin, 1965.
Fiedler, Konrad. *On Judging Works of Visual Art.* Tr. by Henry Schaefer-Simmers and Fulmer Mood. Berkeley: Univ. of California Pr., 1949.
Fischer, Ernst. *Kunst und Koexistenz: Beitrag zu einer modernen marxistischen Ästhetik.* Reinbek 6, Hamburg: Rowohlt, 1966. *Art against Ideology.* Tr. by Anna Bostock. New York: Braziller, 1969.
———. *Von der Notwendigkeit der Kunst.* Hamburg: Claassen, 1967.
Frankl, Paul. *Das System der Kunstwissenschaft.* Brunn and Leipzig: Rohrer, 1938.
Frey, Dagobert. *Gotik und Renaissance als Grundlagen der modernen Weltanschauung.* Augsburg: B. Filser, 1929.
Gablik, Suzi. *Progress in Art.* London: Thames & Hudson, 1977.
Hildebrand, Adolf von. *Das Problem der Form in der bildenden Kunst.* 5th ed. Strasbourg: Heitz, 1905. *The Problem of Form in Painting and Sculpture.* Tr. by Max Meyer and Robert Morris Ogden. New York: G. E. Stechert, 1907.
Kubler, George. *The Shape of Time: Remarks on the History of Things.* New Haven, Conn.: Yale Univ. Pr., 1962.
Lipps, Theodor. *Ästhetische Faktoren der Raumanschauung.* Hamburg: L. Voss, 1891.
Lukács, György. *Beiträge zur Geschichte der Ästhetik.* Berlin: Aufbau-Verlag, 1954.
———. *Probleme des Realismus.* Berlin: Aufbau-Verlag, 1955.
Marcuse, Herbert. *The Aesthetic Dimension: Toward a Critique of Marxist Aesthetics.* Boston: Beacon Pr., 1978.
———. "Art as a Form of Reality." In *On the Future of Art,* pp. 123–34. New York: Viking, 1971.
Pinder, Wilhelm. *Das Problem der Generation in der Kunstgeschichte Europas.* Berlin: Frankfurter Verlagsanstalt, 1926.
Plekhanov, Georgï. *Art and Society.* Tr. by Paul S. Leitner, et al. New York: Critics Group, 1936.
Riegl, Alois. *Die Entstehung der Barockkunst in Rom.* Vienna: A. Schroll, 1908.
———. *Die spätrömische Kunst-Industrie.* Vienna: K. K. Hof-und Staatsdruckerei, 1901–23.

———. *Stilfragen.* Berlin: G. Siemens, 1893.
Semper, Gottfried. *Der Stil in den technischen und tektonischen Künsten.* 3v. Frankfurt: Verlag für Kunst und Wissenschaft, 1860–63.
Tietze, Hans. *Titian: Paintings and Drawings.* Vienna: Phaidon, 1937.
——— and Erica Tietze-Conrat. *The Drawings of the Venetian Painters in the 15th and 16th Centuries.* New York: J. J. Augustin, 1944.
Tietze-Conrat, Erica. *Mantegna: Paintings, Drawings, Engravings.* London: Phaidon, 1955.
Vasari, Giorgio. *Le vite de' più eccellenti pittori scuttori e architettori.* Florence: Lorenzo Torrentino, 1550. Enl. ed. Florence: I. Giunti, 1568. *Lives of the Most Eminent Painters, Sculptors and Architects.* Tr. by Gaston du C. De Vere. 10v. London: Macmillan and the Medici Soc., 1912–15.
Winckelmann, Johann Joachim. *Geschichte der Kunst im Alterthums.* Dresden: Inder Waltherischen Hof-Buchhandlung, 1764. *History of Ancient Art.* 4v. New York: Unger, 1968.
Wölfflin, Heinrich. *Italien und das deutsche Formgefühl.* Munich: F. Bruckmann A.G., 1931.
———. *Die Klassische Kunst.* Munich: F. Bruckmann, 1899. *Classic Art: An Introduction to the Italian Renaissance.* Tr. by Peter and Linda Murray. New York: Phaidon, 1952.
———. *Kunstgeschichtliche Grundbegriffe; Das Problem der Stilentwicklung in der neueren Kunst.* Munich: F. Bruckmann A.G., 1915. *Principles of Art History.* Tr. by M. D. Hottinger. New York: Dover, 1932.
———. *Renaissance und Barock.* Munich: T. Ackermann, 1888. *Renaissance and Baroque.* Tr. by Kathleen Simon. London: Collins, 1964.
Worringer, Wilhelm. *Abstraktion und Einfühlung: ein Beitrag zur Stilpsychologie.* Munich: R. Piper, 1911. *Abstraction and Empathy.* Tr. by Michael Bullock. New York: International Univ. Pr., 1953.
———. *Formprobleme der Gothik.* Munich: R. Piper, 1912. *Form in Gothic.* Tr. by Sir Herbert Read. London: A. Tiranti, 1957.

Kunstwissenschaft

Originating in the nineteenth century, *Kunstwissenschaft* is that tendency by European and especially German-speaking art historians to conceive of art history as a science, based on a rigorous objective and systematic investigation of individual art objects. More specifically, it deals methodically with supposedly inherent, general, historically unconditioned aspects of art.

Kunstwissenschaft is exemplified by the scholarship of the Viennese art historian Hans Sedlmayr (b. 1896). Influenced by Hegelianism, Alois Riegl, and the postivists and other philosophers of science, Sedlmayr aspires to define a *Strukturanalyse,* or configurational analysis, of art objects, by proposing two sciences of art. The aim of the first science is to observe, record, and organize data inherent in

and bearing on works of art; that of the second, the higher of the two sciences, strives to analyze and evaluate the principles of their underlying structural composition.

The second science should evolve under the influence of Gestalt psychology, the methods of which can enable the viewer to arrive at a proper structural analysis of an art work as long as the viewer possesses the "correct mental set." Application of this programmatic theory of art history is illustrated by a number of Sedlmayr's writings, including *Die Architektur Borrominis, Die Entstehung der Kathedrale,* and *Kunst und Wahrheit: Zur Theories und Methode der Kunstgeschichte.* Sedlmayr's influence can be traced in the work of Friedrich Matz, *Geschichte der griechischen Kunst* and in that of the younger scholars whose papers were collected and published in *Probleme der Kunstwissenschaft.*

The limitations of Sedlmayr's application of his method have been incisively pointed out by Meyer Schapiro. Sedlmayr's writings clearly lack a real analysis of historical factors and an adequate conception of the theory of the nature of causation to direct his historical interpretations. Sedlmayr apologized for remnants of positivist, naturalistic thought in Riegl, and he urges his readers to read "part-whole relations" when Riegl says "cause." Even though Sedlmayr mentions idealistic philosophers and sociologists such as Max Ferdinand Scheler (1874–1928) and Alfred Vierkandt (1867–1953), he, following Riegl, ends up alluding to an abstract *Kunstwollen* as the causative factor in historical change. Instead of an empirical study of historical conditions and factors, he seems to offer teleological deductions.

In his later writings, Sedlmayr continued to renounce the causal analysis of history that conceives of historical change merely as a result of blind and isolated chains of causation. For him, there is no such thing as the "meaningful movement of the Spirit which results in genuine historical totalities of events." He is interested not so much in the state of mind or *Weltanschauung* of the artist as in the art works themselves. He is a formalist seeking to define the structure of art, and frequently refers to scientists and logicians of empirical tendency in an attempt to establish a doctrinaire science of art.

Bauer, Hermann, ed. *Probleme der Kunstwissenschaft.* 2v. Berlin: De Gruyter, 1963–67.
Matz, Friedrich. *Geschichte der griechischen Kunst.* 2v. Frankfurt: Klostermann, 1950.

Schapiro, Meyer. "The New Viennese School." *Art Bulletin* 18:258–66 (1936).
Sedlmayr, Hans. *Die Architektur Borrominis.* Berlin: Frankfurter Verlags-Anstalt, 1930.
———. *Die Entstehung der Kathedrale.* Zurich: Atlantis Verlag, 1950.
———. *Kunst und Wahrheit: Zur Theories und Methode der Kunstgeschichte.* Hamburg: Rowohlt, 1958.

3

Studying the
Art Object

In later nineteenth- and twentieth-century Western art scholarship, many genres have flourished. Variety typifies the field today. Most schools of criticism originated at the beginning of this century, but each has been modified and elaborated by changing or changed approaches and methods. All remain with us today; no radically new genre has appeared and won wide acceptance since the Second World War. Contemporary Western art history is traditional and conservative rather than pioneering and progressive.

Art historical scholarship is largely derivative in character. Some art historians have even been inspirational, but none has exhibited the originality of a Karl Marx or a Sigmund Freud. Modern art history relies heavily on the aspirations and methods of other disciplines, especially the humanities and social sciences, but it has immeasurably increased our awareness and understanding of the visual arts.

ARCHIVAL RESEARCH AND GENERAL DOCUMENTARY STUDIES

Most modern art historians are not archivists pursuing documents for their own sake. Rather they seek out and interpret documents in archives when such materials can shed light on the art works they are investigating, answering questions about authenticity, authorship, the original physical setting of an art object, subject matter, the identity and circumstances of patronage, and other external factors bearing on a work of art. Art historians will introduce and assess these documents in their scholarly articles and books when these sources answer the quesions under investigation. These sources often provide

31

the foundation on which the historian builds his or her superstructure. For example, the clue to action painting and pop art is to be found in the articles and lectures by the art critics Clement Greenberg, Harold Rosenberg, and Leo Steinberg rather than in the work of Jackson Pollock, Roy Lichtenstein, or Andy Warhol.

In the nineteenth century, that age of positivism that represented the triumph of empiricism, art historians began to undertake an intensive search for and critical examination of written sources bearing on the arts. They searched for reliable documents as well as for authentic works of art. Among the first historians making such quests were those specializing in the arts of antiquity. Their work included Eduard Müller's history of ancient art theory, Otto Jahn's fundamental paper on Pliny, and Johannes Overbeck's collection of documents bearing on ancient Greek art.

The Vienna School of Art History has made the most significant contribution to the study of written sources on the visual arts. In 1871 it launched a series entitled *Quellenschriften für Kunstgeschichte und Kunsttechnik des Mittelalters und der Neuzeit,* which was edited by Rudolph von Eitelberger von Edelberg (1817–85), a founder of the Vienna School. The first systematic collection of critical editions of texts relevant for the history of medieval and Renaissance art, this series provides both editions of original treatises and general compilations from chronicles, diaries, and poems as they relate to works of art. Its eighteen volumes include standard works like Hubert Janitschek's *Leone Battista Alberti's kleinere kunsttheoretische Schriften* and Wolfgang Kallab's *Vasaristudien.*

Another founding member of the Vienna School, Franz Wickhoff (1853–1909), encouraged the collecting of documents, the study of illuminated miniatures and drawings, and auxiliary studies such as paleography and diplomatics at the University of Vienna. Wickhoff united connoisseurship with archaeology and philosophy to achieve a precision of observation analogous to that demanded by leaders of the Vienna Medical School. He was the first member of the Vienna School of Art History to assert the interdependence of culture, maintaining that early Christian painting had derived from pagan Roman wall murals and relief sculpture. Like Alois Riegl, he argued that every period of art was equally worthy of study. Written with Wilhelm Ritter von Hartel, Wickhoff's most significant publication was an illustrated monograph on the (sixth-century?) Vienna Genesis manuscript. This constitutes the first modern work to identify Ro-

man art as a phenomenon entirely distinct from Greek art in originality and character.

A late and extremely important product of the Vienna School was the monumental work *Die Kunstliteratur; ein Handbuch zur Quellenkunde der neueren Kunstgeschichte* written by Julius von Schlosser, the last member of this Viennese tradition of scholarship. This work is a selected bibliography of writers on art history and covers the period from the Middle Ages to the end of the eighteenth century. It treats the study of sources as a history of criticism and art historiography. Von Schlosser published a new and expanded edition of his work in Italian in 1935.

Related to von Schlosser's contribution is that of the German Paul Frankl. *The Gothic: Literary Sources and Interpretations through Eight Centuries,* a book of nearly 1,000 pages, is concerned with the question of what has been thought and written about the phenomenon of Gothic as a whole since its origin in the time of Suger, the twelfth-century abbot of the royal abbey of St. Denis. Relying heavily upon actual quotations, Frankl examines texts of the Gothic period as well as writings displaying the reaction against and the renewed interest in Gothic—books written as late as about 1952—in an attempt to understand the essence of Gothic. The volume is a virtually encyclopedic approach to one significant aspect of the history of art and ranks as a monumental achievement.

In nineteenth-century Italy the study of sources and documents was best represented by Gaetano Milanesi (1813–95), who published what is still the definitive edition of Giorgio Vasari's *Lives* (see p. 19). Milanesi discovered much archival material, especially on Sienese art, and published it critically. Such a documentary approach to art continues to the present day in Italy represented by Carlo Pedretti (b. 1914), an Italian who emigrated to the United States. Pedretti has a narrow but fertile field of interest, the voluminous writings and drawings of Leonardo da Vinci, some of which had already been published by Jean Paul Richter (1847–1937).

In general, American art historians have not adopted this approach as their specialized genre of scholarship, not because they tend not to be empiricists—for they are—but for the obvious reason that the major repositories of documents for European art are located outside of the United States. Whenever modern American art historians publish written sources, they form but a small (albeit significant) part of larger studies. However, some exceptions stand out.

Compilations of previously published documents have been popular in this country since the Second World War. These publications make accessible materials that are difficult, rare, or available only in unfamiliar languages. Three anthologies of texts dealing with the arts since the Middle Ages, and especially with those of the modern period, have been compiled and edited by Elizabeth G. Holt. Although such anthologies are sometimes criticized for omissions or inaccurate translations, they remain useful to students and the general public.

The *Prentice-Hall Sources and Documents in the History of Art Series,* edited by Horst W. Janson, represents major efforts at translation by reputable specialists. The texts in this series provide an introduction, commentary, explanatory footnotes, and bibliography. In some instances the volumes translate texts into English for the first time. On the whole, they serve as valuable scholarly, as well as teaching, aids.

For modern architecture, sculpture, and painting, Robert Motherwell (b. 1915) has edited the *Documents of Twentieth Century Art,* which comprises anthologies, documents, and monographs based on the writings of artists, their friends, and close associates. Sometimes providing the first English translations of this source material, these volumes are accompanied by critical and textual commentary and detailed bibliographies, indexes, chronologies, and other pertinent scholarly material. This series follows the thirteen titles in *Documents of Modern Art,* co-edited with Bernard Karpel (b. 1911), the last of which was published in 1955.

One recent example in the Motherwell series is *Kandinsky: Complete Writings on Art,* edited by Kenneth C. Lindsay and Peter Vergo. These two volumes make available for the first time in English all the writings on art by the Russian painter Wassily Kandinsky. In addition to the formal writings, they include selected interviews and lecture notes, as well as reproductions of the artist's woodcuts. This work presents in chronological order the writings published between 1901 and 1943.

Because of the prolific publication of archival materials for premodern art in the later nineteenth and early twentieth century, there has been far less of this material to publish in our day. Occasionally, however, new materials come to light and are published. One recent example is provided by Marilyn Aronberg Lavin's *Seventeenth-Century Barberini Documents and Inventories of Art.* In this collection Lavin (b. 1925) reassembles seventeenth-century documents and inventories of the art objects of the Barberini family. Her work con-

stitutes a sequel to the pioneering work of Oscar Pollak (b. 1893), which appeared in 1928–31. Pollak drew his material from a variety of sources in the archives of Rome, especially papal archives in the Vatican, to document the official art commissions and building projects of the time. Pollak's volumes have provided the basis for all subsequent art historical study of the period.

In her volume Lavin treats what Pollak did not, namely, the artistic endeavors of the immediate relatives of Pope Urban VIII (1623–44) and their descendants, some of whom became important art patrons. Having gained access to hitherto uncataloged materials not available for public use, she traces their activities through the documents in the Barberini family's private archives to the end of the seventeenth century, the most significant era of this patrician family's patronage. She publishes household inventories that list the subject matter, material, attribution, sizes, frames, and (infrequently) monetary value of works of art of every description. She also records other inventories, records of a legal nature, notarized contracts, decrees, wills, and official inventories. She located these materials and selected the most significant for publication.

Lavin's work fulfills the primary function of art historical documentation, because her documents and inventories identify and date individual works of art, some of which were known but mislabeled, some of which were thought to be lost, and some totally unrecognized before. The book treats hundreds of works. Since she deals with a whole century, she often finds as many as six or more references to a given object, each providing a vital piece of information. The repeated references define shifts in taste, views of authorship, repairs, copies, and even monetary value. This approach allowed her to compile what constitutes a new summary inventory for the whole century in the form of a master index, in which every reference to an object is brought together. Such archival research will prove highly significant for the study not only of Roman baroque art but also for cultural history as well. Her volume is a model for such compilations in the future.

Documents of Modern Art. Ed. by Robert Motherwell and Bernard Karpel. 13v. New York: Wittenborn, Schultz, 1955.

Documents of Twentieth-Century Art. Ed. by Robert Motherwell. New York: Viking, 1971– .

Frankl, Paul. *The Gothic: Literary Sources and Interpretations through Eight Centuries.* Princeton, N.J.: Princeton Univ. Pr., 1960.

Holt, Elizabeth G. *A Documentary History of Art.* 2d ed. 2v. Garden City, N.Y.: Doubleday, 1957.

———. *From the Classicists to the Impressionists: A Documentary History of Art and Architecture in the Nineteenth Century.* Garden City, N.Y.: Doubleday, 1966.

———. *Literary Sources of Art History; an Anthology of Texts from Theophilus to Goethe.* Princeton, N.J.: Princeton Univ. Pr., 1947.

Jahn, Otto. "Über die Kunsturtheile bei Plinius." *Sächsische Gesellschaft der Wissenschaften, Leipzig, Philologisch-historische Classe, Berichte.* II, 105–42. Leipzig, 1850.

Janitschek, Hubert. *Leone Battista Alberti's kleinere kunsttheoretische Schriften.* Vienna: W. Braumüller, 1877.

Kallab, Wolfgang. *Vasaristudien.* Vienna: K. Graeser, 1908.

Lavin, Marilyn Aronberg. *Seventeenth-Century Barberini Documents and Inventories of Art.* New York: New York Univ. Pr., 1975.

Lindsay, Kenneth C. and Peter Vergo, eds. *Kandinsky: Complete Writings on Art.* 2v. Boston: G. K. Hall, 1982.

Milanesi, Gaetano. *Documenti per la storia dell'arte senese, raccolti ed illustrati.* 3v. Siena: O. Porri, 1854–56.

———, ed. *Le vite de' più eccellenti pittori, scultori ed architettori scritte da Giorgio Vasari.* 9v. Florence: G. C. Sansoni, 1878–85.

Müller, Eduard. *Geschichte der Theorie der Kunst bei den Alten.* 2v. Breslau: J. Max, 1834–37.

Overbeck, Johannes. *Die antiken Schriftquellen zur Geschichte der bildenden Künste bei den Griechen.* Leipzig: W. Engelmann, 1868.

Pedretti, Carlo. *Studi vinciani; documenti, analisi e inediti leonardeschi.* Geneva: E. Droz, 1957.

Pollak, Oscar. *Die Kunsttätigkeit unter Urbano VIII.* 2v. Vienna: B. Filser, 1928–31.

Prentice-Hall Sources and Documents in the History of Art Series. Ed. by Horst W. Janson. Englewood Cliffs, N.J.: Prentice-Hall, 1965– .

Quellenschriften für Kunstgeschichte und Kunsttechnik des Mittelalters und der Neuzeit. Ed. by Rudolf von Eitelberger von Edelberg. 18v. Vienna: C. Graeser, 1871–1908.

Richter, Jean Paul, ed. *The Literary Works of Leonardo da Vinci.* 2nd ed. enl. 2v. London: Oxford Univ. Pr., 1939.

Schlosser, Julius von. *Die Kunstliteratur; ein Handbuch zur Quellenkunde der neueren Kunstgeschichte.* Vienna: A. Schroll, 1924. A new and expanded ed. of this work appeared in Italian as *La Letteratura artistica; manuale delle fonti della storia dell'arte moderna.* Tr. by Filippo Rossi. Florence: Nuova Italia, 1935.

Thieme, Ulrich. *Allgemeines Lexikon der bildenden Künstler von der Antike bis zur Gegenwart.* 37v. Leipzig: Seemann, 1908–54.

Vollmer, Hans. *Allgemeines Lexikon der bildenden Künstler des XX. Jahrhunderts.* 6v. Leipzig: Seemann, 1953–62.

Wickhoff, Franz, and Wilhelm Ritter von Hartel. *Die Wiener Genesis.* Vienna: F. Tempsky, 1895. *Roman Art: Some of Its Principles and Their Application to Early Christian Painting.* Tr. by Mrs. S. Arthur Strong. London: Heinemann, 1900.

PHOTOGRAPHIC COMPILATIONS

Related to the collecting of primary and secondary written sources is the compilation of descriptive inventory material. Photographs represent a permanent record of monuments that are valuable documents of art works at the time when, and under the physical conditions which, the photographs were taken. They serve as indispensable aids to studying both the details of an art work, especially when it is not possible to study it in situ (sometimes art works are simply inaccessible to scholars), or the whole work itself if it has been subsequently damaged or lost. Indeed, works of art sometimes cannot be properly scrutinized in their original settings because of their distance from the beholder or because of poor lighting conditions, a situation that sometimes obtains with sculptures or paintings in monumental churches. Thus, photographs can reveal salient characteristics not readily discernible when the specialist confronts the work face to face. Moreover, photographs also facilitate and expand the scope of comparison of art works. For example, a scholar can stand before an original work of art and compare it to a closely related work or group of works through photographs. Lastly, photographs provide the illustrations needed for the publication of art objects and for teaching.

Yet photography has its limitations. Photographs are imperfect documents of original art works. They cannot record the volume, mass, and proportions of buildings and large-scale sculptures. Depending on the kind of lens used in the camera, they tend to distort the art work. Wide-angle lenses are especially susceptible to considerable distortion. Color photography is notorious for misrepresenting the true colors of art works in all media. Through technological advances, however, photography has made great strides in recent years, and today photographs are far more accurate as records of their subjects than they were previously. In short, photographs are images of works of art; they represent an interpretation of it on the part of the photographer. Never are they reliable substitutes for the original.

Only in recent years have photographic archives without an accompanying text appeared. The *Courtauld Institute of Art Illustration Archives,* edited by Peter Lasko and others, are quarterly periodicals consisting almost entirely of pictures whose aim is to make available the vast photographic resources of the Courtauld Institute

in London. These volumes are intended to supplement existing illustration resources. The subjects are not readily found in books or not treated in such detail. The *Marburger Index* is a visual documentation of the fine arts in Germany—so far, the largest to be published by any one country. When complete, this index will contain 500,000 photographs from the Bildarchiv Foto Marburg and the Rheinisches Bildarchiv in Cologne, including art of foreign origin located in Germany. These photographs were taken between 1850 and 1976; some 100,000 have not been published before. They show works in all media from prehistory to the present day. The *Marburger Index* photographs are being published on microfiches; each microfiche carries a caption that locates and dates the object. The value of this project is evident from the fact that it takes less time to study several hundred photographs in the *Index* than to search one illustrated book.

Scholarly monographs devoted exclusively to the publication of one or more works of art have been rare. One recent notable example is Thomas F. Mathews's *The Byzantine Churches of Istanbul: A Photographic Survey*. Utilizing 655 photographs selected from about 10,000 taken by the author between 1968 and 1973 and from thousands examined in archives, Mathews has compiled a survey of the ancient churches of Constantinople. A history of the Byzantine architecture in the former capital of the empire might someday be based on this visual record. Mathews' comprehensive coverage is intended to be an archive of photographic information in a single volume. Partly because of the cost of publication, and partly because scholars expect interpretative texts to accompany such visual records, publications of this kind remain uncommon.

Of course, full facsimiles of illuminated manuscripts have been published since the later nineteenth century, though they are generally accompanied by written texts that describe and interpret the miniatures. Publications of this kind are useful because they often illustrate all folios of a manuscript, always in their original sequence, and in their original size and colors. An outstanding example of such a facsimile of a medieval illuminated manuscript, accompanied by a full scholarly apparatus, treats the Lindisfarne Gospel Book and was edited by Sir Thomas Downing Kendrick.

Courtauld Institute of Art Illustration Archives. Ed. by Peter Lasko et al. London: Harvey Miller, 1976– . (A quarterly portfolio periodical.)

Kendrick, Sir Thomas Downing, et al., eds. *Evangelia Quattuor Codex Lindisfarnensis.* 2v. Olten and Lausanne: Urs Graf, 1956–60.

Marburger Index. Munich: K. G. Sauer, 1976– .
Mathews, Thomas F. *The Byzantine Churches of Istanbul: A Photographic Survey.* University Park: Pennsylvania State Univ. Pr., 1976.

Illustrated Inventories

Another highly useful scholarly tool of the art historian is the publication of inventories with concise descriptions of buildings and photographic documentation. These inventories cover particular regions or cities and began to appear at the start of this century. Examples include Georg Gottfried Dehio's *Handbook of German Art Monuments* (1905–1912) (the so-called Dehio *Kunstdenkmäler* series), the *Österreichische Kunsttopographie,* and the *Kunstdenkmäler der Schweiz.* Treating secular and religious buildings of all historical periods, these inventories record basic documentation, usually without an accompanying interpretive analysis of the monuments. Such series are lacking for other countries. The Dutch have been issuing volumes based on the German model; historical inventories are available for Spain and Portugal. During World War II, two related series for Italy were discontinued. In 1910, the Royal Commission on Historical Monuments in England started a series of such monographs arranged by county, but it has not progressed rapidly. Until it is completed, students must refer to the 46-volume series *The Buildings of England,* edited by Sir Nikolaus Pevsner. For Scandinavia, France, Greece, and the United States, nothing comparable has appeared.

Dehio, Georg Gottfried. *Handbuch der deutschen Kunstdenkmäler.* 5v. Berlin: E. Wasmuth, 1905–12.
Die Kunstdenkmäler der Schweiz. Basel: Gesellschaft für schweizerische Kunstgeschichte, 1927– .
Österreichische Kunsttopographie. Vienna: A. Schroll, 1907– .
Pevsner, Sir Nikolaus, ed. *The Buildings of England.* 46v. London: Penguin, 1951–74.

Pictorial Dictionaries

The Zentraldirektion of the German Archaeological Institute in West Berlin has published three important pictorial dictionaries on the topography and monuments of ancient and medieval Rome, Athens, and Istanbul. Prepared by scholars who are familiar with the monuments of these cities, the dictionaries contain factual and concise descriptions of the monuments, accounts of recent discoveries, theories about them, and the interpretations and conclusions of the

authors of each volume. Each volume is accompanied by plans and illustrations of exceptional quality. Bibliographical entries referring primarily to recent studies are provided for each monument. Such publications marshal in one convenient place all the latest information and interpretations of major and minor monuments in these three major cities.

Müller-Wiener, Wolfgang. *Bildlexikon zur Topographie Istanbuls: Byzantion-Konstantinupolis-Istanbul bis zum Beginn des 17. Jahrhunderts.* Tübingen: E. Wasmuth, 1977.

Nash, Ernest. *Bildlexikon zur Topographie des antiken Rom.* 2v. Tübingen: E. Wasmuth, 1961–62. *Pictorial Dictionary of Ancient Rome.* 2v. London: A. Zuemmer, 1961–62.

Travlos, John. *Bildlexikon zur Topographie des antiken Athen.* Tübingen: E. Wasmuth, 1971. *Pictorial Dictionary of Ancient Athens.* New York: Praeger, 1971.

Exhibition Catalogs

The art exhibitions of both museums and dealers have become an integral part of the lives and careers of artists, whose artistic aims and livelihood are dependent upon them. For professional artists this situation is perhaps more true today than in the distant past, when a sizable proportion of art was commissioned. Until the seventeenth century, churches, confraternities, and guilds held displays of private art collections. In 1665, when the Royal Art Academy in Paris was established, exhibitions became more rigorously organized in terms of the selection of works of art and their arrangement on the walls, as has been shown by Georg Friedrich Koch. From then on, art exhibitions attracted greater numbers of the public, helping to stimulate art criticism.

The catalogs of comprehensive exhibitions of historical art treasures and individual artists rank among today's most important publications. They have assumed that role since the end of the Second World War, when Europe began to display works that had been kept in storage during the war before their reinstallation in their old quarters or, as often happened, in settings that were restored after war damage. In Europe, the most noteworthy of the great exhibitions have been organized by the Council of Europe. These include Art around 1400 (Vienna, 1962); The Age of Charlemagne (Aachen, 1965); Gothic Europe (Paris, 1968); and The Age of Neo-Classicism (London, 1972). Other large exhibitions have featured the art of particular regions, like the Rhine-Meuse area (Cologne, 1972), while

yet others have been devoted to a single artistic medium: Stained Glass (Paris, 1953). These exhibitions are normally accompanied by catalogs that are often major contributions to knowledge and, as such, become indispensable reference tools; e.g., *Women Artists: 1550–1950.* Some exhibitions lead to important supplementary publications. For example, *Werdendes Abendland an Rhein und Ruhr* (Essen, 1956), an exhibition of early medieval art in Germany, led Victor H. Elbern, its organizer, to assemble and edit three volumes of specialized studies by leading authorities.

In the United States, exhibitions of individual artists and of great art treasures have been numerous in the past decade, reflecting in part a growing public awareness and appreciation of art. These exhibitions are almost always accompanied by catalogs. Representative samples include *Three American Painters: Kenneth Noland, Jules Olitski, Frank Stella; Master Bronzes from the Classical World; The Year 1200; The Great Decade of American Abstraction: Modernist Art 1960 to 1970; Treasures of Tutankhamun; Rauschenberg; Treasures of Early Irish Art, 1500 B.C. to 1500 A.D.; Cézanne: The Late Works; The Splendor of Dresden: Five Centuries of Art Collecting; and The Age of Spirituality: Late Antique and Early Christian Art, Third to Seventh Century.* As in Europe, major exhibitions can also encourage related publications. For example, Theodore Reff, who organized the major Degas exhibition at the Metropolitan Museum in 1976, wrote *Degas: The Artist's Mind.* This work, largely based on previously unpublished material from Dégas's own notebooks, examines the artist's technical innovations, pictorial strategies, and calculations of visual effect.

The Age of Spirituality: Late Antique and Early Christian Art, Third to Seventh Century. Ed. by Kurt Weitzmann. New York: Metropolitan Museum of Art, 1979.

Alloway, Laurence. *Rauschenberg.* Washington, D.C.: National Collection of Fine Arts, 1976.

Cézanne: The Late Works. Ed. by William Rubin. New York: Museum of Modern Art and the Réunion des Musées Nationaux, France, 1977.

Das erste Jahrtausend: Kultur und Kunst im Werdenden Abendland an Rhein und Ruhr. Ed. by Victor H. Elbern. 3v. Dusseldorf: L. Schwann, 1962–64.

The Great Decade of American Abstraction: Modernist Art 1960 to 1970. Ed. by E. A. Carmean, Jr., et al. Houston: Museum of Fine Arts, 1974.

Koch, Georg Friedrich. *Die Kunstausstellung. Ihre Geschichte von den Anfängen bis zum Ausgang des 18. Jahrhunderts.* Berlin: Walter de Gruyter, 1967.

Master Bronzes from the Classical World. Ed. by David Gordon Mitten and Suzannah F. Doeringer. Cambridge, Mass.: Fogg Art Museum, 1967.

Reff, Theodore. *Degas: the Artist's Mind.* New York: Metropolitan Museum of Art, 1976.

The Splendor of Dresden: Five Centuries of Art Collecting. Washington, D.C.: National Gallery of Art, 1978.

Three American Painters: Kenneth Noland, Jules Olitski, Frank Stella. Ed. by Michael Fried. Cambridge, Mass.: Fogg Art Museum, 1965.

Treasures of Early Irish Art, 1500 B.C. to 1500 A.D. Ed. by Polly Cone. New York: Metropolitan Museum of Art, 1977.

Treasures of Tutankhamun. Ed. by I. E. S. Edwards. New York: Viking Pr., 1976.

Women Artists: 1550–1950. Ed. by Ann Sutherland Harris and Linda Nochlin. Los Angeles: Los Angeles Museum of Art, 1976.

The Year 1200. Ed. by Konrad Hoffman and Florens Deuchler. 2v. New York: Metropolitan Museum of Art, 1970.

MATERIALS AND TECHNIQUE

Close physical examination of an art object is essential to determine its maker, date, provenance, and, to some extent, its style and content. Historical studies of the materials and techniques of art works originated in the nineteenth century and continue to the present day. Since so many different materials and techniques have been used in Western art, no comprehensive study of them has ever been made or is likely to be attempted.

Students of ancient Greek sculpture began to examine closely materials and technique after World War I. One of the earliest such scholars was Carl Bluemel (b. 1893), whose *Griechische Bildhauerarbeit* laid the foundation for subsequent studies in the field. Bluemel maintained that "every period has its own way of seeing and representing form, and [that] technical methods have always been directly dependent upon the contemporary view of form." For him, works of ancient sculpture allow us to observe these methods at different periods and in different stages of work over such a wide field that we can obtain an understanding of the main lines of development and practice.

The Technique of Early Greek Sculpture by Stanley Casson (1889–1944) is a more substantial study that investigates Greek methods for making stone and bronze statues so that the "reactions of style upon technique and of technique upon style may be established and analysed." Contending that the way in which a statue is made provides an insight into the mind of its creator, Casson argues that technical methods affect style and outlook of an artist and so lead to changes in the artist's aesthetic intention.

In a more recent study of ancient Greek sculpture, Rhys Carpenter tries to prove "that sculptural styles are not casual mannerisms, such as an artist might at any time invent and popularize, but are strictly conditioned by evolutionary laws which are in turn dependent upon the unchangeable dictates of the mechanism of human vision." For him, "the technique of the artist's craft is the mirror in which the pageant of changing and evolving style is reflected."

For medieval art, a materialistic and technological bias emerges from the writings of the French art historian Henri Focillon (1881–1943). Evolved under the influence of Viennese *Kunstwissenschaft* and Semper's doctrines, Focillon's *Vie des Formes, L'art des sculpteurs romans,* and other books argue for an autonomous internal development of forms, independent of outside forces such as society, in which emphasis is placed upon the material and technical aspects of art objects: "technique is not only matter, tool and hand . . . it is also mind speculating on space." The art object is a product of the interaction of matter and mind.

Beginning in the 1930s, Focillon released art history in France from the confines of its traditional philological and archaeological approach. He influenced a number of scholars, among them the Lithuanian Jurgis Baltrušaitis (b. 1903), who followed up the theme of Focillon's metamorphoses in several stimulating papers. Charles Sterling (b. 1901), in his work on still life painting from antiquity to the present day, also reveals a debt to Focillon. André Chastel (b. 1912) has also fallen under Focillon's influence to some extent.

An interpretation of the history of construction of a major monument that is based exclusively on the materials and technique of construction is offered in the 1977 book on Chartres Cathedral by the Australian architect John J. James. By paying little attention either to the scholarship or to the sparse contemporary records pertaining to the rebuilding of the cathedral launched in 1194, James suggests challenging answers to the major questions of the identity and number of architects of Chartres and whether the cathedral was rebuilt from west to east or east to west. He analyzed the building meticulously, virtually stone by stone, and made highly detailed visual and mensural surveys. His principal technique was to reconstruct the geometrical manipulations used by the masons in designing templates and in setting out and carving each individual stone. Then he compared these geometrical constructs across the entire building. Where he discovered the same or a similar "geometry," he concluded that the design was by the same hand, that of a given contractor and

his crew; and the execution was by the same mason, the contractor's crew (since the names of none of the contractors are recorded, he labels them according to a color code: scarlet, cobalt, ruby, olive, etc.). Accordingly, he asserts that during seventeen different campaigns a sequence of six groups of contractors and their crews, rather than an overall resident master mason, designed and executed the cathedral, and that it was erected from bottom to top, more or less simultaneously over the whole length of the nave, transepts, and choir. Although his findings are debatable, they illuminate critical aspects of the plan of the cathedral, its proportional systems, and its carved decoration that have puzzled observers for generations.

The same monuments, and others of the Gothic period, have been scientifically researched by an engineer, Robert Mark (b. 1930) at Princeton University, for nearly two decades. Since the nineteenth century scholars have engaged in a lively debate about the functional and/or aesthetic roles of Gothic buttressing systems and vault ribbing. To investigate these roles afresh, Mark devised techniques which have involved the analysis of a small-scale physical model of a structure under scaled loadings (simulated by the placement of small weights) or the setting out in an electronic computer of a mathematical description of the geometric form of a building structure and the behavior of its materials. His research suggests that small-scale models made of plastic can be used to predict internal forces with reinforced-concrete structures subjected to normal in-service loadings. As a consequence, he finds that the light, upper flyers at the roof level of Chartres Cathedral were a deliberate addition intended to rectify a structural flaw in the overall construction of the edifice. If this assessment is correct, then he has demonstrated that the architect was unclear about the buttresses. On the question of whether Gothic vault ribbing is functional or aesthetic, Mark finds that in the vault ribbing of Bourges Cathedral the supporting forces are distributed throughout the webs carrying the vault loading directly to the pier supports. The forces are not attracted to the groins formed at the intersection of the webs over the diagonal ribs, as had been assumed by earlier scholars. In short, Mark's engineering studies have refined and augmented historical scholarship based on primary documents, archaeological remains, and stylistic evidence.

Investigation of materials and building methods is important in architectural history, for it leads to an understanding of dating, structure, formal principles of organization, and influences of one monument or group of monuments upon another. Technical studies in ar-

chitectural history began during the nineteenth century. Foremost among the early advocates of this approach was the French architect Eugène Emmanuel Viollet-le-Duc (1814–79), who measured, studied, and restored medieval buildings in France, especially Gothic cathedrals. He regarded the Gothic style as the best of all time. A prolific writer and theorist, Viollet-le-Duc argued that all the forms and the entire construction system of any building result from utilitarian aims. Architects should design only what is functional, and functionalism is sociologically conditioned. Viollet-le-Duc's best known contribution is the *Dictionnaire raisonné de l'architecture française du XI^e ou XVI^e siècle,* whose purpose was to make known the forms of architecture and their raisons d'être, including an account of the social factors that influenced them. Equally important is his *Entretiens sur l'architecture,* in two volumes and two albums, a collection of twenty lectures.

The French scholar Auguste Choisy (1841–1909) wrote several books on the architecture of a number of civilizations in which the monuments are organized according to the materials used, the methods of construction, structural design, and the type of building. Choisy attempts to deduce what is typical for a building in each civilization by means of highly selective descriptions that fall into rigorous categories. He writes histories of architecture without reference to architects and without consideration of how buildings may be socially or culturally related to their periods. At the same time, Wölfflin had independently adopted a similar point of view for Renaissance and baroque art.

Investigations of the material and technical aspects of architecture are common in current scholarship on nineteenth- and twentieth-century buildings. Sir Nikolaus Pevsner (b. 1902) is one of the leading scholars in this field. In his popular survey, *An Outline of European Architecture,* Pevsner recognizes the central importance of materials and techniques. Henry Russell Hitchcock (b. 1903), the leading American scholar specializing in post-Renaissance architecture, focuses on materials in his monograph *In the Nature of Materials: 1887–1941; The Buildings of Frank Lloyd Wright.* Other specialists such as Peter Collins (b. 1920) and Carl W. Condit (b. 1914) have focused on the materials themselves.

As already noted, it was the architect-theorist Gottfried Semper who maintained that changes in art are caused by environment and by changes in materials and technique. Though his materialist doctrine was attacked by Riegl and the Viennese School of Art History, Semper has continued to shape the thinking of art historians. This is

evident in the writings of Sigfried Giedion (1888–1968), a student of Wölfflin and the single most influential historian of modern architecture among scholars and architects alike. In his popular *Space, Time and Architecture; the Growth of a New Tradition,* Giedion writes that the new requirements of modern architecture could not be met until the requisite materials and technology became available.

Baltrušaitis, Jurgis. *Aberrations: quatre essais sur la légende des formes.* Paris: O. Perrin, 1957.

——. *Anamorphoses; ou, Perspectives curieures.* Paris: O. Perrin, 1955. *Anamorphic Art.* Tr. by W. J. Strachan. New York: Abrams, 1976.

——. *Le Moyen âge fantastique; antiquités et exotismes dans l'art gothique.* Paris: A. Colin, 1955.

Bluemel, Carl. *Griechische Bildhauerarbeit. Ergänzungsheft 11.* Jahrbuchdes Deutschen Archäologischen Instituts. Berlin: W. de Gruyter, 1927.

Carpenter, Rhys. *Greek Sculpture, a Critical Review.* Chicago: Univ. of Chicago Pr., 1960.

Casson, Stanley. *The Technique of Early Greek Sculpture.* Oxford: Oxford Univ. Pr., 1933.

Chastel, André. *Art et humanisme à Florence au temps de Laurent le Magnifique; études sur la Renaissance et l'Humanisme platonicien.* Paris: Pr. Univ. de France, 1959.

Choisy, Auguste. *L'art de bâtir chez les Byzantins.* Paris: Société anonyme de publications périodiques, 1883.

——. *L'art de bâtir chez les Égyptiens.* Paris: E. Rouveyre, 1904.

——. *L'art de bâtir chez les Romains.* Paris: Ducher, 1873.

——. *Histoire de l'architecture.* 2v. Paris: Gauthier-Villars, 1899.

Collins, Peter. *Concrete: The Vision of a New Architecture; A Study of Auguste Perret and His Precursors.* New York: Horizon Pr. 1959.

Condit, Carl W. *American Building: Materials and Techniques from the First Colonial Settlements to the Present.* Chicago: Univ. of Chicago Pr., 1968.

Focillon, Henri. *L'art des sculpteurs romans.* Paris: E. Leroux, 1931.

——. *Vie des formes.* Paris: Pr. Univ. de France, 1934.

Giedion, Sigfried. *Bauen in Frankreich; Eisen, Eisenbeton.* 2d ed. Leipzig: Klinkhardt & Biermann, 1928.

——. *Space, Time and Architecture; The Growth of a New Tradition.* Cambridge, Mass.: Harvard Univ. Pr., 1941.

Hitchcock, Henry Russell. *In the Nature of Materials: 1887–1941; The Buildings of Frank Lloyd Wright.* New York: Duell, Sloan & Pearce, 1942.

James, John J. *Chartres: Les Constructeurs.* 2v. Tr. by Dominique Maunoury. Chartres: Société archéologique d'Eure-et-Loir, 1977, 1979. English ed.: *The Contractors of Chartres. I.* Dooralong, Australia: Mandorla Pub.; London: Croom Helm, 1978.

Mainstone, Rowland J. *Developments in Structural Form.* London: Allen Lane, 1975.

Mark, Robert. *Experiments in Gothic Structure.* Cambridge, Mass.: MIT Pr., 1982.

Pevsner, Sir Nikolaus. *An Outline of European Architecture.* New York: Penguin, 1942.
———. *Pioneers of the Modern Movement from Willian Morris to Walter Gropius.* London: Faber & Faber, 1936.
———. *The Sources of Modern Architecture and Design.* London: Thames & Hudson, 1968.
Sterling, Charles. *La Nature morte de l'antiquité à nos jours.* Paris: P. Tisné, 1952.
Viollet-le-Duc, Eugène Emmanuel. *Dictionnaire raisonné de l'architecture française du XIe au XVIe siècle.* 10v. Paris: Bance, 1854–68.
———. *Entretiens sur l'architecture.* 2v., 2 albums. Paris: Q. Morel, 1863–72. *Discourses on Architecture.* Tr. by Benjamin Bucknall. Boston: Milford House, 1973.

CONNOISSEURSHIP

Connoisseurship is the branch of art history that strives to identify the origins of art objects. Connoisseurs ask where, when, and by whom art objects were made. They deal with problems of provenance, dating, attribution to "hands" or individual masters and, thus, authenticity. Connoisseurship requires years of specialized study, firsthand acquaintance with many collections, a memory of objects gained through close and repeated study, and a sensitivity to subtle differences that comes only with experience. Connoisseurs learn the size, condition, medium, technique, quality, and formal characteristics of art objects. They must also identify subject matter, since art has treated certain subjects at specific times.

The questions that connoisseurs address must be answered before others can be asked. It is necessary, for example, to determine whether a painting is by Albrecht Dürer or Raphael before an art historian can attempt to relate it to the social forces that were operative in Germany around 1500.

The first writer to introduce the French term *connaisseur* (formerly *connoisseur*) into English was the painter and collector of drawings Jonathan Richardson the Elder in his book *The Connoisseur* (1719), addressed primarily to collectors. The techniques of connoisseurship were anticipated by European art historians in the early nineteenth century. The first important scholar to study individual art objects and the problem of their attribution was Carl Friedrich von Rumohr (1785–1843). In *Italienische Forschung,* Rumohr originally set out to translate Vasari's *Lives,* but found himself rewriting the history of Italian painting and sculpture. Though his subject was the stylistic development of Italian art, he strove to attribute art works by mar-

shaling all available evidence and assessing it with the tools of a philologist. He also distinguished the original work of art from its copy and perceived the original to represent an aspect of artistic personality. *Italienische Forschung* represents the first applications of empirical method to the study of visual arts and is thus a landmark in the historiography of art. It influenced German art historical thinking from Johann David Passavant (1787–1861) to Adolph Goldschmidt (1863–1944) and his many students in medieval art.

Connoisseurship was first formulated and rationalized by the Italian-born scholar Giovanni Morelli (1816–91). Educated as a physician and an expert in comparative anatomy, Morelli began writing about art only in 1874, and then in a German periodical under the Russian pseudonym Ivan Lermolieff-Schwarze. He set out to determine the authenticity and authorship of Renaissance paintings in Italian and German galleries by undertaking a scrupulous examination not only of such trivial anatomical details as ear lobes, nostrils, the balls of thumbs, and fingernails, as is commonly known, but also of the fundamental characteristics *(Grundformen)* of a work of art, as Wollheim has pointed out. Nonetheless, believing that every artist has a characteristic and unique approach to anatomy, Morelli contended that the true handwriting or style of the artist is more evident in these details than in fundamental forms, because these details required the least energy and thought on the part of the artist, whereas the more general forms in a painting—such as composition or the expression of a face—are subject to the forces of the school or tradition to which the artist belongs. He even published his own drawings of such details in his *Kunstkritische Studien über italienische Malerei.*

Identifying therefore the formation of such details as objective criteria by which artists can be identified and distinguished from each other, and conceiving of his method to be an exact science divorced from intuition, Morelli undertook systematic and categoric classifications of such details in Renaissance paintings to correct attributions made by others, to distinguish among works by different artists, and to identify copies and forgeries. Some of his attributions were revolutionary for their time. The so-called *Magdalen* of Correggio, which throughout most of the nineteenth century was identified as one of the two most important paintings in the Dresden gallery—the other was Raphael's *Sistine Madonna*—he showed to be a late seventeenth-century copy. And he reattributed an obscure painting in the same gallery, that had been cataloged as a copy by Sassoferrato after Ti-

tian, as a masterwork of Giorgione. Of course he made some mistakes, but they do not invalidate his method.

The principal heir of the Morellian method in the field of Renaissance painting and drawing was Bernard Berenson (1865–1959), who for more than half a century was a leading authority. Berenson defined connoisseurship as "that sense of being in the presence of a given artistic personality which comes from a long intimacy." After being trained at Harvard University, he went to Europe and traveled widely in Italy, where he soon settled down and spent the rest of his life. There, at his villa I Tatti outside Florence, he devoted all his time to examining original works of art firsthand, for prolonged periods, and on repeated occasions. He thereby developed a superior "eye" backed by an incomparable memory.

It is significant that Berenson focused on art works from the Renaissance, a period in which individuality reigned supreme, in contrast to the anonymity and communal projects of the Middle Ages. Dealing with an era marked by identifiable artistic personalities, he was able to concentrate on their idiosyncratic stylistic characteristics in order to reconstruct their artistic development. For him, like Morelli, the work of art was the primary datum of investigation. But Berenson differed from Morelli in that he began with written sources, even though he distrusted them. In his essay "Rudiments of Connoisseurship" (written in the 1890s though it was not printed until 1902), Berenson maintained that written sources help to establish proof of attribution to a known master but that proof is complete only when confirmed by connoisseurship. To be sure, his analyses were Morellian since they included anatomical comparisons as well as draperies, landscape, facial expressions, and even, to some extent, color; and he responded to works of art with all his senses and mind alert. Yet Berenson's approach to art was more philosophical than that of Morelli. It had been conditioned by classes he had taken at Harvard University with William James, whose pragmatism, with its emphasis on physiological and psychological problems of perception, Berenson apparently never forgot.

At once respected and controversial, Berenson was remarkable for the role he played in the history of taste and collecting. He stimulated and guided the interest of major American collectors in Italian art (e.g., Isabella Stewart Gardner). His principal written contributions are published lists of quattrocento and cinquecento paintings and drawings attributed to known artists. Although these lists have been amended, expanded, and in some cases supplanted, they remain the

foundation for the continued study of individual Renaissance works of art.

His patient, prolonged, and repeated examination of original works of art notwithstanding, Berenson still relied on his intuition in making attributions. His connoisseurship was refined in the United States by Richard Offner (1889–1956). Offner, too, maintained that constructive criticism must begin with the individual object and proceed inductively. And, like Berenson, he had a tenacious visual memory and a great sensibility to visual values. Unlike Berenson, however, he viewed the task of connoisseurship as the linking of a work of art to its place and period, not to artistic personality. And also in contrast to Berenson, he placed greater emphasis upon the importance of literary evidence, such as inscriptions on paintings and contracts about paintings (both of which Berenson distrusted), and especially upon iconography (which Berenson despised). Indeed, Offner subjected the study of literary evidence and iconography to a most exacting evaluation. As a result, intuition played a lesser role in his scholarship than in that of Berenson.

Offner perceived connoisseurship not as a sort of esoteric Rosicrucian system, but as a definite technique which, if incapable of arriving at scientific precision, may aspire to a validity capable of definite, if not scientific, proof. He also believed that connoisseurship precedes art history. Once the connoisseur has placed a work of art in the historical panorama, the work emerges not as an isolated artifact, but as part of a collective effort, as a factor of spiritual and intellectual culture, which the art historian must interpret.

Offner's great contribution was his multivolume work on Tuscan Trecento painting, which he began publishing in 1930. He was also one of a handful of American scholars who first gave the history of art in the United States international standing. And he trained three generations of students who became eminent art historians in this country (e.g., Millard Meiss, Robert Goldwater, and James Stubblebine).

Today, "pure connoisseurs" like Berenson and Offner are rare; when they exist, they tend to work as curators in major museums or for auction houses. The overwhelming majority of Renaissance paintings, at least, have been attributed and classified, so that the art historian can take over and interpret the lists prepared by the connoisseur. In this process, however, the art historian may still play the role of connoisseur and amend the previously established list of attributions. Such a linking of connoisseurship and art history is evident in the work of Sir John Pope-Hennessy (b. 1913), the most respected

connoisseur and art historian of Renaissance and baroque sculpture today. In his *An Introduction to Italian Sculpture,* the first modern work of its kind with no equivalent in any language, Pope-Hennessy surveys individual monuments, problems of attribution, and the stylistic development of each sculptor. He thus goes beyond the work of a Berenson or Offner, and he deals with sculpture, the connoisseurship of which presents far greater difficulties than the connoisseurship of Italian painting for the simple reason that sculpture has a third dimension. He also provides a series of essays loosely strung together whose only common denominator is Italian sculpture. Starting with a fresh and intense look at the art work rather than a prepared theoretical position, and making full use of written documents bearing on individual monuments, as well as analytical techniques, he considers the art work in its context and intellectual setting. He maintains that "connoisseurship is not a poor substitute for knowledge, but provides the only means by which our limited stock of documented knowledge can be broadened and brought into conformity with what actually occurred" *(The Study and Criticism of Italian Sculpture).* In this and other studies on sculpture, Pope-Hennessy presents historically significant and aesthetically relevant facts.

Connoisseurs thus deal with sculpture as well as painting and drawing. These media of artistic expression are highly susceptible of dislocation from their original niche in the historical panorama because they are highly movable. On the other hand, architecture does not lend itself nearly as easily to the techniques of connoisseurship. Since buildings remain stationary, they do not pose problems of provenance. Further, they are often the product of a collective effort rather than of a single master. Thus, they do not reveal the stylistic matrix discernible in the work of a single artistic personality. One of the few examples of an attempt to apply the techniques of connoisseurship to architecture is *The Architecture of the Palazzo Borghese* by Howard Hibbard (b. 1928). By a kind of Morellian-Berensonian confrontation of motifs, such as carved capitals and moldings, Hibbard strives to attribute the major parts of this palace to different hands. He is successful, because his quasi-statistical approach is applied to two generations of designers that were academically finicky about details.

Even in Berenson's day, intuition and hunches were under suspicion, and today this suspicion has grown considerably. Now there is a demand for objective evidence in connoisseurship. When written evidence is unavailable, scholars turn to a study of iconography.

When iconographic investigation yields inconclusive results, scholars turn to scientific studies for answers. Art historians now have a new respect for the physical properties of a work of art, and there is a new collaboration of the connoisseur with the scientist or restorer. In current studies there is a new conviction that the truth is best found in what is actually there, even in what remains when the restorer has finished his task. For example, X-rays of a painting attributed to Velásquez could reveal that it is a copy if they show no underpainting, since this master commonly sketched in some tentative ideas before he produced the completed canvas.

Contemporary connoisseurs approach the work of art from a point of view inconceivable fifty or seventy-five years ago, when scant attention was paid to the physical properties of art works. This does not mean, however, that science has replaced the "eye" of the art historian. Reattributions or the identifications of forgeries require collaboration between the art historian and the scientist or restorer. The art historian must interpret the results of X-rays or the chemical analysis of pigments. In the last analysis, the art historian's "eye" is decisive.

Collaboration between art historian and scientist remains in an experimental stage, but it has resulted in reattributions by many major museums in the last decade. Since 1970 over 300 European paintings have been reattributed by the Metropolitan Museum in New York City alone. More and more of the larger American museums have been acquiring expensive equipment for the restorer to use in the examination of their holdings, and reassessments of works of art have become more common and frequent. Of course, even Berenson freely changed his attributions. Sometimes he would view a canvas years after his first inspection and reverse himself. "What of it?" he would say. "I have learned to see more clearly, and that alone is important."

The tasks of the connoisseur are less pressing for works of art dating from the modern period, since these objects tend to be better documented. Many are signed—of course, signatures are not infrequently forgeries—and many are recorded in surviving written sources. Still, not all works by any major master of the modern period are securely documented, and even those that may appear to be safely attributed are subject to reassessment. Thus, art historians can assume the role of a connoisseur when dealing with works of art from the past two centuries. Their findings are often published in the form of a corpus, or *catalogue raisonné*. These are comprehensive

lists and descriptions of art works by individual artists, schools of art, or by type of object.

The first corpora and catalogues raisonnés were produced by classical antiquarians in the seventeenth and eighteenth centuries. These scholars worked from preserved monuments, such as marbles, gems, and coins, and arranged their material systematically according to the type of object rather than chronology. Representative early scholars include Ezechiel Spanheim (1629–1710), the founder of modern numismatics, Jacob Spon (1647–85), and Francesco Bianchini (1662–1729).

In modern scholarship the corpus or catalogue raisonné can assume different forms. Always striving to be comprehensive in its listing of the art works with which it is concerned, such a publication consists of entries that contain information about the date and place of execution, patronage, size, medium of expression, physical condition, and previous and present whereabouts. It is not uncommon for every work of art listed in the text to be illustrated as well. Some catalogues raisonnés of a master may also include a biography, the reproduction of pertinent letters and documents, genealogical and chronological tables, lists of exhibitions of that master's works, a discussion of forgeries, indexes of collectors, museums, and persons (if any) represented in that master's works, and a bibliography. They may also include an interpretative analysis of the individual works of art and of the entire oeuvre of the master.

Some of these catalogs are, therefore, massive documents. For prolific artists, they may constitute over a thousand pages of text and several thousand illustrations in more than one volume. If they are accurate in their compilation of basic data, even if they are not comprehensively illustrated, they become standard works of reference. In all cases, the basis on which the compiler of such a publication proceeds is the Morellian-Berensonian technique of connoisseurship.

Berenson, Bernard. *The Drawings of the Florentine Painters Classified, Criticised and Studied as Documents in the History and Appreciation of Tuscan Art.* 2v. New York: Dutton, 1903.
———. *Italian Pictures of the Renaissance: A List of the Principal Artists and Their Works.* Oxford: Oxford Univ. Pr., 1932.
———. "Rudiments of Connoisseurship." In his *The Study and Criticism of Italian Art,* pp. 111–48. 2d ser. London: George Bell, 1902.
Bianchini, Francesco. *La Istoria Universale provata con monumenti, e figurata con simboli degli antichi.* Rome: A. de Rossi, 1697.

Goldschmidt, Adolph. *Die Elfenbeinskulpturen aus Zeit der karolingischen und sächischen Kaiser VIII.–XI. Jahrhundert.* 4v. Berlin: B. Cassirer, 1914–26.

——— and Kurt Weitzmann. *Die byzantinischen Elfenbeinskulpturen des X.–XIII. Jahrhunderts.* 2v. Berlin: B. Cassirer, 1930–34.

Hibbard, Howard. *The Architecture of the Palazzo Borghese.* Rome: American Academy, 1962.

Morelli, Giovanni. *Kunstkritische Studien über italienische Malerei.* 3v. Leipzig: F. A. Brockhaus, 1890–93. *Italian Painters; Critical Studies of Their Works.* Tr. by Constance Jocelyn Ffoulkes. 2v. London: J. Murray, 1893.

Offner, Richard. "Connoisseurship." *Art News* 50:24–25, 62–63 (Mar. 1951).

———. *Critical and Historical Corpus of Florentine Painting.* New York: College of Fine Arts, New York Univ. 1930– .

Passavant, Johann David. *Le peintre-graveur.* 6v. Leipzig: R. Weigel, 1860–64.

———. *Raffael von Urbino und sein Vater Giovanni Santi.* 3v. Leipzig: F. A. Brockhaus, 1839–58. *Raphael of Urbino and His Father Giovanni Santi.* New York: Macmillan, 1872.

Pope-Hennessy, Sir John. *Catalogue of Italian Sculpture in the Victoria and Albert Museum.* Assisted by Ronald Lightbown. 3v. London: H. M. Stationery Off., 1964.

———. *An Introduction to Italian Sculpture.* 3v. New York: Phaidon, 1955–63.

———. *The Study and Criticism of Italian Sculpture.* Princeton, N.J.: Princeton Univ. Pr., 1980.

Richardson, Jonathan. "The Connoisseur." In *The Works of Mr. Jonathan Richardson.* London: T. Davies, 1773. (Reprinted in a modern facsimile as *The Works.* Hildesheim: G. Olms, 1969.)

———. *Two Discourses.* London: W. Churchill, 1719.

Rumohr, Carl Friedrich von. *Italienische Forschung.* 3v. in 1. Berlin: Nicolai'sche buchhandling, 1827–31.

Spanheim, Ezechiel. *Dissertations de prestantia et usu numismatum antiquorum.* New ed. London: Richard Smith, 1706–17.

Spon, Jacob. *Miscellanea Eruditae Antiquitatis.* Lugduni: Sumptibus Fratrum Huguetan, 1685.

Wollheim, Richard. "Giovanni Morelli and the Origins of Scientific Connoisseurship." In *On Art and Mind: Essays and Lectures.* London: Allen Lane, 1973.

Other Important Works of Connoisseurship

Angulo, Diego, and Alfonso E. Perez Sanchez. *A Corpus of Spanish Drawings.* London: Harvey Miller, 1975–77.

Bartsch, Adam von. *Le peintre-graveur.* 21v. Vienna: J. V. Degen, 1803–21.

Beazley, Sir John. *Attic Black-Figure Vase-Painters.* Oxford: Oxford Univ. Pr., 1956.

———. *Attic Red-Figure Vase-Painters.* 2d ed. 3v. Oxford: Oxford Univ. Pr., 1963.

Bode, Wilhelm von. *Rembrandt und seine Zeitgenossen: Charakterbilder der grossen Meister der holländischen und vlämischen Malerschule im siebzehnten Jahrhundert.* Leipzig: E. A. Seeman, 1907. *Great Masters of Dutch and Flemish Painting.* Tr. by Margaret L. Clarke. Freeport, N.Y.: Books for Libraries Press, 1967.

————. *Studien zur Geschichte der holländischen Malerei.* Braunschweig: F. Vieweg, 1883.

Boon, Karel G. *Netherlandish Drawings of the Fifteenth and Sixteenth Centuries in the Rijksmuseum.* 2v. The Hague: Govt. Print. Off., 1978.

Corpus Rubenianum Ludwig Burchard. London and New York: Nationaal Centrum voor Plastiche Kunsten in de XVIde en de XVIIde eeuw in Belgium, 1968– . (See especially *The Ceiling Paintings of the Jesuit Church in Antwerp* [Part I] by John Rupert Martin; *The Decoration of the Torre de la Parada* [Part IX] by Svetlana Alpers; *The Achilles Series* [Part X] by Egbert Haverkamp Begemann; and *The Decorations for the Pompa Introitus Ferdinandi* [Part XVI] by John Rupert Martin.)

Corpus Vasorum Antiquorum. Paris: E. Champion, 1923– .

De Groot, Cornelis Hofstede. *Beschreibendes und Kritisches Verzeichnis der Werke der hervorragendsten holländischen Maler des XVII. Jahrhunderts.* 10v. Esslingen: P. Neff, 1907–28. *A Catalogue Raisonné of the Works of the Most Eminent Dutch Painters of the Seventeenth Century.* Tr. by Edward G. Hawke. Teaneck, N.J.: Somerset House, 1976.

Dortu, M. G. *Toulouse-Lautrec et son oeuvre (Les Artists et leurs oeuvres: Études et documents).* Ed. by Paul Brame and C. M. de Hauke. 6v. New York: Collectors Eds., 1971.

Friedlaender, Max J. *Die altniederländische Malerei.* 14v. Berlin: P. Cassirer, 1924–37.

Furtwängler, Adolf. *Die antiken Gemmen.* 3v. Leipzig: Geisecke & Deurient, 1900.

————. *Griechische Vasenmalerei.* 6v. Munich: F. Bruckmann, 1904–32.

————. *Meisterwerke der griechischer Plastik.* Leipzig: Geisecke & Deurient, 1893.

Hind, Arthur Mayger. *Early Italian Engraving: A Critical Catalogue with Complete Reproduction of All the Prints Described.* 7v. London: M. Knoedler; New York: B. Quaritch Ltd., 1938–48.

Koehler, Wilhelm R. W. *Die karolingischen Miniaturen.* Berlin: B. Cassirer, 1930–.

O'Connor, Francis Valentine, and Eugene Victor Thaw. *Jackson Pollock: A Catalogue Raisonné of Paintings, Drawings, and Other Works.* 4v. New Haven, Conn.: Yale Univ. Pr., 1978.

Popham, Arthur E. *Catalogue of the Drawings of Parmigianino.* 3v. New Haven, Conn. and London: Yale Univ. Pr. for the Pierpont Morgan Lib., 1971.

————. *Correggio's Drawings.* London: Oxford Univ. Pr. for the British Academy, 1957.

————. *Italian Drawings in the Department of Prints and Drawings in the British Museum.* Vol. I: *The 14th and 15th Centuries,* with Philip Pouncey. London: Trustees of the British Museum, 1950.

————. *The Italian Drawings of the XV and XVI Centuries in the Collection*

of His Majesty the King at Windsor Castle, with Johannes Wilde. London: Phaidon, 1949.

Post, Chandler R. *A History of Spanish Painting.* 14v. Cambridge, Mass.: Harvard University Press, 1930–66.

Richter, Gisela M. A. *Korai: Greek Maidens.* London: Phaidon, 1968.

————. *Kouroi: A Study of the Development of the Greek Kouros from the Late Seventh to the Early Fifth Century B.C.* New York: Oxford University Press, 1942.

————. *The Sculpture and Sculptors of the Greeks.* New rev. ed. New Haven, Conn.: Yale Univ. Pr., 1950.

Tietze, Hans, and Tietze-Conrat, Erica. *Kritisches Verzeichnis der Werke Albrecht Dürers.* 3v. Augsburg: B. Filser, 1928–38.

Van Marle, Raimond. *The Development of the Italian Schools of Painting.* 19v. The Hague: M. Nijhoff, 1923–38.

Venturi, Lionello. *Camille Pissarro; son art—son oeuvre.* Paris: P. Rosenberg, 1939.

————. *Cézanne, son art, son oeuvre.* Paris: P. Rosenberg, 1936.

————. *Impressionists and Symbolists.* Trans. by Frances Steegmuller. New York: Scribner, 1950.

Wildenstein, Daniel. *Claude Monet, Biographie et catalogue raisonné.* Vol. I: *1840–1881, Peintures.* Lausanne: La Bibliothèque des arts, 1974.

Winkler, Friedrich. *Die Zeichnungen Albrecht Dürers.* 4v. Berlin: Deutscher Verein für Kunstwissenschaft, 1936–39.

Scientific Studies

Problems of connoisseurship continue to face art historians but connoisseurs today approach their work in a manner inconceivable fifty or sixty years ago, when they paid too little attention to the physical properties of the art works they were examining and judging. Today there is a suspicion of pure intuition, an emphasis on objective, often scientifically verifiable evidence, and a growing collaboration between art historians and scientists or restorers. Contemporary connoisseurship knows empiricism.

Evidence of the history of an art work is frequently contained with the material object itself; the art historian's problem is finding an appropriate way to glean this often elusive information. A growing number of scientific techniques is now available to the historian. Infrared reflectography can reveal the way a painting was built up by disclosing the underdrawings made before the application of the actual pigments. This method makes it possible to penetrate the "artistic personality" of a particular master through a study of his or her technique. See, for example, Molly Faries's "Underdrawings in the Workshop Production of Jan van Scorel." Microscopy can indicate surface morphology and joining procedures; ultraviolet light exami-

nations can pinpoint repairs; thermoluminescence measurements can help date a work; neutron activation autoradiography scrutinizes the interior structure of an object to learn about the material from which it was fabricated and to establish its original appearance. Generally, these and other techniques have become increasingly important in recent decades for persons and museums interested in determining authenticity, authorship, localization, the material nature of a work of art, and the process whereby the art work came into being.

In the 1930s American art historians became aware of the value of technical studies in ascertaining authenticity and authorship. *Technical Studies in the Field of the Fine Arts,* a journal that appeared from 1932 until 1942, was a pioneering achievement of Edward Waldo Forbes, director of the Fogg Art Museum of Harvard University from 1909 until 1944. Concern for the care and preservation of the art objects entrusted to him led Forbes to establish a scientific research department that attracted some of the best conservators of the day. Among these was George L. Stout (b. 1897), an investigator of paints and pigments, who served as managing editor of *Technical Studies.* This journal published accounts of scientific research and experiments and records dealing with the creation, preservation, and conservation of works of art. Technical studies focused on topics such as the chemical analysis of art materials, the use of X-rays, infrared and ultraviolet radiography, the description of fakes and forgeries, and the influence of certain environmental factors upon the life of art works. After *Technical Studies* ceased publication, *Studies in Conservation,* appeared in 1952 and has become a major international journal for disseminating information about the scientific examinations of art works.

During the decade that *Technical Studies* was in publication, monographs began to appear on the study of materials and techniques as a guide to attribution and the technical development of an artist's work. These included *Art Criticism from a Laboratory* by Alan Burroughs (b. 1897), and *The Brush-work of Rembrandt and His School, New Light on Old Masters,* and *The Technique of the Great Painters* by Arthur P. Laurie (1861–1949). More recent, and not outdated, is the useful study on the cleaning of paintings by Helmut Ruhemann.

In 1953, Paul B. Coremans, the director of the central laboratory of the Belgian Museums in Brussels, published the results of an all-embracing scientific examination of the fifteenth-century Ghent Altarpiece: *L'Agneau Mystique au Laboratoire; examen et traitement,*

Les Primitifs Flamands. This volume serves as a pioneering model for the possibilities that can be derived from a collaboration between art historians, scientific research workers, and restorers. In the years since the publication of Coremans's work, interdisciplinary studies of this kind have been increasingly common. Art historians sometimes expect too much of scientific studies, because they are unaware of their true nature. Scientific examination of art works does not always answer the questions of "genuine or fake," the physical nature of an art work, or the conditions whereby a work came into being. The results of such examinations of art works only become meaningful when they are assessed in the light of other art historical data and insights. An analysis and interpretation of the stylistic evidence that can be obtained from such examinations as X-radiographs and reflectograms demand not only a knowledge of style, which is part of the training of an art historian, but also an understanding of the nature of this kind of scientific material and the way it was obtained. Close and regular collaboration between art historian and scientist is necessary for a proper assessment of the evidence produced by scientific tests; it is even needed for planning and conducting such tests.

Moreover, the usefulness of scientific studies increases when more objects are investigated. Although it is possible to point up differences between various groups of related art works, even with material restricted to a few art works in each group, it is rather foolhardy to infer too much from such limited data. Concomitantly, it is difficult to interpret data resulting from the scientific examination of one or two isolated objects when no material for comparison exists.

Thus, in recent decades, cooperation has become increasingly common; nonetheless, the development of such collaboration today remains in an experimental stage. Probably the best indication of the point to which historians and scientists have progressed in this regard is provided by the articles published in the *Nederlands Kunsthistorisch Jaarboek* for 1975. This issue contains an illuminating introduction to the scientific examination of paintings by the physicist J. R. J. van Asperen de Boer.

In archaeology, scientific methods have been used on a much larger scale than in art history, and the published literature is accordingly more extensive. Good introductions are provided by Martin Jim Aitken in *Physics and Archaeology* and by Don R. Brothwell and Eric Higgs, the editors of *Science in Archaeology.* Archaeologists, far more than art historians, have been active in applying the methods of carbon 14 dating and dendrochronology to artifacts and monuments,

for instance. See, however, the papers by Peter Ian Kuniholm and Cecil L. Striker on the timber tie beams in the church of St. Eirene at Istanbul, and those by J. Bauch and D. Eckstein on the painted oak panels of Holland.

Today, the scientific examination of art works is an auxiliary discipline of art history, just as it is very much an applied science for the scientist. In art history such examination has been bringing the historian into more intimate contact with the art work.

Aitken, Martin Jim. *Physics and Archaeology*. New York: Interscience Pub., 1961.

Bauch, J., and D. Eckstein. "Dendrochronological Dating of Oak Panels of Dutch Seventeenth-Century Paintings." *Studies in Conservation* 15:45–50 (1970).

Brothwell, Don R., and Eric Higgs, eds. *Science in Archaeology*. Rev. & enlarged ed. London: Thames & Hudson, 1969.

Burroughs, Alan. *Art Criticism from a Laboratory*. Boston: Little, Brown, 1938.

Coremans, Paul B. *L'Agneau Mystique au Laboratoire; examen et traitement, Les Primitifs Flamands*. III, 2. Anvers: De Sikkel, 1953.

————. *Van Meegeren's Faked Vermeers and De Hooghs: A Scientific Examination*. Tr. by A. Hardy and C. Hutt. Amsterdam: J. M. Meulenhoff, 1949.

Faries, Molly. "Underdrawings in the Workshop Production of Jan van Scorel: A Study with Infrared Reflectography." *Nederlands Kunsthistorisch Jaarboek* 26:89–228 (1975).

Filedt Kok, J. P., et al. "Scientific Examination of Early Netherlandish Painting: Applications in Art History," *Nederlands Kunsthistorisch Jaarboek* 26:vii–268 (1975). (Bussum, Fibula-Van Dishoeck, 1976).

Hours, Madeleine. *Conservation and Scientific Analysis of Painting*. Tr. by Anne G. Ward. New York: Van Nostrand, 1976.

Kuniholm, Peter Ian, and Cecil L. Striker. "The Tie-Beam System in the Nave Arcade of St. Eirene: Structure and Dendrochronology." In *Die Irenenkirche in Istanbul: Untersuchungen zur Architektur* by Urs Peschlow. Istanbuler Mitteilungen, Beiheft 18. Tübingen: Ernst Wasmuth, 1977.

Laurie, Arthur P. *The Brush-work of Rembrandt and His School*. London: Oxford Univ. Pr., 1932.

————. *New Light on Old Masters*. London: Sheldon Pr., 1935.

————. *The Technique of the Great Painters*. London: Carroll & Nicholson, 1949.

Nicolaus, Knut. *Gemälde: Untersucht, entdeckt, erforscht*. Braunschweig: Klinkhardt & Biermann, 1979.

Ruhemann, Helmut. *The Cleaning of Paintings: Problems and Potentialities*. London: Faber & Faber, 1968.

Studies in Conservation. Aberdeen, Scotland: Aberdeen Univ. Pr., 1952– .

Technical Studies in the Field of the Fine Arts. Cambridge, Mass.: William Hayes, Fogg Art Museum, 1932–42.

ICONOGRAPHY

Iconography is an inquiry into the subject of an art object. The term applies to the description and classification of themes, attitudes, and motifs in images. It also means the identification of texts illustrated in a given work of art, whether religious or secular.

Modern iconographic investigation grew from nineteenth-century European scholarship and is related to the rise of historical science late in that century. The extent to which iconography should be viewed as a reaction against the formalist and purely aesthetic approach to art popular at that time is debatable. Some relationship presumably exists and should be examined.

The modern origin of iconography is associated with a number of writers, especially Émile Mâle (1862–1954). Mâle's approach derived from a tradition of manuals and encyclopedic works from the sixteenth century onwards, including Cesare Ripa's *Iconologia,* a dictionary listing of personifications of concepts in alphabetical order; Anne Claude Philippe de Caylus's *Recueil d'antiquités égyptiennes, étrusques, grecques et romaines,* one of the earliest systematic attempts to classify art works according to subject matter; Adolphe Napoleon Didron's *Iconographie chrétienne: Histoire de Dieu;* and Charles Rohault de Fleury's *Archéologie chrétienne: Les saints de la messe et leurs monuments.* Mâle was a student of medieval and Renaissance art. He wrote many books, some of which are still widely read.

French scholars today still compile encyclopedias of medieval iconography; these remain valuable research tools. Fernand Cabrol's *Dictionnaire d'archéologie chrétienne et de liturgie* is one of the most detailed and useful works of this type. Louis Réau's *Iconographie de l'art chrétien* and Guy de Tervarent's *Attributs et symboles dans l'art profane, 1450–1600* are more specifically art history, though useful to scholars in related disciplines. The standard work on secular art in the Middle Ages and the Renaissance is Raimond van Marle's *Iconographie de l'art profane au moyen-âge et à la Renaissance et la décoration des demeures,* which treats the sixth to the seventeenth centuries.

In Germany, manuals and encyclopedias began to appear in the nineteenth century. Important early works include Anton Heinrich Springer's *Ikonographische Studien* and Ferdinand Piper's *Mythologie und Symbolik der christlichen Kunst von der ältesten Zeit bis in's*

sechzehnte Jahrhundert. A serious study of early Christian and medieval paintings in catacombs and churches and carved sarcophagi is Joseph Wilpert's *Die Malereien der kirchlichen Bauten vom IV. bis VIII. Jahrhundert.* Wilpert's *I sarcofagi cristiani antichi* is a corpus of lasting value. In more recent times, German and Austrian scholars such as Hans Aurenhammer, Theodor Klauser, Gertrud Schiller, and Andor Pigler have published encyclopedias of the iconographic type.

Late nineteenth- and early twentieth-century Russia witnessed iconographic publications by Nikodim Pavlovich Kondakov (1844–1925), who wrote studies on Jesus Christ and the Virgin Mary. Kondakov was the first important Russian historian of Byzantine art. He taught Dmitrii Vlas'evich Ainalov (1862–1939), who, in turn, trained Viktor Mikitich Lazarev (1896–1976). These three scholars form an unbroken teacher-to-pupil tradition of the study of Byzantine art; this continuity has given the Russian school much of its strength. The scholarship of these men has remained free of political dogma because it is based on an iconographic method.

Aurenhammer, Hans. *Lexikon der christlichen Ikonographie.* Vienna: Hollinek, 1959– .

Cabrol, Fernand. *Dictionnaire d'archéologie chrétienne et de liturgie.* 15v. Paris: Letouzey et Ané, 1907–53.

Caylus, Anne Claude Philippe de. *Recueil d'antiquités égyptiennes, étrusques, grecques et romaines.*

Didron, Adolphe Napoleon. *Iconographie chrétienne: Histoire de Dieu.* Paris: Imprimerie royale, 1843. *Christian Iconography; the History of Christian Art.* Tr. by E. J. Millington. New York: Frederick Ungar, 1965.

Klauser, Theodor, ed. *Reallexikon für Antike und Christentum.* Stuttgart: Hiersemann Verlags G.M.B.H., 1950– .

Kondakov, Nikodim Pavlovich. *Ikonografiia Bogomateri.* 2v. St. Petersburg: Typografia Imperatorskoi Akademiia Nauk, 1914–15.

———. *Ikonografiia gospoda boga i spasa nashego Iisusa Khrista.* St. Petersburg: Tovarischestvo R. Golike i A. Vil'borg, 1905.

Mâle, Émile. *L'Art réligieux de XIIIe siècle en France; étude sur l'iconographie de moyen âge et sur ses sources d'inspiration.* Paris: E. Leroux, 1898. *The Gothic Image: Religious Art in France of the Thirteenth Century.* Tr. by Dora Nussey. New York: Harper & Row, 1958.

Pigler, Andor. *Barockthemen: Eine Auswahl von Verzeichnissen zur Ikonographie des 17. und 18. Jahrhunderts.* 2v. Budapest: Verlag der Ungarischen Akademie der Wissenschaften, 1956.

Piper, Ferdinand. *Mythologie und Symbolik der christlichen Kunst von der ältesten Zeit bis in's sechzehnte Jahrhundert.* 2v. Weimar: Landesindustrie-comptoir, 1847–51.

Réau, Louis. *Iconographie de l'art chrétien.* 3v. in 6. Paris: Pr. Univ. de France, 1955–59.

Ripa, Cesare. *Iconologia*. Rome: Gio. Gigliotti, 1593. Tr. by Jean Baudouin. New York: Garland, 1976.

Rohault de Fleury, Charles. *Archéologie chrétienne: Les saints de la messe et leurs monuments*. 10v. Paris: Librairies-imprimeries réunies, 1893–1900.

Schiller, Gertrud. *Ikonographie der christlichen Kunst*. Gütersloh: Gütersloher Verlagshaus G. Mohn, 1966– . *Iconography of Christian Art*. Tr. by Janet Seligman. Greenwich, Conn.: New York Graphic Soc., 1971.

Springer, Anton Heinrich. *Ikonographische Studien*. Vienna, 1860.

Tervarent, Guy de. *Attributs et symboles dans l'art profane, 1450–1600*. 3v. Geneva: Droz, 1958–64.

Van Marle, Raimond. *Iconographie de l'art profane au moyen-âge et à la Renaissance et la décoration des demeures*. 2v. The Hague: M. Nijhoff, 1931–32.

Wilpert, Joseph. *Die Malereien der kirchlichen Bauten vom IV. bis XIII. Jahrhundert*. 4v. Freiburg im Breisgau: Herdersche Verlagshandling, 1903.

———. *I sarcofagi cristiani antichi*. 3v. Rome: Pontifico istituto di archaeologia cristiana, 1929–32.

Morey and the Princeton School

Iconography was established in the United States at Princeton University under Charles Rufus Morey (1877–1955). Trained in classical languages and literature, Morey early developed an interest in the refractions and transformations of pagan images in medieval art as well as the iconographic problems posed by these changes. In 1917 he founded the *Index of Christian Art* at Princeton and supervised it until his death (see Helen Woodruff, *The Index of Christian Art at Princeton University*). At present, the *Index* contains over half a million subject entries and more than 260,000 photographs of Christian images dating from before 1400. There are now copies in the United States and Europe. It is a basic research tool for the study of Christian art and is consulted by art historians, theologians, historians, and literary historians.

Morey and the students he attracted to Princeton used iconography as an analytical tool to determine the provenance, dates, and prototypes of manuscript illuminations, carved sarcophagi, ivory carvings, metalwork, and other media. Morey's own theories are summarized in his *Mediaeval Art* and *Early Christian Art: An Outline of the Evolution of Style and Iconography in Sculpture and Painting from Antiquity to the Eighth Century*. Dealing with innumerable art objects produced over a period of about 1,000 years, he dared to reduce the complexity of medieval art to three great concepts: "Hellenistic naturalism," "Latin realism," and "Celto-Germanic dynamism."

Though useful in their day, these concepts have by now been abandoned altogether.

Morey's students have produced important work. Earl Baldwin Smith (1888–1956) wrote iconographic inquiries such as *Early Christian Iconography and a School of Ivory Carvers in Provence, The Dome: A Study in the History of Ideas*, and *Architectural Symbolism of Imperial Rome and the Middle Ages*, as well as a contextual study of *Egyptian Architecture as Cultural Expression*, in which the external factors shaping the development of ancient Egyptian architecture are taken into account.

Assimilating concepts of Strzygowski, Ainalov, and Morey, Myrtilla Avery wielded considerable influence on medieval art scholarship from the 1920s until World War II. Her paper "The Alexandrian Style at Santa Maria Antiqua, Rome" synthesizes these concepts. Marion Lawrence (1901–78), a close follower of Morey, investigated the iconography and, to a lesser extent, the style of early Christian sarcophagi in "City-Gate Sarcophagi," "Columnar Sarcophagi in the Latin West," and *The Sarcophagi of Ravenna*. These studies are still widely quoted today. Another Morey disciple is Ernest T. DeWald (b. 1891), who prepared several corpora of illuminated medieval manuscripts. DeWald never published text commentary to accompany these volumes of illustrations. Sometimes Morey collaborated in the publication of corpora; with Leslie W. Jones he wrote *The Miniatures of the Manuscripts of Terence Prior to the Thirteenth Century*. It was uncommon for the Princeton School to publish iconographic inquiries in the narrow sense of the term. A representative example is J. Carson Webster's *The Labors of the Months in Antique and Medieval Art to the End of the Twelfth Century*. Other followers of Morey specializing in medieval art include Helen Woodruff, Albert M. Friend, Jr. (1894–1956), Edward Capps, Jr. (b. 1902), and Andrew S. Keck. Their contributions took the form of scholarly papers rather than monographs.

After World War II the Princeton School continued to pursue these interests under the successor to Morey, the German-born scholar Kurt Weitzmann (b. 1904). Trained by the great German connoisseur of medieval art, Adolph Goldschmidt (1863–1944), Weitzmann is the leading authority on the iconography of Byzantine art. One of his principal interests has been the study of the origin and development of textual illustration. In his *Illustrations in Roll and Codex*, Weitzmann formulates a tightly constructed method for determining the

visual and textual sources of medieval illuminated manuscripts and their archetypes. Calling to mind linguistic-philological methods, as does the work of Morey himself, Weitzmann's approach has influenced the work of his many students, such as Herbert L. Kessler (b. 1941). Another major interest of Weitzmann has been the survival of the classical tradition in art *(Greek Mythology in Byzantine Art; Geistige Grundlagen und Wesen der Makedonischen Renaissance)*. In this regard Weitzmann has continued an avid interest of his mentor, Goldschmidt, as well as of Aby Warburg and his disciples—in fact, of German scholars generally.

Avery, Myrtilla. "The Alexandrian Style at Santa Maria Antiqua, Rome." *Art Bulletin* 7:131–49 (1925).

Capps, Edward, Jr. "The Style of the Consular Diptychs," *Art Bulletin* 10:61–101 (1927).

DeWald, Ernest T. *The Illustrations of the Ultrecht Psalter*. Princeton, N.J.: Princeton Univ. Pr. for the Dept. of Art and Archaeology, 1932.

———. *The Stuttgart Psalter, Biblia Folio 23, Wuerttembergische, Landesbibliothek, Stuttgart*. Princeton, N.J.: Princeton Univ. Pr. for the Dept. of Art and Archaeology, 1930.

———; Albert M. Friend, Jr.; and Kurt Weitzmann. *The Illustrations in the Manuscripts of the Septuagint*. 3v. Princeton, N.J.: Princeton Univ. Pr., 1941–.

Forsyth, George H., and Kurt Weitzmann. *The Monastery of Saint Catherine on Mount Sinai*. Vol. 1, *The Church and Fortress of Justinian*. Ann Arbor: Univ. of Michigan Pr., 1973. Vol. 2, *The Icons*. Princeton, N.J.: Princeton Univ. Pr., 1976.

Friend, Albert M., Jr. "Portraits of the Evangelists in Greek and Latin Manuscripts," *Art Studies* 5:115–47 (1927), 7:3–29 (1929).

Goldschmidt, Adolph. *Die Elfenbeinskulpturen aus Zeit der karolingischen und sächsischen Kaiser, VIII.–XI. Jahrhundert*. 4v. Berlin: B. Cassirer, 1914–26.

Jones, Leslie Webber. "The Archetypes of the Terence Miniatures," *Art Bulletin* 10:103–20 (1927).

Keck, Andrew S. "A Group of Italo-Byzantine Ivories," *Art Bulletin* 12:147–62 (1930).

Kessler, Herbert L. *The Illustrated Bibles from Tours*. Princeton, N.J.: Princeton Univ. Pr., 1977.

Lawrence, Marion. "City-Gate Sarcophagi." *Art Bulletin* 10:1–45 (1927).

———. "Columnar Sarcophagi in the Latin West." *Art Bulletin* 14:103–85 (1932).

———. *The Sarcophagi of Ravenna*. 2d Monograph on Archaeology and Fine Arts sponsored by the Archaeological Inst. of America. New York: College Art Assn., 1945.

Morey, Charles Rufus. *Early Christian Art: An Outline of the Evolution of Style and Iconography in Sculpture and Painting from Antiquity to the Eighth Century*. Princeton, N.J.: Princeton Univ. Pr., 1942.

———. *Mediaeval Art.* New York: Norton, 1942.

———, and Leslie W. Jones. *The Miniatures of the Manuscripts of Terence Prior to the Thirteenth Century.* Illuminated Manuscripts of the Middle Ages, vols. 1–2. Princeton, N.J.: Princeton Univ. Pr., 1930–31.

Smith, Earl Baldwin. *Architectural Symbolism of Imperial Rome and the Middle Ages.* Princeton, N.J.: Princeton Univ. Pr., 1956.

———. *The Dome: A Study in the History of Ideas.* Princeton,N.J.: Princeton Univ. Pr., 1950.

———. *Early Christian Iconography and a School of Ivory Carvers in Provence.* Princeton, N.J.: Princeton Univ. Pr., 1918.

———. *Egyptian Architecture as Cultural Expression.* New York: Appleton-Century, 1938.

Webster, J. Carson. *The Labors of the Months in Antique and Medieval Art to the End of the Twelfth Century.* Evanston, Ill.: Northwestern Univ. Pr., 1938.

Weitzmann, Kurt. *Geistige Grundlagen und Wesen der Makedonischen Renaissance.* Cologne and Opladen: Westdeutscher Verlag, 1963.

———. *Greek Mythology in Byzantine Art.* Princeton, N.J.: Princeton Univ. Pr., 1951.

———. *Illustrations in Roll and Codex: A Study of the Origin and Method of Text Illustration.* Princeton, N.J.: Princeton Univ. Pr., 1947. 2d printing, with addenda. Princeton, N.J.: Princeton Univ. Pr., 1970.

———. *The Miniatures of the Sacra Parallela, Parisinus Graecus 923.* Princeton, N.J.: Princeton Univ. Pr., 1979.

———. *Studies in Classical and Byzantine Manuscript Illumination.* Ed. by Herbert L. Kessler. Chicago: Univ. of Chicago Pr., 1971.

Woodruff, Helen. *The Index of Christian Art at Princeton University.* Princeton, N.J.: Princeton Univ. Pr., 1942.

———. "The Physiologus of Bern," *Art Bulletin* 12:226–53 (1930).

Twentieth-Century German Iconography

A development in the iconographic interpretations of works of art that followed a direction different from that of Émile Mâle, the manualists, and the Princeton School was launched in Germany by the followers of Aby Warburg (1866–1929). While Warburg himself established iconology, a perspective on art that presupposes iconographic analysis and is far broader in scope (see below, pages 76 ff.), he inspired his disciples in Hamburg to undertake iconographic inquiries in order to understand the subject matter or meaning of works of art.

One of Warburg's earliest devoted followers was the German art historian Fritz Saxl (1890–1948). After studying with Max Dvorák (1874–1921) and Heinrich Wölfflin, Saxl became Warburg's librarian and assistant in Hamburg and, upon Warburg's death in 1929, director of the Warburg research institute until his own death. Since Saxl distrusted most historical methods, his scholarship eludes easy

classification. His writings are now iconographic, now iconological (see *A Heritage of Images*).

In 1933 Saxl collaborated in an iconographic inquiry on "Classical Mythology in Medieval Art" with another Warburg follower, Erwin Panofsky (1892–1968). Panofsky, too, was a learned humanist, and it was primarily he who formulated and refined the iconological method of Warburg and disseminated it to American scholarship after his arrival in this country in 1931. The 1933 paper by Saxl and Panofsky introduced the Warburgian preoccupation with the survival of paganism—the transformation of classical mythology in post-antique times—to American art history. Six years later Panofsky defined iconography as "that branch of the history of art which concerns itself with the subject matter or meaning of works of art, as opposed to their form." When he speaks of "subject matter as opposed to form," he chiefly means the "sphere of secondary or conventional subject matter, viz., the world of specific themes or concepts manifested in images, stories, and allegories, as opposed to the sphere of primary or natural subject matter manifested in artistic motifs" (*Studies in Iconology*).

The correct identification of motifs is the prerequisite of their correct iconographic analysis. For motifs to be identified correctly, a familiarity with specific themes or concepts as transmitted through literary sources is required. Depending on the works of art under investigation, that familiarity may have to be encyclopedic knowledge, and the scholar may also have to read any number of modern and ancient languages. Moreover, the scholar's knowledge must be checked against the history of tradition for the analysis to be convincing, and it must also be tempered with common sense. For instance, a wall painting of thirteen men seated around a table in a certain arrangement and in certain poses cannot be identified as the Last Supper of Christ if the painting is securely dated before the first century A.D.

Panofsky's approach to subject matter differs from that of the Princeton School, which conceived of iconography as an index of morphology and used the method to determine provenance and dating. Panofsky and his followers were far less concerned with these questions than with the analysis of figural imagery and an assimilation of it with other methods, especially iconology. For both groups, however, iconographic inquiry proceeded from the work of art itself.

Art historians draw a clear distinction between the functions of images. An image may represent one thing, symbolize another, and

express yet something else. These three different functions may be present in one image. For instance, an image in a painting by Hierony-mous Bosch may represent a broken vessel, symbolize the sin of glut-tony, and express a conscious or unconscious sexual fantasy on the part of the artist. To the art historian, these three levels of meaning remain distinct. The iconographer interprets the first two levels; the iconologist, primarily interested in the third level, interprets all three, and his or her method is based on synthesis rather than analysis.

While Panofsky was an iconologist at heart, a great humanist seek-ing to explain the content of art based on its iconography, he wrote some papers that were largely iconographic—for example, "Jan van Eyck's *Arnolfini* Portrait" and the facetiously entitled "The Ideologi-cal Antecedents of the Rolls-Royce Radiator." Once he settled in the United States, he began to train a number of American students, some of whom produced iconographic papers, even though they did not become iconographic specialists. These pupils include Millard Meiss (1904–75) ("The Madonna of Humility") and Frederick Hartt (b. 1914) (*"Lignum Vitae in Medio Paradisi"*), and, although never a student of Panofsky, Meyer Schapiro ("Cain's Jaw-Bone That Did the First Murder").

In studies of art since the late eighteenth century, and especially of the twentieth century, iconographic studies have been far less com-mon than in studies of medieval and Renaissance art. Rather, schol-ars dealing with modern art have concerned themselves with formal values. In American art history this concern is explained in part by the fact that researchers do not feel equally at home with literature, history, and philosophy as well as art. The system of higher educa-tion in this country, with specialization at the graduate level, fails to encourage study of more than one discipline; this philosophy of edu-cation stands in contrast to the traditional system of the humanistic liberal arts in Germany. Not a few iconographic studies, even in the *Art Bulletin,* America's leading journal of art history (founded in 1913), verge on caricatures of the finest German iconographic in-quiries. Still, American-trained art historians have produced some distinguished iconographic studies of art since 1800. Mention may be made of Lorenz Eitner's "The Open Window and the Storm-tossed Boat," Robert Rosenblum's "The Origin of Painting," and Patrick McCaughey's "Clyfford Still and the Gothic Imagination."

Eitner, Lorenz. "The Open Window and the Storm-tossed Boat." *Art Bulle-tin* 37:281–90 (1955).

Hartt, Frederick. *"Lignum Vitae in Medio Paradisi:* The Stanza d'Eliodoro and the Sistine Ceiling." *Art Bulletin* 32:115–45 (1950).

McCaughey, Patrick. "Clyfford Still and the Gothic Imagination." *Artforum* 8:56–61 (Apr. 1970).

Meiss, Millard. "The Madonna of Humility," *Art Bulletin* 18:435–64 (1936).

Panofsky, Erwin. "The Ideological Antecedents of the Rolls-Royce Radiator." *Proceedings of the American Philosophical Society* 107:273–88 (1963).

———. "Jan van Eyck's *Arnolfini* Portrait," *Burlington Magazine* 64:117–27 (1934).

———. *Meaning in the Visual Arts.* Garden City, N.Y.: Doubleday, 1955.

———. *Studies in Iconology: Humanistic Themes in the Art of the Renaissance.* New York: Oxford Univ. Pr., 1939. (Reprinted as a Harper Torchbook in 1962.)

Rosenblum, Robert, "The Origin of Painting: A Problem in the Iconography of Romantic Classicism." *Art Bulletin* 39:279–90 (1957).

Saxl, Fritz. *A Heritage of Images: A Selection of Lectures by Fritz Saxl.* Harmondsworth, Middlesex: Penguin, 1970.

———, and Erwin Panofsky. "Classical Mythology in Medieval Art." *Metropolitan Museum Studies* 4:228–80 (1932–33).

Schapiro, Meyer. "Cain's Jaw-Bone That Did the First Murder." *Art Bulletin* 24:205–12 (1942).

Warburg, Aby. *Gesammelte Schriften.* Ed. by Gertrud Bing. 2v. Leipzig and Berlin: B. G. Teubner, 1932.

Other Contemporary Iconography

Iconography in the vein of the Princeton School or the Panofsky tradition continues to attract contemporary English-speaking scholars, but no new developments in the method have occurred in the past several decades. American scholars today will deal with iconography when they are seeking to interpret the subject matter of a work of art. The subject matter of some art works, like Botticelli's mythological paintings or Hieronymus Bosch's canvases, seems to continue to elude correct identification; at least scholars cannot agree on the correct identification of their themes. Or old identifications will be reinterpreted in the light of new discoveries, whether they are the results of the scientific examination of art works or the uncovering of new documentary sources bearing on them.

While the best American and European art historians are trained to deal with iconography, their matrix of scholarly interests is wider than just that method, even if it extends to the related approach of iconology, and their scholarship will assimilate a number of other methods as well, be they connoisseurship, formal analysis, psychoanalysis, or the social history of art. Such a broad contextual

approach often breaks down methodologically into a series of loosely related rather than tightly integrated essays. A successful integration of a variety of approaches does occur, however, in the writings of Meyer Schapiro, whose scholarship, being sui generis, tends to defy easy classification.

In comprehensive monographs on individual masters today, iconographic analysis often dominates the author's point of view. A case in point is Ronald Lightbown's *Botticelli.* While Lightbown publishes a wealth of documentary material, he concentrates on the Florentine master's paintings themselves, subjecting them to a detailed iconographic analysis. In so doing, he extracts a significant part of the history of contemporary Florence from their imagery.

The sustained interest in iconography in the middle decades of the twentieth century has coincided with a period of formalism in art itself. This curious disjunction does not characterize those critics and scholars who write on contemporary art, for they tend to focus on formal values to the exclusion of content, presumably because these arts have no intended subject matter.

Lightbown, Ronald. *Botticelli.* 2v. Berkeley and Los Angeles: Univ. of California Pr., 1978.
Schapiro, Meyer. *Modern Art: 19th and 20th Centuries: Selected Papers.* New York: Braziller, 1978.
Warburg, Aby. *Gesammelte Schriften.* 2v. Leipzig: B. G. Teubner, 1930.

Iconography of Architecture

In the nineteenth century, architectural studies stressed formalistic and technical qualities. They overlooked the symbolical significance of a building; that is, its content or the connection between its shape and its dedication or function. During World War II, the iconography of architecture was established as a branch of art historical scholarship by specialists working independently in Europe and the United States.

One of these was Richard Krautheimer (b. 1897), whose paper "Introduction to an 'Iconography of Medieval Architecture' " laid much of the groundwork for this new method. In this seminal consideration of the iconography of architecture, Krautheimer focuses on how architectural meaning was perceived in the Middle Ages. For him, meaning pertains to the content of a building beyond its immediate use or its structural mass. He investigates "questions of the symbolical significance of the layout or of the parts of a structure

that are prominent: questions of its dedication to a particular saint, and of the relation of its shape to a specific dedication or to a specific religious—not necessarily liturgical—purpose." After examining the "copies" or derivatives of the church of the Holy Sepulchre at Jerusalem and circular-shaped baptisteries, he finds that medieval buildings were sometimes meant to convey a meaning that transcended their visual patterns, and that medieval individuals tended to take the symbol for the real thing because they lacked the modern ability to distinguish between the two. Specifically, for one medieval monument to be an architectural copy of another, it sufficed for the "copyist" to transfer only a couple of significant features from the prototype, and those features could include the dedication, but not necessarily the function or functions, of the prototype. Krautheimer's method is based on several factors. First, the prototype is normally a distinguished building. Second, the prototype and "copy" should have analogous, distinct forms. Third, their dedications should be the same or closely related. Fourth, historical circumstances must exist in order to identify the "copy" and its model.

Krautheimer's thinking about these matters was paralleled, if not stimulated, by contemporary studies in iconography in the United States—Panofsky had arrived here only a few years before Krautheimer—and also possibly by contemporary interest in architectural functionalism by the major manifestos of the 1920s and 1930s by Walter Gropius, Le Corbusier, and Frank Lloyd Wright.

Irving Lavin's celebrated paper on "The House of the Lord" constitutes a recent extension of the methodology proposed by Krautheimer. Attempting to establish a genetic relationship between late Roman imperial triclinia and early Christian palace churches in particular, and the freestanding central-plan church in general, Lavin investigates the triapsidal plan, or triconch, in Roman and medieval architecture, in order to connect the "house of the Lord" of early earthly dominion with that of heavenly kingship, and specifically to show how the imperial presence became associated with the triconch. His study strives to demonstrate that the imperial palace architecture served as a source for church architecture.

During the same period when Krautheimer was formulating his new methodology, the French scholar André Grabar (b. 1896) was preparing his monumental study *Martyrium: Recherches sur le culte des reliques et l'art chrétien antique*. In contrast to earlier and current commentators on the origins of church architecture, Grabar does not explain its development on technical grounds. Assuming that form

and content in late antique and early medieval architecture are two aspects of the same phenomenon, he divides Christian cult buildings into two classes, both in form and function: congregational churches, and martyria and memoriae. Grabar then demonstrates a fundamental distinction between Christian architecture of the Greek East and the Latin West, and newly interprets the origins of these forms and the differences between Eastern and Western medieval architecture. Jean Lassus in his *Les Sanctuaries chrétiens de la Syrie* takes a similar approach but limits his focus to Christian Syria. In Germany, Günter Bandmann (b. 1917) approached the iconography of medieval architecture differently. In his *Mittelalterliche Architektur als Bedeutungsträger,* Bandmann attempts to formulate a comprehensive theory of architectural iconography for the Middle Ages as a whole. Bandmann analyzes the medieval approach to architectural forms in terms of their meanings and the most important and influential meanings in the architecture of the epoch. The success of his work may be questioned on the basis of his highly selective use of evidence and his analysis of architectural iconography, which is less sharply focused and precise than those of Krautheimer, Grabar, and Lassus.

Related works were studied at the same time by art historians in other periods. Karl Lehmann (1894–1960) traced the direct evolution of the dome and its decoration from antiquity to the beginning of the modern era in his paper "The Dome of Heaven." More typological than iconographic is Earl Baldwin Smith's *The Dome: A Study in the History of Ideas.* Hans Sedlmayr in his *Die Entstehung der Kathedrale* and Otto Georg von Simson (b. 1912) in his *The Gothic Cathedral: Origins of Gothic Architecture and the Medieval Concept of Order* are more limited in scope. For the Renaissance period, Rudolf Wittkower's *Architectural Principles in the Age of Humanism* stands in the tradition of Aby Warburg.

Bandmann, Günter. *Mittelalterliche Architektur als Bedeutungsträger.* Berlin: Gebr. Mann, 1951.

Grabar, André. *Martyrium: Recherches sur le culte des reliques et l'art chrétien antique.* 2v. and atlas. Paris: Collège de France, 1943–46.

Krautheimer, Richard. Introduction to an "Iconography of Medieval Architecture." In *Studies in Early Christian, Medieval and Renaissance Art.* New York: New York Univ. Pr., 1969.

Lassus, Jean. *Les Sanctuaries chrétiens de la Syrie.* Paris: P. Geuthner, 1947.

Lavin, Irving. "The House of the Lord: Aspects of the Role of Palace Triclinia in the Architecture of Late Antiquity and the Early Middle Ages." *Art Bulletin* 44:1–28 (1962).

Lehmann, Karl. "The Dome of Heaven." *Art Bulletin* 27:1–27 (1945).

Sedlmayr, Hans. *Die Entstehung der Kathedrale.* Zurich: Atlantis Verlag, 1950.
Simson, Otto Georg von. *The Gothic Cathedral: Origins of Gothic Architecture and the Medieval Concept of Order.* 2d ed. New York: Pantheon Books, 1962.
Smith, Earl Baldwin. *The Dome: A Study in the History of Ideas.* Princeton, N.J.: Princeton Univ. Pr., 1950.
Wittkower, Rudolf. *Architectural Principles in the Age of Humanism.* London: Warburg Inst., Univ. of London, 1949.

TYPOLOGICAL STUDIES

Investigations of a particular theme, motif, or technique of one or more historical periods have been common since the last century. Some studies take an iconographic approach and some are formalistic.

Among the many fundamental contributions to the field of ancient art by the scholar, archaeologist, and museum curator Gisela Marie Augusta Richter (1882–1972), a daughter of the art historian Jean Paul Richter, are two monographic catalogs dealing with Greek nude male statues *(Kouroi: A Study of the Development of the Greek Kouros from the Late Seventh to the Early Fifth century B.C.)* and Greek draped female statues *(Korai: Archaic Greek Maidens; A Study of the Development of the Kore Type in Greek Sculpture).* In these studies she places all known examples of each type in chronological order by combining connoisseurship, technical considerations, and stylistic criteria stressing the development of the form of the statuary. Another female scholar who made fundamental contributions to the field of ancient art through typological inquiry was Margarete Bieber (1879–1978). In her book *The History of the Greek and Roman Theater* she offers an interdisciplinary study that combines archaeological with philological evidence. This comprehensive investigation is widely used in the study of art history as well as theater history.

André Grabar's *L'empereur dans l'art byzantin; recherches sur l'art officiel de l'empire d'Orient* remains the fundamental study of imperial art in Byzantium. Ilene Forsyth (b. 1928) has examined French Romanesque wood sculptures of the enthroned Madonna type in *The Throne of Wisdom: Wood Sculptures of the Madonna in Romanesque France.* In *The Nude: A Study in Ideal Form,* Sir Kenneth Clark studies the nude figure in sculpture and painting, especially in classical antiquity and the Renaissance, demonstrating how artists have given the naked body a variety of configurations in order to communicate certain ideas or states of feeling. Another typological study is Erwin Panofsky's *Tomb Sculpture: Four Lectures on Its*

Changing Aspects from Ancient Egypt to Bernini, in which the funerary art of the Middle Ages, Renaissance, and baroque periods is analyzed according to the types, functions, and forms of tombs, considered as expressive of spiritual attitudes. His interpretations of specific monuments are based on historical method and common sense.

Panofsky's *Tomb Sculpture* revitalized interest in the study of portraiture generally and of funerary portraiture in particular. Before the publication of his book, studies on portraiture usually were iconographic compilations. Such was the case with Percy Ernst Schramm (1894–1970), a prolific historian who in his earlier career was strongly influenced by the Aby Warburg circle. Schramm classified portraits by types. Only in the 1960s and 1970s do we find studies of portraiture as part of a continuing tradition of visual imagery. James D. Breckenridge, in *Likeness: A Conceptual History of Ancient Portraiture,* strives to demonstrate that the portrait in antiquity "is an art form whose occurrence has significance for our understanding of both the development of art and the history of civilization itself." Sir John Pope-Hennessy's *The Portrait in the Renaissance* discusses fifteenth- and sixteenth-century portraiture "in terms of the ideas by which it was inspired" (e.g., the impact of humanist thinking on the portrait, the court portrait, the depiction of individuals as donors or participants).

The first attempt to compile a survey history of building types is Sir Nikolaus Pevsner's *A History of Building Types.* Stressing nineteenth century monuments in Europe and America, this book includes twenty types of buildings such as national monuments, hospitals, prisons, and factories, and seeks to allow for a demonstration of the development both by style and by function, "style being a matter of architectural history, function of social history."

In his *The Railroad Station: An Architectural History,* Carroll L. V. Meeks (b. 1907) studies Western architecture since 1800 as revealed by a single type of building, the passenger railroad station, and chronologically follows developments in the railroad station throughout Europe and Northern America from 1830 to the 1950s. He treats railroad stations as architecture (serving new functions), as engineering (construction of huge roofs in new materials), and as art works (expressing taste). Related investigations include John D. Thompson and Grace Goldin's *The Hospital: A Social and Architectural History,* which documents hospital buildings, including insane asylums, from Greek antiquity to the present day, and Simon Tidworth's *Theatres, an Illustrated History,* a survey of theater buildings.

Bieber, Margarete. *The History of the Greek and Roman Theater*. Princeton, N.J.: Princeton Univ. Pr., 1939. 2d ed. rev. and enl., 1961.

Breckenridge, James D. *Likeness: A Conceptual History of Ancient Portraiture*. Evanston, Ill.: Northwestern Univ. Pr., 1968.

Clark, Sir Kenneth. *The Nude: A Study in Ideal Form*. New York: Pantheon Books, 1956.

Forsyth, Ilene. *The Throne of Wisdom: Wood Sculptures of the Madonna in Romanesque France*. Princeton, N.J.: Princeton Univ. Pr., 1972.

Grabar, André. *L'empereur dans l'art byzantin; recherches sur l'art officiel de l'empire d'Orient*. Paris: Les Belles Lettres, 1936.

Meeks, Carroll, L. V. *The Railroad Station: An Architectural History*. New Haven, Conn.: Yale Univ. Pr., 1956.

Panofsky, Erwin. *Tomb Sculpture: Four Lectures on Its Changing Aspects from Ancient Egypt to Bernini*. Ed. by Horst W. Janson. New York: Abrams, 1964.

Pevsner, Sir Nikolaus. *A History of Building Types*. Princeton, N.J.: Princeton Univ. Pr., 1976.

Pope-Hennessy, Sir John. *The Portrait in the Renaissance*. New York: Bollingen Found. 1966.

Richter, Gisela M. A. *Korai: Archaic Greek Maidens; A Study of the Development of the Kore Type in Greek Sculpture*. London: Phaidon, 1968.

———. *Kouroi: A Study of the Development of the Greek Kouros from the Late Seventh to the Early Fifth Century B.C.* New York: Oxford Univ. Pr., 1942. 2d ed. London: Phaidon, 1960.

Schramm, Percy Ernst. *Die zeitgenössischen Bildnisse Karls des Grossen*. Beiträge zur Kulturgeschichte des Mittelalters und der Renaissance XXIX. Leipzig and Berlin: B. G. Teubner, 1928.

Thompson, John D., and Grace Goldin. *The Hospital: A Social and Architectural History*. New Haven, Conn.: Yale Univ. Pr., 1975.

Tidworth, Simon. *Theatres, An Illustrated History*. London: Pall Mall Pr., 1973. American ed. *Theatres: An Architectural and Cultural History*. New York: Praeger, 1973.

4

Perspectives
on Change

The last parts of this essay will be devoted to those studies that examine art works in terms of other art works or factors shaping their genesis and execution—the external conditions under which they were produced. The exegetical value of such studies seems indubitable, for they can lead only to a fuller knowledge and deeper understanding of works of art. As a general rule, these studies presuppose as full an identification of the art work as possible—that is, they are based on the results of the studies characterized in the preceding part of this essay.

Since the nineteenth century many art historians of Western Europe and the United States have concerned themselves with the isolation, comparison, and interpretation of the individual factors or conditions that are supposed to have lent shape to art works. They have tried to identify one or more factors that they believe have had a determining influence on the work of art. One group has sought to identify the conceptual or symbolic significance of works of art; these persons are iconologists, as opposed to iconographers. A second group of writers, essentially unconcerned with the deeper meaning of art, devises terms and concepts to describe and analyze works of art in a formal sense. Often their studies involve comparison of different works of art by the same or different artists. Related to these studies are those writings that employ the concept of structure in order to interpret the work of art. A third group of art historians has been engaged with psychological approaches. They have interpreted what is known of an artist's life to create his or her biography or to psychoanalyze the artist in an attempt to explain his or her oeuvre. The writings of Freud and Jung will be seen to have influenced some writers on the visual arts. Semiotics, too, has begun to shape the

thinking of some art historians. The fourth and final group of writers to be covered in this essay has turned its attention to art works in the light of their social context. It has examined the extent to which social, economic, political, religious, and cultural factors, as well as ideas, have generated or colored art works. Among these art historians are Marxists or Marxist-inspired writers who are occupied not so much with the description and interpretation of the relationship of such external factors and the artistic process, as with the evaluation of the role of art in society.

ICONOLOGY

An original development from iconographic studies, distinct from the approach of Émile Mâle, the manualists, and the Princeton School, began in Germany in 1912 when the art historian Aby Warburg read "Italienische Kunst und internationale Astrologie im Palazzo Schifanoja zu Ferrara" at the tenth International Congress of Art History. In that paper, Warburg employed the term *ikonologisch* to describe a new method.

Proceeding from iconographic analysis of an art work, but methodologically distinct from it, iconology seeks to identify the deeper meaning or content of a work of art—its conceptual or symbolic significance. For Warburg, iconology was the study of the "interaction of forms and contents in the clash of traditions." Rejecting almost from the beginning the view that art history should primarily be concerned with the history of styles (as Wölfflin was maintaining at that time), Warburg believed that art history should draw upon other fields. He regarded art history as a part of *Kulturgeschichte,* or the history of civilization. The aspects of civilization that appealed to him were the phenomena of "high culture," the arts, literature, scholarship, and science.

Warburg placed art objects in the context of their time and tried to show how the artist was related to the values and beliefs of the day. The qualities of form through which artists express themselves Warburg termed *Pathosformel.* These are roughly equivalent to what rhetoricians call *topoi.* Warburg was inspired by the title of Charles Darwin's 1872 book *The Expression of the Emotions in Man and Animals.* He identified and traced *Pathosformel* by scrutinizing business papers, family letters and diaries, humanist treatises, mythology, emblems, ethnography, grand opera, and linguistic usage, and by analyzing the interaction of distinct religious, literary, philosophical,

political, and other intellectual concepts. Warburg thus expanded art history, which in his day was dominated by Wölfflin, Berenson and their followers. Thanks to Warburg's library, German art scholarship in the 1920s began to favor work more along the lines of Warburg's intellectual interests.

Warburg's last great project was a pictorial atlas called "Mnemosyne," which was begun in 1927 and was composed of screens with photographs, postcards, and even postage stamps pinned on them. The majority of these illustrations were images of the vicissitudes of the ancient Greek gods in the astrological tradition and the role of *Pathosformel* in Renaissance art. The point of this atlas was to map out the survival and transformation of certain types of emotional expressions in art. While calling to mind the Jungian interest in archetypal memories, it was actually influenced by Richard Semon's *Mneme,* in which Semon (1859–1918) speaks of "engrams," a name for the residues that affect living matter. Semon's engrams corresponded to Warburg's notion of memory-charged symbols, and at last Warburg had a concept to enable him to interpret Renaissance imagery in biological, psychological, and social terms.

"Mnemosyne" was never completed or published, but it helped to define the official aim of Warburg's institute as the investigation of the survival of the classics. This preoccupation of the institute was to influence the scholarly interests and even research tools at the Institute of Fine Arts of New York City which, in 1949, launched the Census of Antique Works of Art Known to Artists of the Renaissance and, in 1956, a photographic corpus of the history of engraving and etching. One major publication emerged from these projects: Phyllis Bray Lehmann's *Drawings after the Antique by Amico Aspertini.*

In Hamburg, Warburg had attracted a circle of learned and humanist friends. The art historian Fritz Saxl (1890–1948) came to Hamburg in 1910. He was followed by Erwin Panofsky, Rudolf Wittkower, Edgar Wind, and the neo-Kantian philosopher and historian Ernst Cassirer (1874–1945). These and several others formed the core of what was eventually called the Warburg Institute, which flourished in Hamburg and later in London, where it continues to this day as a nonteaching research facility.

Saxl and Panofsky wrote two studies together. The first, *Dürers "Melencholia I"; eine quellen und typengeschichtliche Untersuchungen,* is concerned with the transmission and transformation of astrological lore and pagan antiquity, an early and favorite topic of Warburg himself. The second was "Classical Mythology in Medieval

Art." With the "Classical Mythology" paper, which is more icono-graphical than iconological, the Warburgian interest in the survival of paganism made its entry into American humanistic scholarship. In his major contribution, *Mithras, typengeschichtliche Untersuchungen,* Saxl studies the relations between the images and the thought of one of the all-powerful syncretistic religions of late antiquity. Like that of Warburg, his method includes specific works of art, epigraphy, history, philosophy, and religion. In short, Saxl studied images in their cultural context.

Panofsky also wrote some iconographic studies, including "Die Perspektive als symbolische Form," a masterly inquiry into conceptions of space from antiquity to the present day. The title of this long essay calls to mind Ernst Cassirer's *Philosophie der symbolischen Formen.* In fact, the essay is an illustration of Cassirer's philosophy as applied to painting and sculpture.

Panofsky's first genuinely iconological work was his *Hercules am Scheidewege und andere antike Bildstoffe in der neueren Kunst,* in which he describes the "mutational changes" or transformations of the major antique theme of the choice of Hercules between vice and virtue and explains them as cultural symptoms. In the introduction to this book, Panofsky proposes fundamental methodological principles for a new iconological approach. Those principles were fully defined nine years later (see below).

After Warburg's death in 1929, the Warburg Institute continued to attract a number of historians, philosophers, and art historians, some of whom produced iconographic studies. These include Wolfgang Stechow (1896–1975), Sir Ernst H. Gombrich, and Rudolf Wittkower. The art historian who has developed Warburg's wide-ranging iconological method most perspicaciously is Edgar Wind (b. 1900). Wind's greatest contribution, *Pagan Mysteries in the Renaissance,* aims to elucidate the "unresolved residues of meaning" in the works of Botticelli, Michelangelo, Rembrandt, and others. He adopts what he terms an iconological approach because "it may help to remove the veil of obscurity which not only distance in time (although in itself sufficient for that purpose) but a deliberate obliqueness in the use of metaphor has spread over some of the greatest Renaissance paintings." The strength of Wind's method is based on his precise reading of, and inference from, pertinent texts and his apt and detailed pursuit of philosophical arguments on their own terms.

In 1931, Panofsky began to teach in the United States, and was shortly followed by some of his students. From the late 1920s, Panof-

sky gradually developed and formulated the methods and aims of iconology, which he published in 1939 in his *Studies in Iconology.* For Panofsky, iconologists

> deal with the work of art as a symptom of something else which expresses itself in a countless variety of other symptoms, and ... interpret its compositional and iconographical features as more particularized evidence of this "something else." The discovery and interpretation of these "symbolical values" (which are often unknown to the artist himself and may even emphatically differ from what he consciously intended to express) is the object of what we may call "iconology" as opposed to "iconography." [*Meaning in the Visual Arts,* p. 31]

His conception of the method not only elevated iconology from an ancillary discipline to a full-fledged genre of scholarship but also offered a new definition of art history itself:

> The art historian will have to check what he thinks is the intrinsic meaning of the work, or group of works, to which he devotes his attention, against what he thinks is the intrinsic meaning of as many other documents of civilization historically related to that work or group of works, as he can muster: of documents bearing witness to the political, poetical, religious, philosophical, and social tendencies of the personality, period, or country under investigation. [Ibid., p. 39]

For Panofsky, the study of history is informed by, but not transcended by, the study of art. A recreation of the visual arts enables the historian to grasp human history more fully.

The importance of Panofsky's *Studies in Iconology* for the historiography of art rivals that of Riegl's *Die spätrömische Kunst-Industrie* and Wölfflin's *Kunstgeschichtliche Grundbegriffe; Das Problem der Stilentwicklung in der neuren Kunst;* its impact on other humanistic disciplines has been just as great, if not greater, than that of Riegl's and Wölfflin's works. Its influence on American art scholarship has been considerable.

In his first complete formulation of iconology, Panofsky held that the principal objective of the method is to discover and interpret symbolic values, "which are generally unknown to the artist himself and may even emphatically differ from what he consciously intended to express." The iconologist was to strive to understand the ideas and thought embodied by, and implicit in, visual forms. Artistic creation was held to be largely an unconscious and irrational activity, a point of view from which formal analysts of the visual arts had proceeded. In a later work, however, Panofsky reversed himself on

this question. In a programmatic chapter entitled "Reality and Symbol in Early Flemish Painting" in his magisterial *Early Netherlandish Painting,* Panofsky declares that the Flemish master Jan van Eyck "could endow with the semblance of utter verisimilitude what was in fact utterly imaginary. And this imaginary reality was controlled to the smallest detail by a preconceived symbolical program." Now Panofsky asserts that creative activity is a rational act, that artists— at least Jan van Eyck—consciously devised and expressed elaborately detailed programs of "disguised symbolism" in their works. Now the task of the iconologist is to decode and interpret the ideas that underlie visual symbols rather than those that are reflected by them. The point is illustrated by Millard Meiss's paper, "Light as Form and Symbol in Some Fifteenth-Century Paintings," in which the first correctly observed rays of sunshine passing through glass are not interpreted as "symbolical form" but understood as a deliberately intended symbol of supernatural radiance. Panofsky holds that the art historian is now supposed to investigate the rays of light in some of van Eyck's paintings, not as unintentional carriers of meaning, but as actual embodiments of the interpretation of the artistic motif itself.

A more plausible assessment of the historical situation is expressed by Meyer Schapiro in his study of the mousetrap symbol in the Mérode Altarpiece by the Master of Flémalle. Schapiro regards the symbolism not as deliberately disguised by the Master of Flémalle, but as implicit—for the artist painter and the modern beholder—in the objects under consideration, because a certain allegorical meaning was traditionally associated with them. And, for Schapiro, the symbols of the altarpiece presuppose the development of realism rather than explain it. Indeed, he emphasizes that "the introduction of nature and, with it, of the domestic human surroundings into painting can hardly be credited to a religious purpose."

The revised position of Panofsky on the nature of creative activity poses a problem for the art historian who wants to integrate the methods of formal analysis and iconology. If the formal values expressed by an artist are supposed to issue from irrational and intuitive activity, as formal analysts tend to hold, and the symbolical values from rational and nonintuitive behavior, how can the methods of the two approaches be synchronized to reach an understanding of the inner meaning of a work of art? Only if the presuppositions of the art historian about the structure of creative activity are consistent can a meaningful synthesis of the two methods be achieved, and the ultimate significance of the work of art be brought to light.

Among the students of Panofsky in Hamburg who migrated to the United States because of German National Socialism are not only Wolfgang Stechow and Rudolf Wittkower but also Adolf Katzenellenbogen (1901–64) and William S. Heckscher (b. 1904). Significantly, most of the major American-born art historians who were either trained by Panofsky in the United States or who collaborated with him have written only a few strictly iconological papers or monographs. The greater part of their contribution reveals an assimilation of his point of view in combination with other methods, and is marked by a broader and higher orientation, as is the later scholarship of Panofsky himself.

Millard Meiss, for example, studied the relation of form, subject, and meaning. By the term "meaning" Meiss includes "what others have called intrinsic significance or implications—implications of the whole work of art which the artist and his patron may or may not have intended. Such meanings are disclosed by correlating the work with modes of expression, with contemporary religious or secular thought, or with attitudes shaped by the forms of social life" *(The Painter's Choice).* Meiss follows Panofsky by using historical methods strictly and tempering them (in Panofsky's words) "if possible by common sense."

Nearly all iconological studies focus on individual works of art or closely related art works, or on single artists. They rarely cover movements or periods of art. One example of a period study is Werner Hofmann's *Das Irdische Paradies; Kunst im neunzehnten Jahrhundert.* Hofmann (b. 1928) is interested in nineteenth-century iconography and advances the thesis that a common bond exists between persons of a given age:

> Such a bond certainly does exist and this book is devoted to the proof of its existence. . . . If we analyze the century according to the various horizons of its imaginative vision, a vision whose irradiating power is as evident in works that are wholly original as in those where there has been a sympathetic yielding to alien influence, it will at once become obvious that its teeming riches, divergent as are often their actual forms, are built up around a comparatively small number of experiential constants. It is these that give the epoch between Goya and Cézanne its character, a clearly defined entity. [p. 33]

These "experiential constants" appear in recurrent iconographic types and motifs that Hofmann identifies with the collapsing values of the Enlightenment and of the manifestations of church and state. The author documents his interpretations by reference to literature,

philosophy, and nineteenth-century art criticism, and endeavors to account for the conscious needs and unspoken compulsions of the artistic mind seeking out "form symbols," often disguised, which reveal them. This important book is at once provocative and controversial.

The general validity of the iconological method of Panofsky and his followers has been challenged by Creighton Gilbert in a major paper, "On Subject and Non-Subject in Renaissance Pictures." In his search for the meaning, or layers of meaning, concealed in visual symbols, the iconographer is faced with the difficulty of knowing where to stop: scholarship in this genre has demonstrated how easy it is to discover meanings in each and every visual form realized by an artist. To guard against reading too much into a work, or of forcing it into a preconceived scheme, the iconographer must inquire "to what extent such a symbolic interpretation is in keeping with the historical position and personal tendencies of the individual master" (Panofsky, *Early Netherlandish Painting,* 1:212). Thus, in her recent book *Manet and the Modern Tradition,* Anne Coffin Hanson identifies the many formal and/or symbolic sources for any one painting by the French painter. Among these she allows for the artist's wit, warning thereby against excessively philosophic or allegorical readings of Manet's paintings. Moreover, the iconologist must base interpretations on the works of art themselves and must exercise care not to give interpretations the authority of the texts on which the works are based. Iconological research is subject to the danger of circular argument.

Cassirer, Ernst. *Philosophie der symbolischen Formen.* 3v. Berlin: B. Cassirer, 1923–29. *The Philosophy of Symbolic Forms.* Tr. by Ralph Manheim. New Haven, Conn.: Yale Univ. Pr., 1953–57.

Gilbert, Creighton. "On Subject and Non-Subject in Renaissance Pictures." *Art Bulletin* 34:202–16 (1952).

Gombrich, Sir Ernst H. *The Heritage of Apelles: Studies in the Art of the Renaissance.* Oxford: Phaidon, 1976.

———. *Symbolic Images: Studies in the Art of the Renaissance.* London: Phaidon, 1972.

Hanson, Anne Coffin. *Manet and the Modern Tradition.* New Haven, Conn. and London: Yale Univ. Pr., 1977.

Heckscher, William S. *Rembrandt's Anatomy of Dr. Nicolaas Tulp; an Iconological Study.* New York: New York Univ. Pr., 1958.

Hofmann, Werner. *Das Irdische Paradies: Kunst im neunzehnten Jahrhundert.* Munich: Prestel, 1960. *Art in the Nineteenth Century.* Tr. by Brian Battershaw. London: Faber & Faber, 1961.

Janson, Horst W. *Apes and Ape Lore in the Middle Ages and the Renaissance.* London: Warburg Inst., Univ. of London, 1952.

Katzenellenbogen, Adolf. *Allegories of the Virtues and Vices in Medieval Art from Early Christian Times to the Thirteenth Century*. London: Warburg Inst., 1939.

——. *The Sculptural Programs of Chartres Cathedral: Christ, Mary, Ecclesia*. Baltimore: Johns Hopkins Univ. Pr., 1959.

Lehmann, Phyllis Bray. *Drawings after the Antique by Amico Aspertini*. London: Warburg Inst., 1957.

Meiss, Millard. "Light as Form and Symbol in Some Fifteenth-Century Paintings." *Art Bulletin* 27:175–81 (1945).

——. *The Painter's Choice: Problems in the Interpretation of Renaissance Art*. New York: Harper & Row, 1976.

Panofsky, Erwin. *Early Netherlandish Painting: Its Origins and Character*. 2v. Cambridge, Mass.: Harvard Univ. Pr., 1953.

——. *Hercules am Scheidewege und andere antike Bildstoffe in der neueren Kunst*. Leipzig: B. G. Teubner, 1930.

——. *Meaning in the Visual Arts*. Garden City, N.Y.: Doubleday, 1955.

——. "Die Perspektive als symbolische Form." *Vorträge der Bibliothek Warburg, 1924/25*, pp. 258–330. Leipzig: B. G. Teubner, 1927.

——. *Studies in Iconology*. New York: Oxford Univ. Pr., 1939.

Riegl, Alois. *Die spätrömische Kunst-Industrie*. Vienna: K. K. Hof- und Staatsdruckerei, 1901–23.

Saxl, Fritz. *Mithras, typengeschichtliche Untersuchungen*. Berlin: Heinrich Keller, 1931.

——, and Erwin Panofsky. "Classical Mythology in Medieval Art." *Metropolitan Museum Studies* 4:228–80 (1933).

——. *Dürers "Melencholia I" eine quellen und typengeschichtliche Untersuchungen*. Leipzig and Berlin: B. G. Teubner, 1923.

Schapiro, Meyer. " 'Muscipula Diaboli,' the Symbolism of the Mérode Altarpiece." *Art Bulletin* 27:182–87 (1945).

Semon, Richard. *Das Mneme als erhaltendes Prinzip im Wechsel des organischen Geschehens*. Leipzig: W. Engelmann, 1904.

Stechow, Wolfgang. *Apollo und Daphne*. Leipzig and Berlin: B. G. Teubner, 1932.

Warburg, Aby. "Italienische Kunst und internationale Astrologie im Palazzo Schifanoja zu Ferrara." Paper read at the 10th International Congress of Art History. In *L'Italia e l'arte straniera. Atti del X Congresso Internazionale di Storia dell'arte, 1912*. Rome: Unione editrice, 1912.

Wind, Edgar. *Pagan Mysteries in the Renaissance*. London: Faber & Faber, 1958.

Wölfflin, Heinrich. *Kunstgeschichtliche Grundbegriffe; Das Problem der Stilentwicklung in der neueren Kunst*. Munich: F. Bruckmann A.G., 1915.

FORMALISM

Wölfflin's formulation of polar categories in the morphological analysis of art works, period styles, and national styles, noted above, has profoundly influenced the historiography of art. Wölfflin himself

refused to speculate on the causes of changes in style, but his ideas can be traced through most modern writings on the visual arts.

Art historians employ specialized terms and concepts to describe and analyze works of art in a formal sense. This language has evolved over the past two hundred years, and in this century, it has fallen especially under Wölfflin's influence. Ideally, the modern art historian uses well-defined terms and concepts, such as form (i.e., structural configuration of the whole or its parts), space, area, plane, mass, volume, proportion, scale, light, color, and texture. Analyses of art that develop from the use of such terms and concepts are called formal studies.

In their narrowest meaning, formal studies exclude considerations of subject matter or content as well as the social and other external forces that lend shape to the artistic process. More broadly speaking, an analysis of form is an essential component of the study of style. Formal studies may contribute partially to understanding the style of an individual art work as well as groups, schools, or periods of art. The art historian's ultimate objective is understanding art styles and style development. At the same time it may be said that what style is, or, more precisely, how it should be defined, remains the central problem of art history. A classic paper on the problem is Meyer Schapiro's "Style."

Formal studies are not uncommon in the field of medieval architecture. Ernst Gall (1888–1958) and Louis Grodecki (1910–82) have made important contributions. Although Erwin Panofsky (1892–1968) was by no means a pure formalist, his *Die deutsche Plastik des elften bis dreizehnten Jahrhunderts* analyzes formal changes in medieval German sculpture.

In the field of Renaissance art, Sidney Freedberg (b. 1914) is a major follower of the formalist tradition. In two monographs, *Painting of the High Renaissance in Rome and Florence* and *Andrea del Sarto*, and a survey book *Painting in Italy: 1500 to 1600*, which echo Wölfflin's *Die Klassische Kunst*, Freedberg inquires into the development of artists' morphological styles and their affinities with the monuments of other masters of the time. He maintains that much can be learned from the art object itself. (This sort of study is not as popular today as studies of the art work's surroundings.)

Wölfflin's *Grundbegriffe* have been adopted and much refined by Walter F. Friedlaender (1873–1966) in his *Mannerism and Anti-Mannerism in Italian Painting*. This is a major account of sixteenth century Italian mannerism, a phase of Renaissance art that Wölfflin

had overlooked. Friedlaender, however, broadens his inquiry to include symbolic qualities and some external factors shaping the arts, points that are also evident in his *David to Delacroix, Caravaggio Studies,* and *Nicolas Poussin: A New Approach.* A more insistent Wölfflinian is Jakob Rosenberg (b. 1893), author of *Rembrandt* and *On Quality in Art; Criteria of Excellence, Past and Present,* in which he writes that "formal organization is still an index of artistic quality."

Freedburg, Sidney. *Andrea del Sarto.* 2v. Cambridge, Mass.: Harvard Univ. Pr., 1963.

————. *Painting in Italy: 1500 to 1600.* Baltimore: Penguin, 1971.

————. *Painting of the High Renaissance in Rome and Florence.* 2v. Cambridge, Mass.: Harvard Univ. Pr., 1961.

Friedlaender, Walter F. *Caravaggio Studies.* Princeton, N.J.: Princeton Univ. Pr., 1955.

————. *David to Delacroix.* Tr. by Robert Goldwater. Cambridge, Mass.: Harvard Univ. Pr., 1952.

————. *Mannerism and Anti-Mannerism in Italian Painting.* New York: Columbia Univ. Pr., 1957.

————. *Nicolas Poussin: A New Approach.* New York: Abrams, 1964.

Gall, Ernst. *Die gotische Baukunst in Frankreich und Deutschland.* Leipzig: Klinkhardt & Bierman, 1925.

Grodecki, Louis. *L'Architecture ottonienne: au seuil de l'art roman.* Paris: A. Colin, 1958.

Panofsky, Erwin. *Die deutsche Plastik des elften bis dreizehnten Jahrhunderts.* 2v. Munich: K. Wolff, 1924.

Rosenberg, Jakob. *On Quality in Art; Criteria of Excellence, Past and Present.* Princeton, N.J.: Princeton Univ. Pr., 1967.

————. *Rembrandt.* 2v. Cambridge, Mass.: Harvard Univ. Pr., 1948.

Schapiro, Meyer. "Style." In *Anthropology Today.* Ed. by Alfred Louis Kroeber. Chicago: Univ. of Chicago Pr., 1953.

STRUCTURAL ANALYSIS

The concept of structure as a tool for understanding and interpreting works of art was first developed during the 1920s in German-speaking countries. Its most systematic and theoretical proponent was Guido von Kaschnitz-Weinberg (1890–1958), a disciple of Alois Riegl. Starting with a study of early carved portraits in ancient Italy, Kaschnitz-Weinberg combined his concept of structure with the concept of the regional continuity of Italian art, with an emphasis on prehistory as the key to all later art in Italy. He employs these concepts in his papers, which have been collected in *Ausgewählte Schriften,* and in his unfinished structural history of ancient Mediterranean art, *Die mittelmeerischen Grundlagen der antiken Kunst.*

By "structure" Kaschnitz-Weinberg means the overall principles of design underlying representational surface forms, especially in sculpture. He seeks to identify the most fundamental overall formal qualities of art works, not their surface details. For example, a carved marble head may combine a cubistic and linear principle of design with naturalistic surface forms; the former qualities constitute its "structure." He thereby reduces our many (especially our aesthetic) impressions of art objects to a few essentials. Treating form as distinct from content, intention, or function, he applies structural analysis to individual art works and to works created in diverse historical periods. Kaschnitz-Weinberg thus compares the arts of ancient Egypt and ancient Greece. When he tries to account for the transmission of certain design qualities in objects created in different cultures, he invokes a supraindividual or collective will. This will, he declares, was expressed by the creators of these objects and thereby perpetuated itself. This concept of will was borrowed from Riegl's *Kunstwollen* and can be criticized as a myth or abstraction.

Kaschnitz-Weinberg has made the most important contribution to the historiography of Roman art since Riegl, in large measure because of his theory of structural analysis. In its emphasis upon pure description and its holistic viewpoint, his theory, though independently developed, coincides in many respects with the methodically unhistorical, functionalist structural anthropology of Claude Lévi-Strauss (b. 1908). It has influenced the study of ancient Mediterranean art, especially the work of Bernhard Schweitzer (1892–1966), Friedrich Matz (1890–1974), and Hans Sedlmayr; it can also be traced in the scholarship of Theodor Hetzer (1890–1946).

Jack Burnham's *The Structure of Art* contains a more theoretical and less influential application of structural analysis to art works. Burnham develops a method that clearly derives from the structural anthropology of Lévi-Strauss and the semiological analysis of Roland Barthes. His premise is that art, like language or myth, employs signs that must be organized in specific relationships or systems. Burnham applies his theory to specific works of forty-five painters and sculptors of the nineteenth and twentieth centuries. More recently, Jean Clay has offered a fresh interpretation of *Modern Art: 1880–1918* in structuralist terms by means of a particular choice of art works and set of categories within which they should be judged.

Badcock, C. R. *Lévi-Strauss: Structuralism and Sociological Theory.* New York: Holmes & Meier, 1976.

Barthes, Roland. *Elements of Sociology.* Tr. by Annette Lavers and Colin Smith. London: Cake, 1967.

Burnham, Jack. *The Structure of Art.* New York: Braziller, 1971.

Clay, Jean. *Modern Art: 1880–1918.* New York: Vendome, 1978.

Hetzer, Theodor. *Aufsätze und Vorträge.* Ed. by Gertrude Berthold. 2v. Leipzig: E. A. Seeman, 1957.

Kaschnitz-Weinberg, Guido von. *Ausgewählte Schriften.* Ed. by Helga von Heintze. 3v. Berlin: Gebr. Mann, 1965.

————. *Die mittelmeerischen Grundlagen der antiken Kunst.* Ed. by Peter H. von Blanckenhagen and Helga von Heintze. Berlin: Gebr. Mann, 1965.

Matz, Friedrich. *Geschichte der griechischen Kunst.* Frankfurt am Main: Klostermann, 1950.

Schweitzer, Bernhard. *Die Bildniskunst der Römischen Republik.* Leipzig: Koehler & Amelang, 1948.

————. *Die geometrische Kunst Griechenlands: Frühe Formenwelt im Zeitalter Homers.* Cologne: Du Mont Schauberg, 1969. *Greek Geometric Art.* Tr. by Peter and Cornelia Usborne. New York: Phaidon, 1971.

Sedlmayr, Hans. *Spätantike Wandsysteme.* Munich: Verlag der Bayerischen Akademie der Wissenshaften in Kommission bei Beck, 1958.

5

Psychological Approaches

Biographical data and the writing and statements of artists and their associates provide basic information and insights into the creative process and the nature of art objects. Biography can tell the scholar and critic about the artist's personality and the events in his or her life. It does not, however, necessarily explain the nature of the work, since this is not simply a reflection or expression of life experience.

In establishing a biographical structure, the scholar must rely on primary source material such as letters, photographs (if available), documents such as the household inventories of patrons like the seventeenth-century Roman Barberini family or gallery account books, and the works of art themselves. Sometimes, however, a great deal of the information about an artist derives from less dependable sources—reminiscences colored by the passage of time, or carelessly conducted interviews. The art biographer must integrate primary and secondary source materials, and care must be exercised not to discard the latter completely because of a few flaws.

Giorgio Vasari's *Le vite de' più eccellenti pittori, scuttori e architetti*, which is traditionally identified as the first art history, is a classic example of the biographical approach to the visual arts. *The Lives* is biographical, comprising the histories of artists rather than the history of art. Vasari wrote because he was convinced that only tradition and memory can keep art alive. *The Lives* is a record of events and statements by Italian artists and their associates from the thirteenth to the sixteenth centuries. Vasari gathered data about the external circumstances of each artist's life and personality, and chronologically arranged information on the works of each artist to

construct a picture of individual development. Some of Vasari's material is legendary, incorrect, or strongly biased. This has been demonstrated by Ernst Kris and Otto Kurz in *Die Legende vom Künstler: ein geschichtlicher Versuch,* a study of the role of tradition in artistic biographies. Biographical sources must thus be carefully checked for their veracity and reliability, and the biases of their authors must be evaluated.

The biographical approach to art did not originate with Vasari; it derives from antiquity. Vasari was the first, however, to treat artistic biography extensively and systematically. His *Lives* established a school of writing that survives to the present. Art biography has been surveyed by Evert F. van der Grinten (b. 1920) in *Enquiries into the History of Art-Historical Writing.*

One of the first important biographies of an artist that applied critical standards to documentary sources and supplanted anecdotal legend with fact was compiled by Johann David Passavant (1787–1861): *Raffael von Urbino und sein Vater Giovanni Santi.* Passavant's historical account of Raphael is still not altogether superseded; his Raphael catalog remains a basic reference work. Passavant's study became a model for all subsequent monographs on artists.

The late nineteenth century was the first period when major biographies of artists were written. Karl Justi's *Diego Velázquez und sein Jahrhundert* extols Velázquez as an ordinary man and great heroic personality, revealing Justi (1832–1912) as a late German romantic author. This book remains a standard monograph on Velázquez. Justi's other two major monographs, *Winckelmann: sein Leben, seine Werke und sein Zeitgenossen* and *Michelangelo; Beiträge zur Erklärung der Werke und des Menschen* present enormous amounts of biographical and other documentary materials and attest to Justi's faith in the theory of the "Great Man."

Today the biographical approach to the visual arts is common in the study of modern art. Lionello Venturi (1885–1961), one of the first Italian art historians to deal with art outside of Italy, and perhaps the single most important influence on Italian art historians since Benedetto Croce, studied impressionism not as a collective movement but in order to define the artistic personalities of its individual practitioners. Venturi compiled literary sources (e.g., *Les Archives de l'Impressionisme*) and wrote biographical catalogs of Cézanne, Pissarro, and others. John Rewald (b. 1912) has written biographies of impressionist and postimpressionist painters. Albert Hamilton Barr, Jr. (1902–81) has published biographical materials

on the lives and work of major modern masters, such as *Picasso: Fifty Years of His Art,* and *Matisse: His Art and His Public. Matisse, Picasso and Gertrude Stein* records the conversations of the poet and art collector Gertrude Stein (1874–1946) with Henri Matisse and Pablo Picasso. In his *Cubism and Abstract Art,* Barr marries biography to an analysis of the formal traits in early twentieth-century abstract art in terms of their departure from or rejection of representational values. For artists and art history in the United States, this book was of importance because it introduced a number of cubist and other abstract masters.

Biography presents important evidence for understanding art and its creator, but is of limited value unless it is combined with analysis of style, content, or other factors. In some instances, even massive biographical data cannot elucidate the iconography or iconology of an art work. Such is the case with the baroque master Nicolas Poussin, for whom much biographical data, produced by the artist and his circle of friends, has survived. Notwithstanding the many statements of Poussin and his associates, Poussin's paintings incorporate philosophical and other intellectual concepts that are never mentioned in these statements. Sir Anthony Blunt (b. 1907) has treated this problem in his *Nicolas Poussin.*

Artistic biography continues to interest art historians who approach the life and work of artists in a much broader context than they did earlier in this century. In his *Albrecht Dürer,* Erwin Panofsky draws upon a wealth of documentary materials as he describes the development of Dürer's work and analyzes the social and intellectual context within which it was created. Panofsky's assessment of Dürer's life and career is based on the history, psychology, and philosophy of late fifteenth- and early sixteenth-century Germany. Panofsky establishes Dürer's awareness of his German situation and the manner in which his work reflects it. *Albrecht Dürer* describes the historical reality of the period and the significance of the artist's life and work.

Barr, Alfred. *Cubism and Abstract Art.* New York: Museum of Modern Art, 1936.
———. *Matisse: His Art and His Public.* New York: Museum of Modern Art, 1951.
———. *Picasso; Fifty Years of His Art.* New York: Museum of Modern Art, 1946.
Blunt, Sir Anthony. *Nicolas Poussin.* 2v. New York: Bollingen Found., 1967.
Justi, Karl. *Diego Velázquez und sein Jahrhundert.* Bonn: M. Cohen, 1888.

Diego Velázquez and His Times. Tr. by A. H. Keane. London: H. Grevel, 1889.

———. *Michelangelo; Beiträge zur Erklärung der Werke und des Menschen.* Leipzig: Breitkopf & Härtel, 1900.

———. *Winckelmann: sein Leben, seine Werke und sein Zeitgenossen.* 3v. Leipzig: F. C. W. Vogel, 1866–72.

Kris, Ernst, and Otto Kurz. *Die Legende vom Künstler: ein geschichtlicher Versuch.* Vienna: Krystall-verlag, 1934. *Legend, Myth and Magic in the Image of the Artist: An Historical Experiment.* Tr. by Alistair Laing. Rev. by Otto Kurz. New Haven, Conn.: Yale Univ. Pr., 1979.

Panofsky, Erwin. *Albrecht Dürer.* 3d., enl. ed. 2v. Princeton, N.J.: Princeton Univ. Pr., 1948.

Passavant, Johann David. *Raffael von Urbino und sein Vater Giovanni Santi.* 3v. Leipzig: F. A. Brockhaus, 1839–58. *Raphael of Urbino and His Father Giovanni Santi.* New York: Macmillan, 1872.

Rewald, John. *Cézanne et Zola.* Paris: A. Sedrowski, 1936. *Paul Cézanne, a Biography.* Tr. by Margaret H. Liebman. New York: Simon & Schuster, 1948.

———. *The History of Impressionism.* New York: Museum of Modern Art, 1946.

———. *Post-Impressionism from Van Gogh to Gauguin.* New York: Museum of Modern Art, 1956.

Stein, Gertrude. *Matisse, Picasso and Gertrude Stein.* Paris: Plain ed., 1933.

Van der Grinten, Evert F. *Enquiries into the History of Art-Historical Writing.* Amsterdam: Municipal Univ., 1952.

Vasari, Giorgio. *Le vite de' più eccellenti pittori, scuttori e architetti.* Florence: Lorenzo Torrentino, 1550. Enlarged ed. Florence: T. Giunti, 1568. *Lives of the Most Eminent Painters, Sculptors & Architects.* Tr. by Gaston du C. de Vere. 10v. London: Macmillan and the Medici Soc., 1912–15.

Venturi, Lionello. *Les Archives de l'Impressionisme.* Paris and New York: Durand-Ruel, éditeurs, 1939.

———. *Camille Pissarro; son art—son oeuvre.* Paris: P. Rosenberg, 1939.

———. *Cézanne, son art, son oeuvre.* Paris: P. Rosenberg, 1936.

PSYCHOANALYTIC STUDIES

Studies of the psychoanalytic aspects of artistic creation have been relatively common since the late nineteenth century. They received a systematic frame of reference from Sigmund Freud (1856–1939), whose first book on art was *Eine Kindheitserinnerung des Leonardo da Vinci.* In this psychosexual study of a childhood reminiscence, Freud took one passage about a vulture in one of Leonardo's notebooks and, on the basis of these words, characterized the artist's personality through psychoanalytic concepts, presenting a study in psychoanalytic biography. Freud argued, for example, that the figures of the Virgin Mary and St. Anne in Leonardo's masterpiece in

the Louvre represent a compositional innovation that refers to the artist's childhood experience of having a natural mother and a step-mother. Freud also attributed the smiles of the Mona Lisa and the Virgin to Leonardo's childhood memory of an affectionate mother. Freud thus employs psychoanalytical concepts to explain some of the salient formal and symbolic qualities of Leonardo's works.

Meyer Schapiro (b. 1904) has since shown that Freud based his interpretation on a mistranslation of Leonardo's writing and that he overlooked or was inattentive to a number of pertinent artistic, historical, and social conditions. (See Meyer Schapiro, "Leonardo and Freud: An Art-Historical Study" and Richard Wollheim, "Freud and the Understanding of Art.") The criticisms of Schapiro and Wollheim require comments. Freud realized that much of his study rested on uncertain assumptions about Leonardo's life and that his method was risky. He admitted that he was inexpert in Leonardo's style and technique and that he focused only on certain aspects of the subject matter. Freud declared that the psychoanalytic method fails to explain fully the nature of the creative process. He did believe, however, that psychoanalysis "could reveal the factors which awaken genius and the sort of subject matter it is destined to choose." Moreover, Schapiro has obscured the fact that an artist can express private meanings only in the forms, symbols, and traditions of his age, an important point to which Freud's study draws attention.

Art historians today do not construct complex towering art-historical theories on the basis of a single datum, as Freud did. The art historian considers the relevance of the evidence at hand, the importance of a single work within the artist's oeuvre, the qualities of the artist's style, and historical and social conditions at the time the work was created.

Notwithstanding the shortcomings of his psychoanalytic method, Freud did raise new questions about Leonardo and his life—questions that illuminate the artistic process—and his imperfect theories and false conclusions do not invalidate the psychoanalytic approach to the visual arts.

Freud, Sigmund. *Eine Kindheitserinnerung des Leonardo da Vinci.* Leipzig: F. Deuticke, 1910. *Leonardo da Vinci: Psychosexual Study of an Infantile Reminiscence.* Tr. by A. A. Brill. New York: Moffat, Yard, 1916.
Schapiro, Meyer. "Leonardo and Freud: An Art-Historical Study." *Journal of the History of Ideas* 17:147–78 (1956).
Wollheim, Richard. "Freud and the Understanding of Art," in his *On Art and the Mind: Essays and Lectures.* London: Allen Lane, 1973.

Kris and Gombrich

One of Freud's foremost disciples was Ernst Kris (1900–57), who published a number of studies in the field of psychoanalytic ego psychology. After studying art history at Vienna University, Kris joined the department of sculpture and applied art of the Vienna Museum, which housed and still houses the great Hapsburg collections. Soon he became the leading specialist on Renaissance engraved gems and intaglios, on which he published the standard work in 1929 at the age of twenty-nine. But connoisseurship did not satisfy his fertile and inquisitive mind. Kris met Freud in Vienna early in his career and took an interest in Freud's work. In 1927, Kris was invited to join the Austrian Institute of Psycho-Analysis; in the late 1930s Freud entrusted Kris and Dr. Robert Waelder with the editorship of the periodical *Imago, Zeitschrift für die Anwendung der Psychoanalyse auf die Geisteswissenschaften.*

Kris later edited the first volumes of the London edition of Freud's collected writings as well as the *Internationale Zeitschrift für Psychoanalyse und Imago.* In 1940, one year after the death of Freud, Kris emigrated to the United States where he became a leading exponent of modern ego psychology, which originated in the work of the psychoanalyst Heinz Hartmann and the later thought of Freud himself.

Kris's major work is *Psychoanalytic Explorations in Art,* a compilation of his papers based on twenty years of intensive work in the psychology of art, clinical psychoanalysis, and art history. This volume is one of the best sources on ego psychology. Kris poses some fundamental questions suggested by the study of art and artistic creation: "What are those things . . . which . . . tend to be endowed with the specific aura which the word ART conveys? What must the men have been like who made these things, and what did their work mean to themselves and to their public?" Searching for, and relying on, minute observation, while never losing sight of the whole, Kris tries to develop a valid methodology for further investigation, and cautiously to formulate research hypotheses. He avoids abridgments and oversimplifications. Approaching his field of inquiry from surface phenomena rather than pure speculation, Kris analyzes the circumstances under which the phenomena came to be observed and strives to establish their origins and functions. His approach to modern ego psychology is based on his training in Vienna as a connoisseur of goldwork and carved gems. His writings disclose how intensively he studied the role of the unconscious in the artistic process,

and the extent to which the tools of psychoanalysis can be applied to investigations of this creative activity. Kris offers no systematic methodology, but by researching the literary content of specific works, he derives working hypotheses that may eventually yield a valid methodology.

Kris was fully aware of the limitations of the psychoanalytic method for the study of the visual arts. This art historian turned psychoanalyst realized that historical and social forces shape the function of art in general and more specifically that of any given medium in any given historical setting. These factors condition the frame of reference in which artistic creation occurs. The artist applies his or her talent or genius within this framework but cannot work outside of it. For Kris, "there is little which psychoanalysis has as yet contributed to an understanding of the meaning of this framework itself; the psychology of artistic style is unwritten."

In the last 25 years, another Viennese art historian, Sir Ernst H. Gombrich, has investigated the history of representational images in the light of the findings and hypotheses in psychology and psychoanalysis and the perceptual aspects of artistic tradition. Trained as an art historian in Berlin and Vienna, Gombrich moved to London in 1936 where he became a research assistant at the Warburg Institute and, in 1950, an editor of the *Journal of the Warburg and Courtauld Institutes*. He published a number of important papers based on the iconographic method in this periodical.

Gombrich's most important book is *Art and Illusion: A Study in the Psychology of Pictorial Representation*. In this work, Gombrich examines the history of representational art in the light of hypotheses and findings of studies in the psychology of perception, information, and communication. He asks: "Why does representational art have a history?" Why did Titian and Picasso, Leonardo and Constable, Hals and Monet represent the visible world in such different ways? Previously the answer to this question was ordinarily framed in terms of technical advances or the artist's desire to imitate nature. Gombrich maintains that the artist's point of departure is not the imitation of nature or "reality" but the experience of works of art. He writes that all representational art remains conceptual, a manipulation of a vocabulary, and that even the most naturalistic art generally starts from what may be termed schemata, or artists' techniques of depiction in the fullest sense of the term technique, which are modified and adjusted until they appear to match the visible world. Representational art thus changes when the artist checks the traditional schemata

against nature—a process of making and matching in accordance with his or her perception. The history of representational art, in short, is the product of a specific tradition of reinterpreted images by memory-guided responses that are shaped by the artist's experience in the world. Gombrich thus views the history of Western art in terms of artistic choice rather than of recondite external forces influencing the artist, such as a Hegelian historicist would maintain.

In *Art and Illusion* Gombrich specifically applies the empirical constructivist theory of perception to problems posed by pictorial representations. A group of perceptual psychologists owing a great debt to the work of Hermann von Helmholtz, the constructivist perceptionists are concerned with the question of how do we ever arrive at a meaningful percept in the face of the unmodified, constantly elemental, sensations present in life. They are called constructivists because in the presence of essentially unstructured stimulation and indeterminate information, the perceiver is left to construct the meaning that will give a functionally valid percept. The essentials of constructivist theory form the core concepts around which Gombrich details his sophisticated version of the traditional distinction between seeing and knowing. According to his account of the development of style in Western art, seeing is equivalent to the awareness of sensations and/or retinal images, while knowing deals with the stuff of perceptions or object hypotheses. Moreover, Gombrich assumes that all adult vision is "theory laden" by past experience, that all visual images experienced by adults are thus perceptually or conceptually determined because only in such a way can order be given to the sensory chaos.

Gombrich's conception of artistic development is also based on his deep distrust of historicism, determinist laws, and metaphysical speculations on the nature of stylistic evolution. Indebted to the staunchly anti-Hegelian philosophy of Karl R. Popper (b. 1902), Gombrich rejects any notion of the structural unity of a culture and of an inner driving force that impels a style forward. The history of art, for Gombrich, is an empirical discipline, and should seek a descriptive interest in specific works of art rather than laws or a deus ex machina like Riegl's *Kunstwollen*. The task of the art historian is to describe empirically the changes exemplified by works of art, not to speculate on why they exhibit change.

Another important influence on Gombrich is the classical archaeologist and theorist Emanuel Loewy (1857–1938), whose lectures Gombrich had attended as a student. In his *Die Naturwiedergabe in*

der älteren griechischen Kunst, Loewy investigates the evolutionary development of ancient Greek art and identifies memory images as the source of natural representation. Gombrich is also indebted to the thinking of Aby Warburg and Julius von Schlosser on tradition and conventions in art, and to Ernst Kris. Gombrich differs from these authors in that he provides a fuller and more persuasive account of tradition in art, an account developed on the basis of recent research into the psychology of perception and other scientific fields.

Gombrich's *Art and Illusion* is perhaps the most important work in art historiography since Panofsky's 1939 *Studies in Iconology.* While its findings and hypotheses are based specifically on Western painting and the problems central to it, Gombrich's book sheds light on problems faced by all the arts—the nature of realism, the role of convention, problems of ordering, and the participatory roles of the creator, the viewer, and even the listener.

In some recent papers, Gombrich has elaborated his theories and findings in *Art and Illusion.* In "Moment and Movement in Art," he poses new questions about the problem of representing time and space in the visual arts. His "Visual Discovery through Art" deals with problems in *Art and Illusion* in their perceptual aspects. In "Light, Form and Texture in Fifteenth-Century Painting," he applies some of the methodology suggested in *Art and Illusion* to concrete examples of Flemish and Italian painting. The formal differences between these Flemish and Italian works, Gombrich argues, are to be explained not by direct observation of natural phenomena, as has been widely assumed by art historians, but by systematic modification and refinement made by the painters of the traditions of light and texture. In an essay in *Illusion in Nature and Art,* Gombrich extends the discussion begun in *Art and Illusion* concerning the underlying mechanisms of perception and the double perception of paintings as representations and as objects in themselves. In his published lecture *Means and Ends: Reflections on the History of Fresco Painting,* Gombrich pursues another idea mentioned in *Art and Illusion,* namely, that form follows function. The development of this idea forms part of his interpretation of the history of painting from ancient Egypt to the twentieth century, with special focus on the art of Leonardo da Vinci. Finally, in *The Heritage of Apelles: Studies in the Art of the Renaissance* Gombrich concerns himself, among other things, with the problem of the objectivity of standards in the rendering of the visible world.

The art historian Richard Bernheimer (1907–58) has also investigated aspects of the problem of representation in his *Nature of Representation: A Phenomenological Inquiry.* Bernheimer's book bears a complementary relation to Gombrich's *Art and Illusion,* although Bernheimer confines his inquiry to the semantics of "the function and inner structure of artistic representation." His aim is to demonstrate "that representation has an inner structure of its own, akin to but by no means identical with that possessed by various categories of signs; and finally that the function most akin to representation is not, as semanticists suppose, that of signification, but the much neglected and little-known one of substitution." Much of this book deals with an elucidation of this function and is closely written, based on an analytical method.

Less theoretical but equally provocative is *Prints and Visual Communication* by William M. Ivins, Jr. (1881–1961). Formerly curator of prints at the Metropolitan Museum of Art in New York City, Ivins attempts "to find a pattern of significance in the story of prints." He contends that people have become "aware of the difference between pictorial expression and pictorial communication of fact" only since the invention of photography. Because they are exactly repeatable visual statements, prints have exerted a profound effect upon the development of Western European thought and culture by providing descriptions that words could not convey with similar precision. The interests and insights of Ivins call to mind André Malraux's *Psychologie de l'art;* Malraux argued, as did Gombrich, that art rather than nature begets art, and also echoes the sensational and highly popular commonplaces of Herbert Marshall McLuhan (1911–81). McLuhan writes that the main determinant of historical change in society, culture, and the human individual results from the prevailing or predominant medium of human communication.

The influence of Freudian theory is much more evident in the critical writings of English-born Adrian Durham Stokes (1902–72). In his later work—for example, *Michelangelo, Greek Culture and the Ego,* and *Reflections on the Nude,* Stokes tries to associate two modes of art that he had identified in his earlier writings—namely, the carving and modeling traditions—with the paranoid-schizoid position and the depressive position in infantile development. For Stokes the associations are both multiple and complex, and in many instances they are mediated by a number of intervening factors or run through chains. As Wollheim has pointed out, in each case

Stokes makes, the mode or tradition of art is said to reflect or to celebrate the kind of relation to the outerworld that is typical of the corresponding position.

Bernheimer, Richard. *Nature of Representation: A Phenomenological Inquiry.* Ed. by Horst W. Janson. New York: New York Univ. Pr., 1961.

Freud, Sigmund. *Gesammelte Werke.* Ed. by Anna Freud. 17v. London: Imago, 1940–52.

Gombrich, Sir Ernst H. *Art and Illusion: A Study in the Psychology of Pictorial Representation.* New York: Pantheon Books, 1960.

———. *The Heritage of Apelles: Studies in the Art of the Renaissance.* Oxford: Phaidon, 1976.

———. "Illusion and Art" In *Illusion in Nature and Art,* pp. 193–243. Ed. by Richard Langton Gregory and E. H. Gombrich. London: Duckworth, 1973.

———. "Light, Form and Texture in Fifteenth-Century Painting." *Journal of the Royal Society of Arts* 112:826–49 (Oct. 1964).

———. *Means and Ends: Reflections on the History of Fresco Painting.* London: Thames & Hudson, 1976.

———. "Moment and Movement in Art." *Journal of the Warburg and Courtauld Institutes* 27:293–306 (1964).

———. "Visual Discovery through Art." *Arts Magazine* 40:17–28 (Nov. 1965).

Helmholtz, Hermann von. *Treatise on Physiological Optics.* Ed. by J. P. C. Southall. New York: Dover, 1962.

Imago: Zeitschrift für die Anwendung der Psychoanalyse auf die Geisteswissenschaften. Leipzig and Vienna: H. Heller, 1912– . (First editor, Sigmund Freud)

Internationale Zeitschrift für ärztliche Psychoanalyse. Leipzig and Vienna: H. Heller, 1913– . (First editor, Sigmund Freud)

Internationale Zeitschrift für Psychoanalyse und Imago. Ed. by Ernst Kris.

Ivins, William M., Jr. *Prints and Visual Communication.* Cambridge, Mass.: Harvard Univ. Pr., 1953.

Kris, Ernst. *Meister und Meisterwerke der Steinschneidekunst in der italienischen Renaissance.* Vienna: Anton Schroll, 1929.

———. *Psychoanalytic Explorations in Art.* New York: International Univ. Pr., 1952.

Loewy, Emanuel. *Die Naturweidergabe in der älteren griechischen Kunst.* Rome: Loescher, 1900.

Malraux, André. *Psychologie de l'art.* 3v. Geneva: A. Skira, 1947–50. *The Psychology of Art.* Tr. by Stuart Gilbert. New York: Pantheon, 1949–50.

McLuhan, Herbert Marshall. *The Mechanical Bride: Folklore of Industrial Man.* New York: Vanguard Pr., 1951.

———. *The Medium Is the Massage.* New York: Bantam Books, 1967.

———. *Understanding Media: The Extensions of Man.* New York: McGraw-Hill, 1964.

Panofsky, Erwin. *Studies in Iconology.* New York: Oxford Univ. Pr., 1939.

Popper, Karl R. *The Poverty of Historicism.* London: Routledge & Paul, 1957.

Stokes, Adrian Durham. *Greek Culture and the Ego: a Psycho-Analytic Survey of an Aspect of Greek Civilization and of Art.* London: Tavistock, 1958.
————. *Michelangelo: A Study in the Nature of Art.* New York: Philosophical Lib., 1956.
————. *Reflections on the Nude.* London: Tavistock, 1967.
Wollheim, Richard. Introduction to *The Image in Form: Selected Writings of Adrian Stokes.* Ed. by Richard Wollheim. New York: Harper & Row, 1972.

GESTALT PSYCHOLOGY

Pioneering work in perceptual psychology by Wolfgang Köhler, *Gestalt Psychology* and Kurt Koffka, *Principles of Gestalt Psychology* has influenced the outlook of Gombrich and other art historians, who have endeavored to apply the vocabulary and doctrines of Gestalt psychology to art history and criticism. The Gestaltists basically denied the truth of the fundamental position of constructivist perceptual theory, which espoused that percepts are composed of unmodified and constantly varying elemental sensations and thus can be decomposed, without injury, into their component parts. Gestalt psychology maintains that this conceptualization of percepts altogether fails to capture their intrinsic character of organization. The whole is greater than, or different from, the sum of its parts. Hence, it posits that the study of perception is more properly the study of the laws of organization than the associations of sensations (see Koffka).

One of the earliest such attempts by an art historian was made by the Austrian scholar Hans Sedlmayr in his *Die Architektur Borrominis.* According to Sedlmayr, Borromini designed his churches in terms of units that were derived from late antique architecture. By using these units, Borromini created an architecture that has the animation of a complicated geometrical pattern. The architecture is only apparently organic; this appearance results from the use of "double structure," a term employed by Gestalt psychologists. For Gestalt psychologists, all meaningful perception is in structured patterns. The pattern is seen against a neutral, unstructured ground and has "thing" character. In a given field of vision more than one pattern may exist, but only one can be perceived at a given moment. Sedlmayr finds two patterns coexisting in Borromini's churches.

In 1930, at its publication, Sedlmayr's book advanced a pioneering method for the history of art. The shortcomings of this method were at once perceived, however. Different specialists would identify dif-

ferent mental sets. They could not agree on a single "Gestalt" that was valid under all historical circumstances. Sedlmayr ignores altogether the purpose for which Borromini designed his buildings. He failed to understand that seventeenth-century Jesuits viewed a church as a place of worship, and not as abstract architecture.

In recent years, at least one of Wolfgang Köhler's followers moved from psychology into the field of art. Rudolf Arnheim (b. 1904) has published several works dealing with visual images from the Gestalt point of view. Arnheim's *Art and Visual Perception: A Psychology of the Creative Eye* considered sense, perception, and conception as pertinent to balance, shape, form, growth, space, light, color, movement, tension, and expression. After publishing a compilation of essays, *Toward a Psychology of Art: Collected Essays,* Arnheim reached the culmination of his investigations in *Visual Thinking,* in which the whole range of factors from sense to percept to concept to cognition and to thought is taken into consideration, with symbols, imagination, inspiration, and creativity falling into place. In *Visual Thinking,* Arnheim attempts to reestablish the unity of perception and thought, to demonstrate that perception and conception are basically not verbal but visual, and to contend that visual perception seeks to grasp generalities by images of "kinds" of objects or situations, which form the basis of "higher" conceptualizations. In his recent contribution, *Dynamics of Architectural Form,* Arnheim takes a fresh approach to the expressive visual qualities of buildings, utilizing the principles of visual perception worked out in his earlier books. His efforts offer the most ambitious and the most comprehensive statement of the relations between art and perception that can be found in the history of psychology.

Anton Ehrenzweig (1908–66) has analyzed the limitations and shortcomings of the Gestalt theory applied to artists, their work, and aesthetic experience generally. In *The Hidden Order of Art: A Study in the Psychology of Artistic Imagination,* Ehrenzweig turns to a psychoanalytic theory of art that is post-Freudian in its presuppositions and outlook. His point of view is largely centered on a phylogenetic explanation that has not found wide acceptance among art historians today.

Like psychoanalysts, Gestalt psychologists writing on art tend to confine themselves to detailed descriptions or explanations of phenomena within fairly clearly defined limits. Their writings indicate that Gestalt is a generally useful concept to the art historian. A danger in these studies is the temptation to apply the accounts of

individual phenomena to larger groups, movements, or periods of art history in which identical or similar phenomena occur. Walter Abell (1897–1956), for example, was inspired by the Marxist writings of Georgi Plekhanov and tried to posit a psychohistorical theory of culture on the basis of an "interplay" between varied and contrasting aspects of experience. The origins of this interplay are said to be at once immaterial and material, personal and collective, psychological and technological. Art historians have greeted large-scale unifying hypotheses, such as the theory of unconscious mental activity based on individual case studies, with caution and skepticism.

Abell, Walter. *Collective Dream in Art: A Psycho-Historical Theory of Culture Based on Relations between the Arts, Psychology, and the Social Sciences.* Cambridge, Mass.: Harvard Univ. Pr., 1957.

Arnheim, Rudolf. *Art and Visual Perception: A Psychology of the Creative Eye.* Berkeley: Univ. of California Pr., 1954.

———. *Dynamics of Architectural Form.* Berkeley: Univ. of California Pr., 1977.

———. *Toward a Psychology of Art: Collected Essays.* Berkeley: Univ. of California Pr., 1966.

———. *Visual Thinking.* Berkeley: Univ. of California Pr., 1969.

Ehrenzweig, Anton. *The Hidden Order of Art: A Study in the Psychology of Artistic Imagination.* London: Weidenfeld & Nicolson, 1967.

Koffka, Kurt. *Principles of Gestalt Psychology.* New York: Harcourt, Brace, 1935.

Köhler, Wolfgang. *Gestalt Psychology.* New York: Liveright, 1929.

Sedlmayr, Hans. *Die Architektur Borrominis.* Berlin: Frankfurter Verlags-Anstalt A.-G., 1930.

JUNGIAN PSYCHOLOGY

The analytical psychology of Carl Gustav Jung (1875–1961) has exerted far less an impact on art history than have the psychoanalytic theories of Freud and his disciples. The Swiss psychologist held that the creative process is an autonomous complex, "a detached portion of the psyche that leads an independent psychic life withdrawn from the hierarchy of consciousness." At the source of all autonomous psychic activities Jung found the phenomenon of the archetype, the primordial image. He assumed that the profoundest social experiences of mankind must have left some physiological trace in the structure of the brain, and that therefore archetypes are inherited with the structure of the brain. He believed that archetypes are unactivated until charged with some psychic current, whereupon they act

in a predetermined way. Through a fund of unconscious primary images left by countless typical experiences of our ancestors, the artist modifies and extends the images.

Jung himself wrote about art, individual artists such as Picasso, and the specific qualities of art works. He maintained that some works of art were created deliberately by artists' conscious will and judgment, while others were spontaneous, fully formed before they were actually executed. His writings on art met with little critical acclaim from art historians (e.g., Christian Zervos). A few art critics, however, pursued his theories. Sir Herbert Read attempted to interpret Picasso's *Guernica* and Henry Moore's reclining figures in Jungian terms in the light of archetypal images. In his essay on Leonardo da Vinci the analytic psychologist and Jungian art critic Erich Neumann (1905–60) attempted to relate certain canvases by this master to the mother archetype. Unlike Freud, who derived Leonardo's psychology from the personal events of his childhood, Neumann found a fundamental, not a pathological, phenomenon in the dominance of the mother archetype—that is, of a supranatural mother image in the creative man. His interest in the development of creative consciousness and archetypes is also evident in his study of Henry Moore.

In the 1970s a Jungian point of view was embraced by a handful of younger American art historians dealing with the early paintings and drawings of Jackson Pollock (e.g., Wolfe, Freke, Langhorne, and Donald Gordon). These writers assumed that Pollock's imagery of the 1940s is specific, that it lends itself to quite a precise interpretation in the light of Jungian psychology. They even go so far as to accept that at that time Pollock consciously adopted a Jungian program for his oeuvre. They are aware that because of his alcoholism, Pollock was involved from 1939 to 1942 in Jungian analysis, and that his paintings of 1938 to 1944 often deal with mythology, or seemingly mythological subjects, which at least indirectly may have been influenced by his analytic experience. In fact, later in his life Pollock admitted that he had been a Jungian for a long time, and in 1944 he stated that he was particularly impressed with the "concept of the source of art being the Unconscious" (quoted in Chipp, *Theories of Modern Art,* p. 546). Since some of his early works reveal a matrix of primitive archaic and mythic elements, these writers argue that these early works reflect a concern for Jung's central thesis of the "collective unconscious," and at least some references to particular images and symbols discussed in his analytic sessions.

The interpretations of these writers, however, have met with a

broadscale attack from William Rubin. Rubin points out that the Jungian disciples tend to interpret unfamiliar configurations in Pollock's early works as symptoms of his mental problems; that they are too inattentive to the plastic aspects of his works—his geometric configurations, draughtsmanship, color, and exploitation of the painted surface; that they concentrate almost exclusively on the identification and interpretation of symbols, which are often too elusive to pin down or confirm; that they ignore other approaches to these works by Pollock.

The Jungian approach of these writers clearly has its limitations. It concentrates on only those symbols that can be assimilated to a system of archetypes of the collective unconscious, as defined in Jung's writings. These writers are too interested only in those aspects of Pollock's works that—while no less symbolic—belong to an aspect of his psychology and personal history not universally shared or easily mythologized. They dwell on his animal imagery and ignore the tables, chairs, mirrors, and ladders in his early works, features that are just as prominent and apparently meaningful as his animal imagery. In short, the new wave of Jungian interpretations presents a lopsided account of some works by one master, and this account boils down to an iconographic inquiry that is partial rather than comprehensive. Nonetheless, these scholars have made valuable insights into the iconography of certain of Pollock's early works, some of whose symbolism does, in fact, seem archetypal.

Chipp, Herschel B. *Theories of Modern Art: A Source Book by Artists and Critics.* Berkeley and Los Angeles: Univ. of California Pr., 1968.

Freke, David. "Jackson Pollock: A Symbolic Self-Portrait." *Studio International* 186:217–21 (Dec. 1973).

Gordon, Donald. "Pollock's 'Bird' or How Jung Did Not Offer Much Help in Myth-Making." *Art in America* 68:43–53 (Oct. 1980).

Jung, Carl Gustav. "Picasso." *Wirklichheit der Seele; Anwendungen und Fortschritte der neueren Psychologie.* Zurich: Rascher Verlag, 1934.

———. *Wandlungen und Symbole der Libido* 4th rev. ed. Leipzig and Vienna: F. Deuticke, 1912. *Symbols of Transformation.* (*Collected Works,* Vol. 5). Tr. by R. F. C. Hull. New York and London: Pantheon Books, 1956.

Langhorne, Elizabeth. "A Jungian Interpretation of Jackson Pollock's Art through 1946." Ph.D. dissertation, University of Pennsylvania, 1977.

Neumann, Erich. *The Archetypal World of Henry Moore.* Tr. by R. F. C. Hull. New York: Pantheon Books, 1959.

———. *Kunst und schöpferisches Unbewusstes.* Zurich: Rascher Verlag, 1954. *Art and the Creative Unconscious: Four Essays.* Tr. by Ralph Manheim. New York: Harper & Row, 1959.

Read, Sir Herbert. "The Dynamics of Art." In *Aesthetics Today*, ed. by Morris Philipson, pp. 324–48. Cleveland and New York: World, 1961. (Originally published in *Eranos-Jahrbuch, 1952*. Zurich: Rhein-Verlag, 1953.

Rubin, William. "Pollock as Jungian Illustrator: The Limits of Psychological Criticism." *Art in America* 67:104–23 (Nov. 1979); 67:72–91 (Dec. 1979).

Wolfe, Judith. "Jungian Aspects of Jackson Pollock's Imagery." *Artforum* 11:65–73 (Nov. 1972).

Zervos, Christian. "Picasso étudié par le Dr Jung." *Cahiers d'art* 7:352–54 (1932).

INTEGRATED STUDIES

Studies that integrate psychological and psychoanalytic techniques with the more conventional methodology of art history are of great interest to art historians. Studies of this kind have been done on major artists of the past hundred years because much biographical and other primary documentary evidence is available. Kurt Badt (b. 1890), for example, interprets the psychological sources of Cézanne's card players paintings in *Die Kunst Cézannes*. Rejecting the thesis that these paintings are genre pictures of an actual cafe, Badt sees in the motif of Cézanne's card playing "reminders of Cézanne's past, memorials of some great experience in his youth as were the monumental genre scenes of 'The Bathers.' " In developing his argument, Badt employs Freud's and Jung's explanation of the importance of early life impressions, of the role of the subconscious, and of memory. Meyer Schapiro's work on Cézanne and Van Gogh is more persuasive. Schapiro offers a broad but systematic interpretation of Cézanne's still-life of apples in "The Apples of Cézanne: An Essay on the Meaning of Still-Life." He examines the artist's practice, his letters and conversations, and the problem of form in his work. Schapiro rejects the view of Roger Fry and Erle Loran (b. 1905) that the artist saw only a problem of form and color in the objects he painted. Schapiro interprets Cézanne's preference for the still-life of apples as the "game of an introverted personality who has found for his art of representation an objective sphere in which he feels self-sufficient, masterful, free from disturbing impulses and anxieties aroused by other human beings, yet open to new sensation." Schapiro supposed that the choice of objects was personal and deliberate rather than accidental. In Cézanne's "habitual representation of the apples as a theme by itself there is a latent erotic sense, an unconscious symboliz-

ing of a repressed desire," and hence a close relationship between this artist and the things he painted.

In another study, *The Parma Ildefonsus,* Schapiro offers a psycho-analytic interpretation of a Romanesque artist's sexual projection implied by his placement of an open door beneath the figure of the Virgin Mary. This was exceptional on the part of the artist; in medie-val texts, the universal attribute of the Virgin Mary is the *porta clausa* or closed door, which symbolizes her virginity. As Walter Cahn has pointed out, however, the psychoanalytic hypothesis offered by Schapiro as a tentative explanation is not very convincing. Cahn believes that the scene in question is perhaps best explained as an illustration of Ildefonsus's vision of the Virgin. As its medieval author writes, ". . . as Ildefonsus was nearing the church to celebrate Mass, the portal suddenly opened . . . and he beheld the Virgin seated in the place of the bishop on an ivory throne."

Schapiro and his former students at Columbia University have been aware of, and responsive to, the wide spectrum of conventions and expression in modern art. In order to deal with this art they have evolved new terminologies and concepts—drawing upon psychology, psychoanalysis, phenomenology, and even existentialism to some ex-tent—and integrated them with more formal and iconographic points of view. They do not proceed from a position outside of the art object. The methods they apply depend on the nature of the problem at hand. Their flexible approach is clear from Schapiro's own writings.

Schapiro and his students have examined the role of body imagery in painting. They conclude that the body provides an inexhaustible source for a vocabulary of expressive forms and serves as an integral and ineradicable component of artistic and aesthetic experience. Their findings have been published in scholarly papers, rather than monographs. The group includes Matthew Lipman, Lawrence D. Steefel, and Theodore Reff.

Persons working outside the field of art history have also taken up the psychoanalytic study of art but, with three exceptions, their re-sults have not been accepted. H. R. Graetz, who has written exten-sively on general psychopathology and the nature of psychotherapy, has devoted a monograph to *The Symbolic Language of Vincent Van Gogh.* Graetz bases his interpretation of the symbolic content of Van Gogh's paintings primarily on what the painter himself said in and about his work, and secondarily on a study of the works and psycho-logical research. In his *Strindberg und Van Gogh: Versuch einer*

pathographischen Analyse unter vergleichender Heranziehung von Swedenborg und Hölderlin, Karl Jaspers (1883–1969) explores Van Gogh, especially in terms of general psychopathology and the nature of psychotherapy. In "Michelangelo's Mutilation of the Florence *Pietà:* A Psychoanalytic Inquiry," Robert S. Liebert, M.D., criticizes those who interpret Michelangelo's puzzling attempt to destroy his masterpiece in exclusively sexual or technical terms. Focusing on the artist's preoccupation with death in his later years, Liebert draws attention to Freud's essay, "Mourning and Melancholia" *(Standard Edition . . .),* which describes human response to the death of beloved persons, and describes the unconscious "rage toward the abandoning loved one." This combination of love and rage is called "ambivalence." Liebert associates the imminent death of Michelangelo's beloved servant Urbino with the remote but unforgettable loss of his mother at the age of six, and accounts thereby for Michelangelo's ambivalent reaction to Urbino's dying. Liebert concludes that Urbino's "nagging" Michelangelo to complete the *Pietà* provided the excuse for venting his angry pain, in the celebrated attack on the *Pietà.*

Psychoanalysis has much to offer the interpretation of works of art. As Roger Fry observed in 1924, "it looks as though art had got access to the substratum of all the emotional colors of life, to something which underlies all the particular and specialized emotions of actual life" *(The Artist and Psychoanalysis).* But Fry also warned of the danger involved, declaring that "nothing is more contrary to the essential esthetic faculty than the dream." Art historians and critics working with the methods and concepts of psychoanalysis have too often been seduced into dealing with one-to-one equivalencies between art works and their alleged Freudian or Jungian counterparts and have therefore been reading unjustified or unjustifiable meanings into the images. Even statements by artists themselves have been misinterpreted. A fully convincing psychoanalytic interpretation of the arts must be based on the power and meaning of specific works or configurations within an artist's personal psychology, on the artist's ability to externalize and sustain those configurations in his or her works, and on whether those configurations were symptomatic of the attitudes of a large number of the artist's contemporaries and meaningful to them. For the applicability of psychoanalysis to the humanities in general, consult Otto Rank et al., *Psychoanalysis as an Art and a Science.*

A recent book that discusses experimental psychological investiga-

tions of the modes of color and light appearance in painting is Wolfgang Schöne's *Über das Licht in der Malerei.* This study is extremely important because it is entirely devoted to the phenomenon of light in Western painting. Publications dealing with color and the modifications of color in painting have been rare in modern scholarship. Art historians have been slow to assimilate the discoveries of psychology and physical science in the field of color. Schöne examines light in medieval, Renaissance, and modern painting, its history in Western painting in relation to the psychological data of color perception, and the religious or transcendental meaning of light in painting. His approach to the phenomenal world is shaped to some extent by Martin Heidegger's existentialist philosophy; it integrates exactitude in the description of phenomena with a thorough analysis of the sensory and mental conditions under which these phenomena are brought about and perceived. Although Schöne's book is speculative, it proceeds from, and contributes to, the history of Western art. It has opened up new possibilities for future research.

Badt, Kurt. *Die Kunst Cézannes.* Munich: Prestel-Verlag, 1956. *The Art of Cézanne.* Tr. by Sheila Ann Ogilvie. Berkeley: Univ. of California Pr., 1965.

Cahn, Walter. "Review of Meyer Schapiro, *The Parma Ildefonsus.*" *Art Bulletin* 49:72–75 (1967).

Freud, Sigmund. "Trauer und Melancholie," in *The Standard Edition of the Complete Psychological Works of Sigmund Freud,* 14:239–58. Ed. by James Stracher and Alan Tyson. 24v. London: Hogarth Pr. and the Institute of Psycho-Analysis, 1955–74.

Fry, Roger. *The Artist and Psychoanalysis.* London: L. and V. Woolf, 1924.

Graetz, H. R. *The Symbolic Language of Vincent Van Gogh.* New York: McGraw-Hill, 1963.

Jaspers, Karl. *Strindberg und Van Gogh; Versuch einer pathographischen Analyse unter vergleichender Heranziehung von Swedenborg und Hölderlin.* Bern: F. Bircher, 1922. *Strindberg and Van Gogh: An Attempt of a Pathographic Analysis with Reference to Parallel Cases of Swedenborg and Hölderin.* Tr. by Oskar Grunow and David Woloshin. Tucson: Univ. of Arizona Pr., 1977.

Liebert, Robert S., M.D. "Michelangelo's Mutilation of the Florence *Pietà:* A Psychoanalytic Inquiry." *Art Bulletin* 59:47–54 (1977).

Lipman, Matthew. "The Aesthetic Presence of the Body." *Journal of Aesthetics and Art Criticism* 15:425–34 (1957).

Loran, Erle. *Cézanne's Composition.* 3rd ed. Berkeley and Los Angeles: Univ. of California Pr., 1963.

Rank, Otto, et al. *Psychoanalysis as an Art and a Science.* Detroit: Wayne State Univ. Pr., 1967.

Reff, Theodore. "Cézanne's Bather with Outstretched Arms." *Gazette des Beaux Arts* 59, 6th ser.: 173–79 (1963).

Schapiro, Meyer. "The Apples of Cézanne: An Essay on the Meaning of Still-Life." *Art News Annual* 34:35–53 (1968).
———. *Modern Art: 19th and 20th Centuries; Selected Papers.* New York: Braziller, 1978.
———. "On a Painting of Van Gogh." *Perspectives U.S.A.* 1:141–53 (Fall 1952).
———. *The Parma Ildefonsus: A Romanesque Illuminated Manuscript from Cluny and Related Works.* New York: College Art Assn. of America, 1964.
———. *Paul Cézanne.* New York: Abrams, 1952.
———. *Vincent Van Gogh.* New York: Abrams, 1950.
Schöne, Wolfgang. *Über das Licht in der Malerei.* Berlin: Gebr. Mann, 1954.
Steefel, Lawrence D. "Body Imagery in Picasso's 'Night Fishing at Antibes.' " *Journal of Aesthetics and Art Criticism* 25:356–63 (1966).

SEMIOTICS

The increasingly popular field of semiotics, or the theory of signs and sign functions, has attracted few art historians, largely because the theory is still in a nascent state marked by a relative plurality of terms, some of which have roughly the same meaning.

Semiotics makes frequent use of structural models borrowed from linguistics in an endeavor to reduce nonlinguistic systems to linguistic ones, so that such systems can be analyzed and described in language. Some investigators have asked in this regard whether paintings, sculptures, or buildings can be considered a "language," with structural properties? So far this question has not been satisfactorily answered, but those interested in semiotics continue to ask it. To be sure, knowledge of the grammatical and syntactic rules of a language allows us to understand it. Knowledge of the grammar of old French helps us to determine the precise literal meaning—in contrast to the deeper symbolical meanings that may be present—of the *Song of Roland* (ca. 1100). This is not such a simple task with a Romanesque carved tympanum from the beginning of the twelfth century. We can tabulate the contents of the tympanum of Vézelay, but it is much more difficult, if not impossible, to define the mutual relations of the figures depicted, and what the precise major theme is, quite aside from its symbolical meaning (which the iconographer or iconologist would try to unravel). In a linguistic structure such relations would be built into a syntactic frame. Thus, clarification of the relations between image and language would pose the challenge to the researcher in semiotics. For this researcher the question of the linguistic character of art and that of the visual sign needs to be tackled, and

the difficulty of this task cannot be overestimated. How shall he or she analyze those images, unaided by words or a fixed code of equivalences between words and image? For instance, we cannot tell if an image represents "a tree" or a particular tree. In fact, as Gombrich pointed out in 1949, any image can be made to function either way. Art historians have long denied that the "generalized" or "idealized" image can be identified with the "abstract" or "universal" image. Today such an attempt at identification would amount to mistaken semiotic analysis.

Semiotics was first introduced into architectural debate in Italy during the late 1950s; in the late 1960s it was being discussed for its architectural implications in France, Germany, and England.

In the anthology entitled *Signs, Symbols and Architecture,* edited by Geoffrey Broadbent, Richard Bunt, and Charles Jencks, the theoretical issues of architectural signification are dealt with. This volume of essays emphasizes the Italian tradition of architectural semiotics, which was influenced by French structuralism and Italian semiotic theories.

Meaning in Architecture contains four articles concerned with the possibility of applying semiological concepts to architecture or urbanism. Such an approach treats the problems of architecture as a "language" that allows architecture to be considered in terms of information and communication theory. A major semiological work by an art historian is Meyer Schapiro's *Words and Pictures: On the Literal and the Symbolic in the Illustration of a Text.* This monograph deals primarily with Old Testament images from the fifth to the thirteenth century. His discussion of frontal and profile poses of figures as signs demonstrates one way in which semiology can be applied to art history. Schapiro interprets the directness of the frontal poses as a confrontation with the viewer and finds a parallel in language, the use of the first-person pronoun, while the profile image, which is removed from the space of the viewer, corresponds to the impersonal third-person pronoun. He goes on to assert that it is the "notion of polarity" between two poses, and not their intrinsic meaning, that is important to the interpretation of a work of art. In a 1972 paper Schapiro investigates the theme of the "nonmimetic" elements of the image-sign and their role in constituting the sign—for example, whether the location of an element in the "image-field" of a painting (left/right, close/far apart, high/low, etc.) may be the structural expression of some standardized meaning. In other words, he inquires whether structural constants correspond to constants of meaning.

In his book *The Semiotics of the Russian Icon,* the Soviet linguist Boris Uspensky proceeds from the assumption that the system of representational devices in painting is communicative by nature and that it is ordered. As such it constitutes a "language," that is, a system of signs, that is conducive to analysis on various levels. The principal level Uspensky identifies is that of the syntax, the internal articulation, of the icon, both in its strictly formal ("geometrical") and semantic aspects. An interpretation of the interrelation between formal and semantic systems of representation enables Uspensky to establish various constituents of icon paintings and to discover the hierarchical and functional status of these constituents.

Broadbent, Geoffrey, Richard Bunt, and Charles Jencks, eds. *Signs, Symbols and Architecture.* New York: Wiley, 1980.

Gombrich, Sir Ernst H. "Review of Charles Morris's *Signs, Language and Behavior*" (New York: Prentice-Hall, 1946). *Art Bulletin* 31:68–73 (1949).

Meaning in Architecture. Ed. by Charles Jencks and George Baird. London: Barrie & Rockliff, 1969.

Schapiro, Meyer. "On Some Problems in the Semiotics of Visual Art: Field and Vehicle in Image-Signs." *Semiotica* 1:223–42 (1969). Reprinted in *Simiolus: Netherlands Quarterly for the History of Art* 6:9–19 (1972/73).

———. *Words and Pictures: On the Literal and the Symbolic in the Illustration of a Text.* The Hague: Mouton, 1973.

Uspensky, Boris. *The Semiotics of the Russian Icon.* Ed. by Stephen Rudy. Lisse: Peter de Ridder Pr., 1976.

6

Art and
Society

In the two preceding sections I have examined studies addressing art in relation to the artist—his or her biography, psychological makeup, psychoanalytic analysis. The concluding section of this essay will focus on those art historical contributions that interpret works of art in the light of their social context. By social context I refer not only to the individual's institutional life—in social, economic, and political conditions—but also to such other collective creations of the human mind as religion, culture, and the history of ideas.

Social historians of art ask questions about the relation of works of art to a given social situation, to a social, economic, political, religious, cultural, or intellectual factor or system. They strive to describe and pinpoint the influence of the action of external forces in society and/or ideas on art; some, especially Marxists, also strive to judge and evaluate the position of art in society.

Most social historians of art write in terms of general correlations between art and society. They try to establish no specific links between art and social factors, and offer no laws or principles; nor do they evaluate art. Their histories usually make correlations on a work-by-work basis and resemble common sense generalizations, in that they suggest a relevance between the phenomena they link. There is no close examination of art and social phenomena, nor are ultimate causes of works given.

In the end, such approaches as these must be regarded as incidental to a specific understanding of the art works themselves. They can be judged as illuminating and meaningful only if they document in detail and analyze judiciously the nature of the correlation between art and society. In my view, no such successful social history of art has been written thus far. The reason for this lack of success is both a dearth of

those written sources needed to document such relationships and the general reluctance on the part of social historians to admit the influence of nonsocial factors bearing upon the creative process.

A representative sample of such scholarly endeavors will be discussed shortly. These examples will be organized in terms of patronage and other economic factors, including the history of taste—a great deal of research has been conducted on patronage in this century by art historians on both sides of the Atlantic—as well as religious institutions and movements and political factors.

A second group of social historians is far more rigid in that it applies deterministic causal methods to its study. Whereas the first group of social historians includes primarily art historians and theorists, the second group includes primarily political philosophers, educationists, moralists, reformers, Marxist art historians, and others who have demonstrated greater concern for determining the ways in which society may be influenced by the arts and the effects they have, or might or should have, on persons as members of a society. While the first point of view is a descriptive discipline, the second is a normative one.

The second group of social historians of art professes a belief in social causation and is usually the most deterministic of all art historians. For example, they may maintain that a class or group in society *causes* works of art to come into existence. Friedrich Antal states that the very existence of Jacques Louis David's painting *The Oath of the Horatii* was "determined by the strong feeling of opposition then prevailing against the demoralized court and its corrupt government" ("Reflections on Classicism and Romanticism"). Arnold Hauser, in *The Social History of Art,* calls material facts the ultimate causes of the visual arts. Antal and Hauser seem to proceed from the Euclidean principle that things equal to the same thing are equal to each other, when they hold that what is true of the effects of one kind of social factor is true of all the effects of that social factor. Hauser writes that "all factors material and intellectual, economic and ideological, are bound up together in a state of indissoluble interdependence." As a rule, these historians seek out underlying laws or principles that are valid in all circumstances.

These same writers also suggest that art works express or reflect social factors. For example, Hauser characterizes mannerism as "the artistic expression of the crisis which convulses the whole of Western Europe in the sixteenth century and which extends to all fields of political, economic, and cultural life." And Antal says of David's

Oath of the Horatii that "this picture is the most characteristic and striking expression of the outlook of the bourgeoisie on the eve of the revolution," and that the "historically inevitable style of David's picture . . . accurately reflected its social background" ('Reflections on Classicism and Romanticism"). Both Hauser and Antal speak not of art *and* certain social factors, but of art *because of* certain social factors. Richard Wollheim has tried to argue that this type of explanation differs from a causal one in that we presumably can observe directly the connection between art and its social determinants: the physiognomy of an art work reveals the social environment of its time and place of creation. This line of reasoning makes it unnecessary to look at contemporaneous works of art, as is required in the case of causal explanations, Wollheim continues, because it does not presuppose any general connection between art and society. But Wollheim fails to realize that "expression of" does not militate against "caused by," but, rather, reinforces it by further specifying a mode of causation.

The fallacy of causal-expressive explanations is that art is not always a mirror of society. What may be true of one work by an artist is not necessarily true of that artist's other works. Only after making a comprehensive examination of all available evidence linking the work of art to other art works and social factors can sociological explanations be made convincing.

Marxists best illustrate this deterministic approach to the visual arts. Major Marxist writers will be discussed in the section in the pages following my account of the "correlational" social histories. It can be pointed out that the majority of art historians interested in art and society make more modest claims than the determinists. They aim to identify only some degree of correlation between the art work and its setting and sources, and they will assume that some light will be thrown from such knowledge, though the precise relevance of their correlations may escape them. Their studies have met with greater acclaim in the field, the lack of specificity in their findings notwithstanding. And among these writers, those who correlate individual works of art with several or many external factors are more successful than those who endeavor to account for art by reference to one factor, because art simply cannot be explained in terms of a single cause.

The third subsection to follow will be devoted to those art historians who regard the visual arts as a manifestation of culture and interpret them in relation to all human activity and thought. This

genre of scholarship reached a peak in the work of Jacob Burckhardt (1818–97), who is acknowledged as the greatest cultural historian, and who exerted a considerable impact on scholars throughout Europe (but not America) until the advent of the First World War. Since that time meaningful interpretations of works of art in light of their cultural background have become less common, in part because art historians often lack the training or temperament that is required to make such an integration. It certainly is true that in the United States today younger scholars, and especially current graduate students, are not trained to deal competently with the source material of other disciplines. Some graduate departments of art history even discourage study in other fields. One way in which writers can overcome this shortcoming in their training is exemplified by the recent monograph on the Palace of the Buen Retiro, built in the 1630s on the outskirts of Madrid. This richly documented cultural history of the palace resulted from the collaboration of the art historian Jonathan Brown and the historian John Huxtable Elliott. But collaboration remains rare in contemporary scholarship; its instances are limited to survey books and, as previously noted, to the scientific examination of works of art.

The fourth subsection of "Art and Society" will take up *Geistesgeschichte* (the history of ideas or of the human mind or "intellectual history"), a specifically German method of inquiry that is a branch of the history of ideas. Emerging from the tradition of Hegelianism and other forms of nineteenth-century romantic thought, *Geistesgeschichte* was first stated in the work of Wilhelm Dilthey (1833–1911). He was a great German philosopher and historian, an idealist rather than a positivist, and the originator of the modern history of ideas. For Dilthey, the history of ideas encompassed a study of both rational and irrational (or imaginative) thoughts. Dilthey's work on the history of the human mind or spirit embraced literature, poetry, music, and philosophy, but excluded the visual arts and social and political ideas. He left to others the task of relating the visual arts to a study of the concept of the human mind.

The fifth and concluding subsection of these pages will examine those scholars who pursue a different method from *Geistesgeschichte*. These scholars work in the tradition of A. O. Lovejoy (1873–1962) who, with George Boas (b. 1891), founded the *Journal of the History of Ideas* in the United States in 1940. In *The Great Chain of Being: A Study in the History of an Idea*, Lovejoy introduces and applies this new method. Rather than deal with large

systems or aggregates of idea complexes (as in *Geistesgeschichte*), he confines his investigation to the elemental component parts, namely the "unit-ideas," that exist within the system or complexes. He defines unit-ideas as "types of categories, thoughts concerning particular aspects of common experience, implicit or explicit presuppositions, sacred formulas and catchwords, specific philosophic theorems, or the larger hypotheses, generalizations or methodological assumptions of various sciences." This approach to the history of ideas examines works of art as documents and illustrations of prevailing unit-ideas or idea complexes, and for this reason possesses great exegetic value. Properly applied, Lovejoy's method can show how ideas were understood by artists and how they are embodied, modified, or rejected in their work. This approach to the visual arts elucidates the intellectual attitudes of artists and leads thereby to a fuller understanding of art as creative work in time and space.

The study of art and society originated in the second half of the nineteenth century, and received a great impetus from the increasing popularity of the social sciences during the first half of the twentieth century. It remains common in our day.

Antal, Friedrich. "Reflections on Classicism and Romanticism." *Burlington Magazine* 56:160 (1935). Reprinted in his *Classicism and Romanticism with Other Studies in Art History.* New York: Basic Books, 1966.

Brown, Jonathan and John Huxtable Elliott. *A Palace for a King: The Buen Retiro and the Court of Philip IV.* New Haven, Conn. and London: Yale Univ. Pr., 1980.

Dilthey, Wilhelm. *Gesammelte Schriften.* 12v. Leipzig: Teubner, 1914–58.

Hauser, Arnold. *The Social History of Art.* Tr. by Stanley Godman. 2v. London: Routledge & Paul, 1951.

Lovejoy, A. O. *The Great Chain of Being: A Study in the History of an Idea.* Cambridge, Mass.: Harvard Univ. Pr., 1936.

Wollheim, Richard. "Sociological Explanation of the Arts: Some Distinctions." In *Atti del III Congresso Internazionale di Estetica, Venezia 3–5 settembre 1956.* Turin: Edizioni della Rivista di estetica Istituto di estetica dell'Università di Torino, 1957.

CORRELATIONAL SOCIAL HISTORIES OF ART

Social historians seeking to describe relations between works of art and one or more influential social organizations have examined patronage, economic and political factors, and religious institutions and movements. The majority of these studies have been devoted to patronage.

Patronage

Patronage has been important to the visual arts for the greater part of history, including the modern period. Today private patrons, museums, and governments play a role in the art world. Examining the relations between artist and patron can lead to discoveries about the materials, technique, size, location, function, and choice of subject matter for a work. The letters from Albrecht Dürer to Jakob Heller, a wealthy cloth merchant from Frankfurt who had ordered an altar panel from Dürer, for example, show the importance of material and economic factors in the execution of art works. A patron commissioning a work can dictate, for instance, that the artist is to execute a mosaic on the ceiling and walls of a church baptistery, to depict the baptism of Christ on the ceiling, and that the project is to be complete within a specified time period. Further, by offering a high fee, the patron can assure that the work is entirely by the artist's hand (a lower fee will secure a work by the artist and assistants). The patron cannot determine the work's intrinsic formal qualities, though it is true that certain traditions, especially in iconography, may dictate the choice of colors and so forth. Therefore, while a study of patronage can clarify many important conditions that are external to a work of art, it cannot tell much about the work's intrinsic formal qualities.

Patronage varies from one period to the next. During the course of the Renaissance, for example, the claims of tradition upon the patron and the artist seem to have diminished rapidly. Innovation in iconography and style appeared more desirable. Private collectors emerged, seeking art on new secular subjects. Though patrons customarily selected the subject, whether secular or religious, they frequently consulted with the artist. By the end of the fifteenth century, however, a highly respected artist such as Giovanni Bellini could refuse to execute a subject requested by so powerful a patron as Isabella d'Este. (Bellini eventually persuaded her to accept a theme of his own choice.) The growing independence of Renaissance artists raises art historical and social questions that are different than those that relate to the trecento or early quattrocento.

If an analysis of patronage fails to provide the art historian with answers, other approaches can be taken. The decoration of the Brancacci family chapel in the Church of Santa Maria del Carmine in Florence is a case in point. The fresco cycle in this chapel was painted in the 1420s by Masolino and Masaccio, but the authorship of some frescoes remains debatable, as has been demonstrated by Anthony

Molho in "The Brancacci Chapel: Studies in Its Iconography and History." The available documents do not show unambiguously who painted what in this chapel. They do not tell why the patron, Felice Brancacci, chose Masolino and Masaccio—if indeed Brancacci himself commissioned Masaccio to replace Masolino when Masolino left Florence sometime in the 1420s. They also fail to account for the particular selection of subjects decorating the chapel walls and why, for example, the *Tribute Money*, which seldom had been represented in the history of Christian art, dominates the room. They provide no clues to the dramatic difference in the style of the two artists who executed the paintings. Even recent technical examination of the murals apparently cannot settle the authorship question. Law B. Watkins bases his paper, "Technical Observations on the Frescoes of the Brancacci Chapel," on an unpublished technical examination of the paintings by Leonetto Tintori. Clearly the murals in the Brancacci chapel underscore the complexity of the art patronage problem in Renaissance Florence and suggest that, in the final analysis, problems of authorship can be settled only by connoisseurship or stylistic analysis.

Exact connoisseurship of the individual work of art, as taught by Richard Offner, was the cornerstone of Millard Meiss's scholarship. For Meiss, it constituted the foundation on which he could erect a historical superstructure. When Erwin Panofsky arrived in the United States in the 1930s, his iconographic method shaped the thought of Meiss, who published a number of studies in the 1940s that traced the history of an iconographic type, such as the Madonna of Humility, the ostrich egg, or light in fifteenth-century Netherlandish painting, in order to understand the religious character of European art. These interests coalesce in Meiss's *Painting in Florence and Siena after the Black Death*. In this work, Meiss seeks to demonstrate that the style of Florentine and Sienese painting around the middle of the fourteenth century is to be understood in light of the psychological and social changes among patrons and artists under the impact of the great plague and the economic disasters of the 1340s.

The patronage of medieval cathedrals has begun to engage the attention of scholars in recent years. One example of such a study is Henry Kraus's *Gold Was the Mortar*. In this book Kraus studies how eight major cathedrals, mostly of the twelfth to the fifteenth centuries, were funded. He finds that the wealthy bourgeoisie, rather than the ecclesiastical aristocracy, donated the money to the fabric funds used for these undertakings.

Andrew Martindale, in *The Rise of the Artist in the Middle Ages and Early Renaissance,* provides a brief survey of the positions of artists and architects after 1300 and during the Early Renaissance, and sheds some light on questions of patronage.

Patronage was of immediate interest to Aby Warburg. In "Bildniskunst und florentinisches Bürgertum," he examines the mentality and artistic taste of Florentine middle-class patrons at the time of Lorenzo de'Medici. He asks why these patrons wanted their portraits painted by Flemish artists and why they collected Flemish art so fervently. After careful examination of archival and documentary evidence, he concludes that these patrons, since they were yarn dyers and silk manufacturers, appreciated the heavy, expensive garments so well illustrated in Flemish art works.

Michael Baxandall's *Paintings and Experience in Fifteenth-Century Italy: A Primer in the Social History of Pictorial Style* maintains that a society expresses itself in particular symbolic structures, and that painting, one of the major symbolic modes, can be interpreted more closely by taking specific clues and general analogies from the other modes. Baxandall assumes that some questions asked when Renaissance art works were executed elude us today because of historical distance, and that we can more easily obtain answers to those questions by assessing contemporary documents, such as early Renaissance humanist and popular literature, manuals, schoolbooks, and artists' contracts and letters. In his unsystematically structuralist approach, Baxandall was influenced by the impact of linguistic and social-anthropological theory on the history of ideas, and ultimately by the Warburgian tradition. His book, while lucidly argued, is insufficiently documented to be wholly convincing.

The relationship of artists to patrons in the fifteenth century can be reconstructed from contracts and letters. This theme is extensively treated by Martin Wackernagel (1881–1962) in *Der Lebensraum des Künstlers in der Florentinischen Renaissance* and by David Sanderson Chambers in *Patrons and Artists of the Italian Renaissance.* Wackernagel has written a social and intellectual history of Renaissance art from about 1420 to 1530 that inquires into the demands of different patrons and guilds, and their motives and tastes, while Chambers translates early Renaissance letters, contracts, financial records, and other memoranda. In his monograph *Donatello and Michelozzo,* Ronald W. Lightbown defines the role of the patrons as well as that of the two sculptors in the creation of their major works in the 1420s and 1430s. By analyzing contemporary documents, pub-

lished for the first time, the role of Cosimo de'Medici and the Medici bank, as intermediary between sculptors and patrons, is established. The patronage of the Medicis and their role as arbiters of taste during the Italian Renaissance are also examined in Sir Ernst H. Gombrich's paper "The Early Medici as Patrons of Art" (in *Norm and Form*, pp. 35–57). Another recent essay of importance for an understanding of the interdependence of artists and patrons in the early Italian Renaissance, that provides a challenging hypothesis about the fundamental change in the style of the visual arts at that time, is Frederick Hartt's "Art and Freedom in Quattrocento Florence." Stimulated by Renaissance historian Hans Baron's *Crisis of the Early Italian Renaissance: Civic Humanism and Republican Liberty in an Age of Classicism and Tyranny*, Hartt (b. 1914) contends that Florentine artists were concerned over the fate of their society, deeply committed to its preservation, and responsible in large measure for the growth of its ideals. He also suggests that the guilds may have played a key role in the emergence of the Renaissance style in Florentine painting and sculpture. These ideas are also treated in Hartt's *History of Italian Renaissance Art: Painting, Sculpture, Architecture.* George L. Hersey's *Alfonso II and the Artistic Renewal of Naples 1485–1495* contains "seven linked studies which range through the literature, the portraits, the urbanism, the chief buildings, and the funeral sculpture." Hersey shows that, among other things, the renewal of the Duke of Calabria, Alfonso II, "expressed certain constant ideas: the legitimacy of the Aragonese house, the power of the Crown over the barons, and the need for a Florentine alliance to keep up Naples' political momentum."

Painting north of the Alps, works of the so-called Flemish primitives, is much less well documented than contemporary Italian Renaissance painting. Serious study of the patronage of these Northern artists is much more recent than that of Italian paintings. In her *Early Netherlandish Triptychs: A Study in Patronage*, Shirley Neilsen Blum investigates eleven painted altarpieces—polyptychs as well as triptychs—examples for which the circumstances of the donation are well detailed, especially the donor's intentions and the physical setting in which the altarpiece was placed. Building upon Erwin Panofsky's contribution to the iconographic content in early Netherlandish painting, especially of disguised symbolism, Blum goes much further. She examines the elaboration of the complex iconographic programs as influenced by the donor. In order to reach a deeper understanding of these dense iconographic programs, she probes the position and

character of the donor and his or her instructions to the painter, particularly in regard to the liturgical and often funerary function of the altarpiece.

Studies of baroque patronage have been frequent in recent years. Francis Haskell's *Patrons and Painters: A Study in the Relations between Italian Art and Society in the Age of the Baroque,* warns that "any attempt to 'explain' art in terms of patronage has been deliberately avoided." A more general survey of art patronage is Haskell's article "Patronage" in the *Encyclopedia of World Art.*

Clara Bille describes eighteenth-century Dutch patronage and collecting in *De Tempel der Kunst; of, Het Kabinet van den Heer Braamcamp.* In *Painting at Court,* Michael Levey investigates the history and development of types and styles of paintings created for royal patrons in six selected courts of Europe between the fourteenth and the nineteenth centuries. An essential essay that covers French patronage in the nineteenth century is Albert Boime's "Entrepreneurial Patronage in Nineteenth-Century France." For the role of patronage in American nineteenth-century art, see Lillian B. Miller's *Patrons and Patriotism: The Encouragement of the Fine Arts in the United States, 1790–1860.* Theda Shapiro has written *Painters and Politics: The European Avant-Garde and Society, 1900–1925,* which is a more general study of patronage in our own time.

Baron, Hans. *Crisis of the Early Italian Renaissance: Civic Humanism and Republican Liberty in an Age of Classicism and Tyranny.* 2v. Princeton, N.J.: Princeton Univ. Pr., 1955.

Baxandall, Michael. *Paintings and Experience in Fifteenth-Century Italy: A Primer in the Social History of Pictorial Style.* Oxford: Clarendon Pr., 1972.

Bille, Clara. *De Tempel der Kunst; of, Het Kabinet van den Heer Braamcamp.* 2v. Amsterdam: J. H. De Busey, 1961.

Blum, Shirley Neilsen. *Early Netherlandish Triptychs. A Study in Patronage.* California Studies in the History of Art, XIII. Berkeley: Univ. of California Pr., 1969.

Boime, Albert. "Entrepreneurial Patronage in Nineteenth-Century France." In *Enterprise and Entrepreneurs in Nineteenth- and Twentieth-Century France,* pp. 137–207. Ed. by Edward C. Carter II, Robert Forster, and Joseph N. Moody. Baltimore: Johns Hopkins Univ. Pr., 1976.

Chambers, David Sanderson. *Patrons and Artists of the Italian Renaissance.* London: Macmillan, 1970.

Gombrich, Sir Ernst H. *Norm and Form: Studies in the Art of the Renaissance.* London: Phaidon, 1966.

Hartt, Frederick. "Art and Freedom in Quattrocento Florence." In *Essays in*

Memory of Karl Lehmann, pp. 114–31. Ed. by Lucy F. Sandler. Locust Valley, N.Y.: New York Univ., Inst. of Fine Arts, 1964.

———. *History of Italian Renaissance Art: Painting, Sculpture, Architecture.* Englewood Cliffs, N.J.: Prentice-Hall, 1974.

Haskell, Francis. "Patronage." In *Encyclopedia of World Art.* Vol. 11. New York: McGraw-Hill, 1966.

———. *Patrons and Painters: A Study in the Relations between Italian Art and Society in the Age of the Baroque.* New York: Knopf, 1963.

Hersey, George L. *Alfonso II and the Artistic Renewal of Naples 1485–1495.* New Haven, Conn. and London: Yale Univ. Pr., 1969.

Kraus, Henry. *Gold Was the Mortar.* London: Routledge & Paul, 1979.

Levey, Michael. *Painting at Court.* London: Weidenfeld & Nicolson, 1971.

Lightbown, Ronald W. *Donatello and Michelozzo. An Artistic Partnership and Its Patrons in the Early Renaissance.* 2v. London: Harvey Miller, 1980.

Martindale, Andrew. *The Rise of the Artist in the Middle Ages and Early Renaissance.* Library of Medieval Civilization. Ed. by Joan Evans and Christopher Brooke. New York: McGraw-Hill, 1972.

Meiss, Millard. *Painting in Florence and Siena after the Black Death.* Princeton, N.J.: Princeton Univ. Pr., 1951.

Miller, Lillian B. *Patrons and Patriotism: The Encouragement of the Fine Arts in the United States, 1790–1860.* Chicago: Univ. of Chicago Pr., 1966.

Molho, Anthony. "The Brancacci Chapel: Studies in Its Iconography and History." *Journal of the Warburg and Courtauld Institutes* 40:50–98 (1977).

Shapiro, Theda. *Painters and Politics: The European Avant-Garde and Society, 1900–1925.* New York: Elsevier, 1976.

Wachernagel, Martin. *Der Lebensraum des Künstlers in der Florentinischen Renaissance.* Leipzig: E. A. Seeman, 1938. *The World of the Florentine Renaissance Artist: Projects and Patrons, Workshop and Art Market.* Tr. by Alison Luchs. Princeton, N.J.: Princeton Univ. Pr., 1981.

Warburg, Aby. "Bildniskunst und florentinisches Bürgertum. 1902; reprinted in *Gesammelte Schriften.* 2v. Leipzig: B. G. Teubner, 1932.

Watkins, Law B. "Technical Observations on the Frescoes of the Brancacci Chapel." *Mitteilungen des Kunsthistorischen Institutes in Florenz* 17:65–74 (Band 1973, Heft 1).

Economics

James S. Ackerman's study of the economic history of the Venetian cinquecento describes the function and design of Andrea Palladio's secular architecture: *Palladio* and *Palladio's Villas.* Improved farming methods, the introduction of corn cultivation in the sixteenth century, and reclamation of swamplands and deltas led the Venetian nobility to develop great estates that were functional, utilitarian, and appropriate symbols of dignified aristocratic life. Although the new economic and social situation did not in itself produce a mature

Palladian villa, Ackerman (b. 1919) maintains that it affected villa building, and especially the simple classical grandeur and magnificence of the estates designed by Palladio.

Ackerman, James S. *Palladio.* Baltimore and Harmondsworth, England: Penguin, 1966.
————. *Palladio's Villas.* Locust Valley, N.Y.: J. J. Augustin for the Inst. of Fine Arts, 1967.

Taste

The social history of art includes the history of taste—that is, the history of art theories, exhibitions, art collecting, and art dealing. The first scholarly treatment of the history of art collecting was Julius von Schlosser's *Die Kunst- und Wunderkammern der Spätrenaissance; Ein Beitrag zur Geschichte des Sammelwesens.* More recently, Francis Henry Taylor treated collecting in *Taste of Angels: A History of Art Collecting from Rameses to Napoleon.* See also Gerald Reitlinger's *Economics of Taste: The Rise and Fall of Picture Prices, 1760–1960,* and John Walker's *Self-Portrait with Donors: Confessions of an Art Collector.* Taylor and Walker were directors of major museums.

The history of taste between about 1790 and about 1870 is documented in Francis Haskell's lectures *Rediscoveries in Art: Some Aspects of Taste, Fashion, and Collecting in England and France.* Haskell examines taste from several points of view: "The availability or otherwise to the collector or connoisseur of recognized masterpieces; the impact of contemporary art; the religious or political loyalties that may condition certain aesthetic standpoints; the effects of public and private collections; the impression made by new techniques of reproduction and language in spreading fresh beliefs about art and artists." In his *Academies of Art, Past and Present,* Sir Nikolaus Pevsner surveys the education of painters and sculptors from the time of Leonardo da Vinci to the twentieth century, and evaluates artistic education in the light of prevailing aesthetic, political, social, and economic factors. Critic George Boas (b. 1891) traces Leonardo's *Mona Lisa* in the history of taste in *Wingless Pegasus, a Handbook for Critics,* while the Gothic in the history of taste is examined by Sir Kenneth Clark in *The Gothic Revival, an Essay in the History of Taste* and by Paul Frankl in *The Gothic: Literary Sources and Interpretation through Eight Centuries.* Frankl's book is a valuable addition to the historiography of art, as pointed out above.

Boas, George. *Wingless Pegasus, A Handbook for Critics*. Baltimore: Johns Hopkins Univ. Pr., 1950.

Clark, Sir Kenneth. *The Gothic Revival, an Essay in the History of Taste*. Rev. & enl. ed. New York: Scribner's, 1950.

Frankl, Paul. *The Gothic: Literary Sources and Interpretation through Eight Centuries*. Princeton, N.J.: Princeton Univ. Pr., 1960.

Haskell, Francis. *Rediscoveries in Art: Some Aspects of Taste, Fashion, and Collecting in England and France*. Ithaca, N.Y.: Cornell Univ. Pr., 1976.

—— and Nicholas Penny. *Taste and the Antique: The Lure of Classical Sculpture, 1500–1900*. New Haven, Conn. and London: Yale Univ. Pr., 1981.

Pevsner, Sir Nikolaus. *Academies of Art, Past and Present*. Cambridge and New York: Cambridge Univ. Pr., 1940.

Reitlinger, Gerald. *Economics of Taste: The Rise and Fall of Picture Prices, 1760–1960*. 3v. London: Barrie & Rockliff, 1961–70.

Schlosser, Julius von. *Die Kunst- und Wunderkammern der Spätrenaissance; Ein Beitrag zur Geschichte des Sammelwesens*. Leipzig: Klinkhardt & Biermann, 1908.

Taylor, Francis Henry. *Taste of Angels: A History of Art Collecting from Rameses to Napoleon*. Boston: Little, Brown, 1948.

Walker, John. *Self-Portrait with Donors: Confessions of an Art Collector*. Boston: Little, Brown, 1974.

Religion

Art works and religious institutions and movements have been investigated by those social historians of art interested in the entire development of Western art from ancient times to the present day.

Religious studies relating to antiquity have been common. In *L'art en Grèce*, Waldemar Deonna (1880–1958) and André de Ridder (1868–1921) emphasize the relationship between ancient Greek art and social life and stress the religious origins of Greek art. Deonna writes that art for a long time was only a form of cult, and that Greek art was "the docile servant of official religion." He goes on to say that "religion penetrates even the industrial arts destined to practical ends," and that "religion . . . is responsible for the spirit in which the artist treats his themes and which changes with the changes in belief." Guido von Kaschnitz-Weinberg in *Die mittelmeerischen Grundlagen der antiken Kunst* maintains that all ancient Greek architecture derives from the phallic cult brought into the Mediterranean basin by Nordic and Indo-Germanic tribes. He adds that ancient Roman architecture is based on the worship of mother earth in underground chambers (the womb).

In his investigation of about 150 sites of ancient Greek temples, *The Earth, the Temple, and the Gods*, Vincent Scully (b. 1920),

historian of modern architecture, has described these temples as "physical embodiments of the gods in sacred places . . . as unique unions of the natural and the man-made." Scully says that space was instrumental in the genesis of architecture and stipulates a reciprocal relationship between the topography of ancient Greek temple sites and the morphology of the structures. Scully makes use of Greek mythology, poetry, and other forms of literature to arrive at a mythological and religious meaning for temple siting and design. While Scully's sensational thesis cannot be documented, it has expanded our historical understanding of ancient architecture of the Western world.

Pre-twentieth century studies of medieval art rarely covered religious and liturgical problems. The study of medieval liturgies was virtually the exclusive province of theologians and church historians. Since the middle of the eighteenth century, however, historians and other specialists in the art of antiquity had researched the cults and religious institutions of Greece, Rome, and the Near East as cultural phenomena. Only when the close ties between medieval and modern history study were severed, and when the distinctions between the profane and the sacred were removed, did medievalists begin to examine the relationship between art and liturgy. Ernst H. Kantorowicz (1895–1963), historian, iconographer, and art historian, examined these connections in *Laudes Regiae: A Study in Liturgical Acclamations and Medieval Ruler Worship*, in *The King's Two Bodies: A Study in Medieval Political Theology*, in "The Baptism of the Apostles," and in other papers reprinted in his *Selected Studies*. Thomas Mathews has scrutinized the interdependence by early Christian and Byzantine architecture and liturgy in *The Early Churches of Constantinople: Architecture and Liturgy*. Mathews attempts to reconstruct the ceremonial uses of early Constantinople churches by investigating archaeological evidence pertaining to the layout of pre-iconoclastic churches in Istanbul and by interpreting historical and liturgical texts.

Several German scholars, including Wolfgang Schöne, Victor H. Elbern, Otto Georg von Simson, and Erich Dinkler, have studied the relationship of early Christian and early Western medieval art and liturgy. Victor H. Elbern's papers are particularly important for their development of a method he calls the "iconography of ornament," especially in liturgical objects. Elbern's thought was influenced by Günter Bandmann's studies on the iconography of architecture.

Ernst Kitzinger (b. 1912), a leading authority in late antique, early

Byzantine, and medieval art, writes on the transition from the art of classical antiquity to medieval art. He focuses on the specifically visual aspect of the work of art; much of his work deals with processes of stylistic change and the interpretation of these processes in historical terms. Over more than forty years, Kitzinger has experimented with a number of approaches that are complementary and overlapping in part rather than mutually exclusive (see *The Art of Byzantium and the Medieval West: Selected Studies*). Some of his papers have been iconographical or iconological, with a view to shedding light on the intellectual, religious, or political climate in which the art work was created. At times he has sought to examine actual relationships between stylistic innovations and developments in the social and religious life of a period, particularly as those developments affected the role and function of religious images. Kitzinger has also investigated patronage; i.e., how the patron influences the subject matter and content of a commissioned work and may influence its stylistic composition. In *Byzantine Art in the Making: Main Lines of Stylistic Development in Mediterranean Art, 3rd–7th Century,* Kitzinger synthesizes the stylistic development of a number of major paintings and sculptures over five centuries and demonstrates that the political, social, religious, and intellectual transformations in Rome and Byzantium were subtly reflected in their art. By anchoring works of art in their social and religious context, he discerns a succession of dominant stylistic trends and traces the change from classical humanism to medieval spirituality.

Arthur Kingsley Porter, in *The Crosses and Culture of Ireland,* interprets the carved standing Irish crosses in the light of that country's church history from the fifth century to the Viking domination. Meyer Schapiro connects the ambivalence in the formal and symbolic qualities of the early medieval Ruthwell Cross to the struggle for power between the Roman and Northumbrian churches in a 1944 paper. Ernest K. Kantorowicz challenged Schapiro's interpretation in 1960. Schapiro's 1963 rejoinder argues that not all figures represented in medieval Christian art should be understood as religious.

The plan of St. Gall, the earliest extant medieval architectural drawing, has been interpreted as a product of the monastic reform movement of the early ninth century by the art historian Walter Horn and the architect Ernest Born in *The Plan of St. Gall: A Study of the Architecture and Economy of, and Life in a Paradigmatic Carolingian Monastery*. This three-volume book of over 1,000 pages and approximately 1,200 illustrations is an intellectual and visual

reconstruction of all the buildings on the plan of St. Gall. It analyzes the life and aims of the communities it was intended to serve.

Renaissance architecture was the "daughter of religion" as shown in *Architektur und Religion* by Heinrich von Geymüller (1839–1909). A more recent text is Donald Drew Egbert's "Religious Expression in American Architecture." Egbert (1902–72) seeks "to show how the architecture of American churches, meeting houses, and synagogues has tended to exemplify, in highly tangible form, important aspects of prevailing American religious beliefs and practices" from the seventeenth and early eighteenth centuries to the present day.

Today, monographs on artists who treated religious subject matter invariably include a discussion of religion. Walter F. Friedlaender's *Caravaggio Studies* is a representative example. In one chapter of this book, "Caravaggio's Character and Religion," Friedlaender surveys the religious climate in Rome during Caravaggio's productive years, 1600–1606, and draws parallels between his paintings and the religious attitudes of St. Filippo Neri and the "low church" of Rome. "Caravaggio's realistic mysticism is the strongest and most persuasive interpretation of the popular religious movements of the period in which he lived," Friedlaender writes.

Robert Rosenblum (b. 1928), who studied under Walter Friedlaender, recently published a provocative assessment of modern painting. In his *Modern Painting and the Northern Romantic Tradition,* Rosenblum discards the often held interpretation of modern painting as based on two schools, French and non-French. In its place he offers the following: "My own reading is based not on formal values alone . . . but rather on the impact of certain problems of modern cultural history, and most particularly the religious dilemmas posed in the Romantic movement, upon the combinations of subject, feeling, and structure shared by a long tradition of artists working mainly in Northern Europe and the United States."

De Ridder, André, and Waldemar, Deonna. *L'art en Grèce.* Paris: Renaissance du Livre, 1924. *Art in Greece.* Tr. by V. C. C. Collum. New York: Knopf, 1927.

Egbert, Donald Drew. "Religious Expression in American Architecture." In *Religious Perspectives in American Culture.* Ed. by James Ward Smith and A. Leland Jamison. Vol. 2 in *Religion in American Life;* no. 5, Princeton Studies in American Civilization. Princeton, N.J.: Princeton Univ. Pr., 1961.

Elbern, Victor H. "Das Engerer Bursenreliquiar und die Zierkunst des frühen

Mittelalters," *Niederdeutsche Beiträge zur Kunstgeschichte.* 10:41–102 (1971).

Friedlaender, Walter F. *Caravaggio Studies.* Princeton, N.J.: Princeton Univ. Pr., 1955.

Geymüller, Heinrich von. *Architektur und Religion.* Basel: Spittler, 1911.

Horn, Walter, and Ernest Born. *The Plan of St. Gall: A Study of Architecture and Economy of, and Life in a Paradigmatic Carolingian Monastery.* 3v. Berkeley and Los Angeles: Univ. of California Pr., 1979.

Kantorowicz, Ernst H. *The King's Two Bodies: A Study in Medieval Political Theology.* Princeton, N.J.: Princeton Univ. Pr., 1957.

———. *Laudes Regiae: A Study in Liturgical Acclamations and Medieval Ruler Worship.* Berkeley and Los Angeles: Univ. of California Pr., 1946.

———. *Selected Studies.* Locust Valley, N.Y.: Augustin, 1965. Reprints "The Baptism of the Apostles" (1955), "The Archer on the Ruthwell Cross" (1960), and other major papers.

Kaschnitz-Weinberg, Guido von. *Die mittelmeerischen Grundlagen der antiken Kunst.* Frankfurt am Main: V. Klosterman, 1944.

Kitzinger, Ernst. *The Art of Byzantium and the Medieval West: Selected Studies.* Ed. by W. Eugene Kleinbauer. Bloomington: Indiana Univ. Pr., 1976.

———. *Byzantine Art in the Making: Main Lines of Stylistic Development in Mediterranean Art, 3rd–7th Century.* London: Faber & Faber, 1977.

Mathews, Thomas. *The Early Churches of Constantinople: Architecture and Liturgy.* University Park and London: Pennsylvania State Univ. Pr., 1971.

Porter, Arthur Kingsley. *The Crosses and Culture of Ireland.* London: Oxford Univ. Pr., 1931.

Rosenblum, Robert. *Modern Painting and the Northern Romantic Tradition: Friedrich to Rothko.* New York: Harper & Row, 1975.

Schapiro, Meyer. "The Religious Meaning of the Ruthwell Cross," *Art Bulletin* 26:232–45 (1944). (Reprinted in Schapiro's *Late Antique, Early Christian and Mediaeval Art: Selected Papers,* pp. 150–76. New York: Braziller, 1979.)

Scully, Vincent. *The Earth, the Temple, and the Gods: Greek Sacred Architecture.* New Haven, Conn.: Yale Univ. Pr., 1962.

Politics

Otto Georg von Simson (b. 1912) has examined three churches in the city of Ravenna built during the reign of the emperor Justinian (527–565), "to see them against the entire panorama of the age in which they were executed and in the political atmosphere of which they were a part" *(Sacred Fortress: Byzantine Art and Statecraft in Ravenna).* He finds that "the imaginative creations of the architect and the mosaicist were designed to mirror the decisive political issues of the age."

In a non-Marxist study of the relationship between socialism and American art, Donald Drew Egbert describes important events of

political, social, and artistic radicalism and their impact on artists and their works *(Socialism and American Art in the Light of European Utopianism, Marxism, and Anarchism)*. Egbert's *Social Radicalism and the Arts, Western Europe; A Cultural History from the French Revolution to 1968* documents the interdependence of the visual arts, social history, and the history of ideas in a manner that is free of the dogmatic strait jacket in which Marxist art history and criticism is so often imprisoned.

The official policies of the Third Reich toward modern artists and art drew the attention of specialists as early as 1936, when Emil Wernert published his *L'Art dans le IIIe Reich; une tentative d'esthétique dirigée*. After the fall of the Nazi regime, Paul Ortwin Rave *(Kunst Diktatur im Dritten Reich)* and Hellmut Lehmann-Haupt *(Art under a Dictatorship)* expanded Wernert's material. The most thoroughly documented interpretation of the visual arts in Nazi Germany is Barbara Miller Lane's *Architecture and Politics in Germany, 1918–1945*. Lane draws attention to what she calls "a long-standing tendency in Germany to regard the arts as a focus of political concern."

In *Art and Architecture in the Service of Politics,* a collection of essays, seventeen art critics and scholars employ a variety of approaches and methods ranging from documentary and empirical to Marxist in their interpretation of monuments dating from the time of the emperor Constantine the Great to the modern comic strip and Philip Guston. These essays examine instances in which art has served political aims—instances in which artistic intentions and political strategies have intersected.

Although political purpose in art has not been a major focus of art historians in recent decades, it has attracted the interests of some scholars, especially those concerned with the arts of the nineteenth and twentieth centuries. A few other representative examples include Albert Boime's "The Second Republic's Contest for the Figure of the Republic," Eugenia W. Herbert's *The Artist and Social Reform,* Robert L. Herbert's *David, Voltaire, 'Brutus' and the French Revolution,* and Robert Rosenblum's "Painting during the Bourbon Restoration, 1814–1830."

Art and Architecture in the Service of Politics. Ed. by Henry A. Millon and Linda Nochlin. Cambridge, Mass.: MIT Pr., 1978.
Boime, Albert. "The Second Republic's Contest for the Figure of the Republic." *Art Bulletin* 53:68–83 (1971).

Egbert, Donald Drew. *Socialism and American Art in the Light of European Utopianism, Marxism, and Anarchism.* Princeton, N.J.: Princeton Univ. Pr., 1967.

———. *Social Radicalism and the Arts, Western Europe; A Cultural History from the French Revolution to 1968.* New York: Knopf, 1970.

Herbert, Eugenia W. *The Artist and Social Reform: France and Belgium, 1885–1898.* New Haven, Conn.: Yale Univ. Pr., 1961.

Herbert, Robert L. *David, Voltaire, 'Brutus' and the French Revolution: An Essay in Art and Politics.* London: Allen Lane, 1972.

Lane, Barbara Miller. *Architecture and Politics in Germany, 1918–1945.* Cambridge, Mass.: Harvard Univ. Pr., 1968.

Lehmann-Haupt, Hellmut. *Art under a Dictatorship.* New York: Oxford Univ. Pr., 1954.

Rave, Paul Ortwin. *Kunst Diktatur im Dritten Reich.* Hamburg: Gebr. Mann, 1949.

Rosenblum, Robert. "Painting During the Bourbon Restoration, 1814–1830." In *French Painting 1774–1830: The Age of Revolution.* Exhibition catalog, Réunion des Musées Nationaux, Paris, 1975.

Simson, Otto Georg von. *Sacred Fortress: Byzantine Art and Statecraft in Ravenna.* Chicago: Univ. of Chicago Pr., 1948.

Wernert, Emil. *L'Art dans le IIIe Reich: une tentative d'esthétique dirigée.* Paris: Centre d'études de politique étrangère, 1936.

THE VARIETIES OF MARXISM

Marxists offer the most extreme and some of the most popular interpretations of the social history of art. Marxist approaches to art history grew out of realistic criticism of the arts. Systematic Marxist doctrine began to evolve during the 1890s. Marxist criticism can be traced back to scattered references in the writings of Karl Marx and Friedrich Engels, and ultimately to Hegel. Marx himself made no systematic interpretation of art and culture or any formulation of a consistent aesthetic. We possess only fragments of his thoughts on art, the development of which has been summed up by Mikhail Lifshitz (b. 1905).

Among his statements on art is a now lost article "On Religious Art" of 1842, which can be reconstructed from some notes Marx drafted for it. This article reveals the main features of Marx's revolutionary-democratic beliefs, and much of what it contained did not altogether disappear in his later thought. Marx maintained that the origin of art lies in free, organic social life. Drawing upon idealist art critics, he develops the notion that art in the service of religion is alienated from its ideal quality, which is human realism of the sort found in ancient Greek art. Oppression and fear, slavery and tyr-

anny, call for that which is inimical to art. The realism of ancient art depended upon the democracy of the Greek republics, whereas Christian art of the post-classical period reveals a different aesthetic, one based on quantity and formless matter, exaggeration and distortion. Christian art adapted these qualities from antagonism between art and religion, thereby radicalizing Hegel's distinction of the two phenomena as parallel forms of human activity. The basic thesis of his 1842 article was the antithesis between the ancient principle of beautiful form and the fetishistic workshop of materiality. He contrasted the creative activity of humanity with the crude naturalism and practicality of the fetishistic world. Marx contrasted the formless matter and crude naturalism of Christian art with the creative activity and beautiful forms of ancient Greek art, because at that time he believed that the objects of fetishistic cult worship were not forms but things, or materiality, in which humanity obtains a source of well-being.

Owing to the lack of a consistently doctrinaire interpretation of art by Marx and Engels, there are almost as many varieties of Marxism as there are Marxist art critics. If these persons share any belief in common, it is an acceptance of a universal law, according to which all manifestations of culture, including works of art, are conditioned by changes in the organization of primary production. Many of them also subscribe to a dialectical theory of history and the importance of the class struggle. Not infrequently, they assume or assert that Marx held that the higher the general state of production, the greater and richer the art. On this score they are mistaken. In the introduction to his *A Contribution to the Critique of Political Economy,* Marx spoke of the unequal relation between the development of material production and art: "It is well known that certain periods of highest development of art stand in no direct connection with the general development of society, nor with the material basis and the skeleton structure of its organization." As a consequence of this misinterpretation, many modern Marxists deviate from the seemingly paradoxical but strict Marxist doctrine of the disparity between artistic and general social progress.

A systematic Marxist doctrine on art was formulated in Germany by Franz Mehring (1846–1916) and in Russia by Georgi Plekhanov (1856–1918). Both Mehring and Plekhanov recognize a certain autonomy of the work of art and think of a Marxist approach more as an objective science of the social determinants of a work than as a doctrine that identifies aesthetic questions and prescribes subject

matter and style to artists. The first systematic study of the arts based on Marxist thought was Plekhanov's monograph of 1918 on French art and society of the eighteenth century, which appeared in English as *Art and Society*. Plekhanov correlates forms of literature and art with the social conditions under which they arose.

One of the most important Marxist art writers in early twentieth-century Germany was Wilhelm Hausenstein (1882–1957). In *Der nackte Mensch in der Kunst aller Zeiten und Völker,* Hausenstein seeks to develop a social aesthetic and to apply it throughout art history to the nude form. He contends that the prevailing mood of social life determined the forms that artists used at any period. He also writes that bourgeois societies, whether in fourth-century Greece, in Florence during the Renaissance, or under nineteenth-century industrialism, have created naturalistic art works. By stressing the formal element in art, Hausenstein had an impact on art theory in the Soviet Union through his influence on Nikolai Bukharin, the painter who became a celebrated Soviet political figure and theoretician before he was purged by Stalin in the 1930s. Hausenstein's writings are an early example of the sociological approach to art history that developed primarily in Germany and Austria under strong Marxist influence. This variety of *Kunstsoziologie* ("art sociology") was to spread from central Europe to other countries of western Europe, especially after 1933, when the approach was repudiated in Hitler's Germany, and its proponents were forced to emigrate.

Kunstsoziologie was a major school of art history, theory, and criticism that originated with the French poet, philosopher, and sociologist Jean Marie Guyau (1854–88). In *Les problèmes de l'esthétique contemporaine* Guyau reacted against the tradition in idealistic aesthetics from Kant to Spencer, which held that aesthetic enjoyment is necessarily free from all practical and ideal interests, and also against the positivist philosophy of Hippolyte Taine (1828–93), who argued that to understand art works it is necessary to view them in the light of "the general social and intellectual condition of the times to which they belong" (*Philosophie de l'art*)—in sum, art works are products of their environment, and nothing else. In his *L'art au point de vue sociologique,* an exaggerated ethical work, Guyau examines the relations between art and society, and, above all, the importance of art for social solidarity and moral progress. According to his definition, art is "a methodical whole of means chosen to create that general and harmonious stimulation of conscious life which consti-

tutes the feeling of beauty." This feeling of beauty is explained by
what may be called an "introjection" of the idea of social order, "the
highest form of the sentiment of solidarity and unity in harmony; it is
the consciousness of a society in our individual life." Guyau wanted
to break down the barriers that separate art from the other aspects of
civilization and represented aesthetic experience, with its culmination
in artistic enjoyment. In his view, social phenomena, like organic
phenomena, can only be interpreted in terms of the principle of life;
and every individual, far from being an isolated entity, is bound by
sympathy to all other creatures, achieving completeness in unity with
them. Transferring this thinking to aesthetics, he contended that art
is a social phenomenon whose aim is to produce an aesthetic emotion
of a social sort. He wrote that "the principle of life is . . . life
itself . . . The highest aim of art is, after all, to make the human heart
throb, and, as the heart is the very center of life, art must find itself
interlaced with the whole moral and material existence of mankind."

Guyau's work on art sociology was read by the Russian-born
Marxist anarchist Prince Peter Kropotkin (1842–1921), who had an
important influence on French artists in the 1880s. It was in Central
Europe, however, that *Kunstsoziologie* developed further along
Marxist lines, and is evident in the work of such Marxist art histori-
ans as Francis Donald Klingender (1907–55).

The interpretation of art was affected by Marxist thought earlier in
Russia and Germany than elsewhere in Europe or the United States.
In this country scholars began to apply Marxist methods and models
during the decade of the Great Depression. Marxism was far more
common in literary criticism than in art history and criticism. The
best known American Marxist critic was Granville Hicks, who pro-
duced a remarkably innocuous reinterpretation of American litera-
ture: *The Great Tradition: An Interpretation of American Literature
since the Civil War*. From 1934 to 1937 the Artist's Union of New
York, whose membership numbered about 1,300, issued the maga-
zine *Art Front,* edited by Ben Shahn and Stuart Davis, to which
William Gropper, Maurice Becker, and Meyer Schapiro contributed.
This journal published papers on the problems of race, nationality,
and art. The most notable Marxist interpretations of the visual arts
at this time include Milton Wolf Brown's *The Painting of the French
Revolution* and Meyer Schapiro's "Nature of Abstract Art." Scha-
piro's article is a spirited review of Alfred H. Barr's (1902–81) Mu-
seum of Modern Art catalog *Cubism and Abstract Art*. Schapiro
criticizes Barr's presentation as formalist art history that lacks any

historical context and advances the claim that medieval artists were the forerunners of those twentieth-century artists who claimed to be the avant-garde of social progress.

In 1939 Schapiro published another paper, "From Mozarabic to Romanesque in Silos," one of his most important contributions to Western art history. In this study Schapiro undertakes a sociological explanation of Romanesque style. The premise and argumentative structure of this paper are Marxist, as Otto Karl Werckmeister has suggested. Schapiro argues that the development of style from Mozarabic to Romanesque is based on the class struggle between the church and the ascending bourgeoisie and on the social change of Castile and León from a regional kingdom with a backward-looking economy of agriculture and looting, to an advanced, internationally oriented town civilization. It is probably not coincidental that in 1938 the New York Critics Group published an account, in English, of what is known of Marx's lost 1812 article "On Religious Art," and that Marx's views on art, society, and religion apparently provided Schapiro with a new understanding of the possible correlation of art and religion. This new perception of Marxist theory, therefore, underlies his 1939 paper on the sculptures in Silos. In the same year, Schapiro joined the Trotskyist League for Cultural Freedom and Socialism, whose program maintained that scholars and artists, free from ties to government and politics, could contribute to the actual advance of a socialist democracy. This apparent Marxist phase in Schapiro's scholarship did not survive the Second World War. Like many other scholars and artists in the 1940s, Schapiro became disillusioned with Marxism because of the Soviet invasion of Finland and the repressive authority of the Communist party in the United States; his postwar writings cannot be interpreted as Marxist.

The Marxist interlude in American art scholarship was both short-lived and primarily confined to the New York area. During that period, Sidney Hook (b. 1902), a disciple of John Dewey, began to establish his reputation as one of America's leading interpreters of the varieties of Marxism (as well as the most distinguished and articulate proponent of pragmatism and democracy on the philosophical scene) through his teachings at Washington Square College. Hook's contributions include *Towards the Understanding of Karl Marx* and *From Hegel to Marx*.

English art writers such as John Ruskin and William Morris had an impact upon the aesthetics and social ideas of twentieth-century British art critics such as Roger Fry (1866–1934), Wyndham Lewis

(1882–1957), and Sir Herbert Read (1893–1968). Of these three, only Read was somewhat sympathetic to Marxism. A later generation of social-minded critics, who differed significantly from Fry, Lewis, and Read, rose to prominence in England in the period preceding and following World War II under the influence of Marxism or Marxism-Leninism. This later generation included Francis D. Klingender, Frederick Antal, Arnold Hauser, John Berger, David Kunzle, and Timothy J. Clark.

Francis Donald Klingender (1907–55) was trained at the London School of Economics where he developed an interest in economics and sociology as well as in Marxism and the Communist party. His *Marxism and Modern Art: An Approach to Social Realism* supports realism in art and attacks the formalism of Roger Fry. For Klingender, "Marxist criticism consists in discovering the specific weight within each style, each artist and each single work of those elements which reflect objective truth in powerful and convincing imagery." Klingender points to "a continuous tradition of realism" that began with Paleolithic cave paintings and has lasted to the present day, and a "tradition of spiritualistic, religious or idealistic art" that began when "mental labour was divided from material labour" and has been continuous "until it will vanish with the final negation of the division of labour—i.e., in a Communist world." Klingender maintains that a Marxist art history should describe the absolute struggle between these two opposite and mutually exclusive trends.

Klingender wrote two additional volumes from a Marxist point of view: *Art and Industrial Revolution* and *Goya; In the Democratic Tradition.* In the Goya study, Klingender argues that "there is a close connection between the wider social experience which Goya shared with his contemporaries and his own attitude to that experience." He attempts to show that the "many conflicting tendencies of Goya's style development can only be interpreted as the necessarily varying expressions of as many social moods and attitudes." Klingender's interpretation of Goya as a type of revolutionary democrat fails to recognize that Goya's role during the Napoleonic period in Spain was politically insignificant. Klingender's assertive Marxism and historical oversimplifications dominate *Animals in Art and Thought to the End of the Middle Ages,* in which he examines how artists and writers have used animal imagery to symbolize their religious, social, and political beliefs from prehistory to the Renaissance.

The thought of Frederick Antal (1887–1954) on the history of art has been more influential in recent scholarship than Klingender's.

Antal, a Hungarian-born writer, emphasized the relation of class to style along Marxist lines. After studying art history first with Heinrich Wölfflin and later with Max Dvořák in Vienna, Antal became a close friend of György Lukács (1885–1971), the Hungarian Communist aesthetician and critic who became minister of education in the Communist government of Bela Kun in 1919. Antal's 1914 dissertation, "Klassizismus, Romantik und Realismus in der französischen Malerei von der Mitte des XVIII. Jahrhunderts bis zum auftreten Géricaults," became the starting point for five articles called "Reflections on Classicism and Romanticism" that appeared in the *Burlington Magazine* between 1935 and 1941. These papers extol Géricault because this painter was a member of the middle class who took an interest in progressive politics and devoted himself to depicting everyday occurrences. His art, accordingly, showed a new realism or "naturalism." Géricault, moreover, was the first major artist to employ lithography, a new mass-production medium, "in his drive toward the democratization of art." Antal identifies Géricault as "the forerunner of most that is progressive in nineteenth-century French painting . . . a revolutionary master."

Stressing content rather than style, Antal's Marxist papers reject the formalist, Wölfflinian-based approach of his own earlier studies. Antal maintains that art works are conditioned by political, economic, and social factors. His sociological explanations of paintings, like David's *Oath of the Horatii,* are thus causal and expressive when he declares that David's masterpiece "accurately reflected its social background."

From the mid-1920s until his death in 1954, Antal systematically and, at times, rigidly applied social determinism to art history. In *Florentine Painting and Its Social Background,* Antal returns to the subject of a 1924 paper, in which he had traced two stylistic trends in trecento and early quattrocento painting, the one rational, the other irrational—a dichotomy of styles that is characteristic of early twentieth-century German and Viennese art history. Antal argues that the significant change in Florentine painting from about 1300 to 1434 is closely related to the attitudes of the classes in contemporary Florentine society. He explains the rational style of Giotto and Masaccio by the emergence of a progressive upper middle class. The emotional, sentimental, dramatic, and mystical style of some of Giotto's and Masaccio's contemporaries is attributed to the conservative upper middle class and the lower middle class. Antal writes, moreover, that the ideas of these classes were the immediate causes

of the new emerging art. According to him, the fact that a class accepted an art is proof that the class generated it.

Antal's philosophy is basically Marxist, but independent of any political party line. Nevertheless, it reveals an awareness of Marxism's flaws. Marx had asserted incorrectly that the patterns of belief in a society are determined by patterns of ownership of the means of production. Antal was aware that such simple causal relationships are not to be found. He urged investigation of the full historical context of a work of art, not just those aspects considered important for some transient reason.

In his book on Florentine painting Antal describes the link between art and society. He examines the iconography of Florentine painting and produces the first such iconographic study of this art. By examining iconography in the light of the political, economic, and social events of the time as well as literature and science, he raises questions of fundamental importance for a deeper understanding of Florentine art. The book's principal weakness lies in its misunderstanding of the original documentary material, in its oversimplification of certain facts and its selective choice of evidence, and in its failure to present a convincing motivation for the very social changes that Antal considers so vital to the development of Florentine painting. Antal hardly mentions wars and overlooks crises; he might have used these to account for changes in style.

Antal's book, like his two posthumously published volumes, *Fuseli Studies* and *Hogarth and His Place in European Art,* uses the thematic content of art to link the outlook on life with the styles of art works. Of Fuseli he says: "Fuseli's subjective passionate art was a mixture of progressive and reactionary tendencies. Though originating in the newly-founded emotionalism of the middle class, it tended, at the same time, to direct itself to the happy few, to a cultural escapist *elite.* . . ."

Another Hungarian-born art historian writing in England whose work was based on Marxist philosophy is Arnold Hauser (b. 1892). Hauser studied in Budapest, Paris, and Berlin, where his thinking was stimulated by the philosopher Henri Bergson, the literary historian and critic Gustave Lanson, the sociologists Georg Simmel and Max Weber, Warner Sombart, Ernst Troeltsch, and the art historians Adolf Goldschmidt and Heinrich Wölfflin. Like Antal, Hauser was in close communication with Gyorgy Lukács and his Marxist circle in Budapest. After he emigrated to England in 1938, his friend the sociologist Karl Mannheim (1893–1947), author of *Ideologie und*

Utopie, encouraged him to develop his interest in the sociology of art. In 1951 Hauser published *The Social History of Art,* at once the most ambitious and most adversely criticized social art history ever written outside of the communist world. Hauser bases his work on the assumption that rigid, hieratic, and conservative styles are preferred by societies dominated by a landed aristocracy, while elements of naturalism, instability, and subjectivism are likely to reflect the mentality of urban middle class elements. Hence, the geometric style of Egyptian, Greek, and romanesque art reflect the first category, while the naturalism of classical Greek and Gothic art are related to the rise of urban civilizations. Hauser's point of view is exemplified in such statements as ". . . the unification of space and the unified standards of proportion [in Renaissance art] . . . are the creations of the same spirit which makes its way in the organization of labor . . . the credit system and double entry book keeping." Hauser believes in the dialectical character of historical events, and applies the dialectical method without due caution or respect for factual evidence. Moreover, in this book art history becomes a handmaiden of sociology. Hauser views the study of art simply as one of the social sciences.

Hauser's *Philosophie der Kunstgeschichte* takes a social but less specifically Marxist approach to art history. This work deals with the methodology of art history and hence with questions of historical thought. Hauser's thinking is more flexible in this volume than in *The Social History of Art.* In *Philosophie der Kunstgeschichte,* Hauser denies that a complete accord between art and society ever exists, much less an accord between the different arts within the same society. He sees only "correlations, empirically observable links between what goes before and what follows, and such formulations can always be modified or upset; and can never guarantee the recurrence of like effects." Indeed, he observes that "there is nothing that could be called a universal law of the social history of art." No rigid laws governing the relationship between social form and art form can be established. Like Antal in his later writings, Hauser is aware of the flaws in the socially deterministic thinking of Marx. He seems to be advocating what have been identified in this essay as correlational sociological explanations of the arts.

One of the leading twentieth-century Italian art historians with a definite Marxist bent was Ranuccio Bianchi Bandinelli (1900–75), who was a member of the Italian Communist party. In his volume of collected essays on ancient Greek and Roman art, *Storicità dell'arte classica,* Bianchi Bandinelli contends that art can be properly under-

stood only in terms of the culture that generated it: art belongs both materially and spiritually to its age. His philosophic outlook is rooted in the aesthetics of Benedetto Croce. Because Bianchi Bandinelli focused on the role of the artist in the creative process, his thinking was antagnostic to German *Kunstwissenschaft* and the Darwinian determinism of Anglo-Saxon scholars. Nevertheless, his *Storicità* can hardly be labeled Marxist.

In two major interrelated monographs on Roman art, *Roma: L'arte romana nel centro del potere* and *Roma: La fine dell'arte antica*, Bianchi Bandinelli posits a development in Roman republican and imperial art based on a division between plebeian and patrician traditions or currents. He focuses on the plebeian and patrician socioeconomic classes that served as the sources of patronage and alternative political powers. Bianchi Bandinelli's Marxist thinking gives him an acute awareness of the function of class interactions in determining the styles of Roman culture.

For him, Roman art developed as an internal process that can be traced largely within the context of the "Eternal City" of Rome itself, and which is largely independent of the artistic expressions of the provinces of the Empire. Bianchi Bandinelli denies the notion that Roman art should be viewed as a continuous historical process, evolving Etruscan parochialism from as early as the sixth to fifth centuries B.C. The basis of these two books on Roman art rests on Bianchi Bandinell's conviction that the middle class, or plebeians, whose origins go back to Latin stock of the early republic, produced the Roman elements in the art of the republic and empire to the third century A.D. These patrons stand apart from the imperial families and other members of the aristocracy, who were the official source of patronage. Bianchi Bandinelli associates plebeian norms with romanized provincial values in the western provinces, which he believes produced the European art of the city of Rome, as distinguished from the Hellenic forms in Roman art.

Though major Roman art works cast doubt on Bianchi Bandinelli's thesis, his two volumes focus on the large corpus of nonaristocratic art. This work, often of significant value, has been too little examined by modern art historians, who have devoted their scholarly energies to the arts of the highest ranking classes in society. This neglect is to be lamented because, among other reasons, possible sources of the arts created for the upper levels of society are overlooked.

Another leading Italian proponent of Marxist-based art historical analysis is Giulio Carlo Argan (b. 1909). Professor of the history of

art at the University of Rome, editor of the periodical *Storia dell'arte,* and coeditor of *L'Arte,* Argan has written more than twenty-five books. His major works include *Umberto Boccioni; Marcel Breuer, disegno industriale e architettura; Storia dell'arte italiana;* and *Die Kunst des 20. Jahrhunderts, 1880–1940.* Argan regards his own position as predominantly phenomenological, with Marxist tendencies. He does not believe that art works are determined by, rather than determining, the cultural context. When Michelangelo painted the *Last Judgment,* Argan writes, he did not incorporate any specific notions that were current in the Roman curia. Even so, his work is more important than any of the extant theological writings of the time. "A work of art determines social changes just as scientific discoveries do." It may be observed that such thinking by an Italian art historian postdates the Second World War. Until that time Italian art history was indebted heavily to the aesthetics of Croce. Since the war, however, Italian scholars have begun to read not only Marx but also Heidegger and Husserl, and they have dealt with non-Italian art.

In contemporary scholarship and criticism Marxist-inspired writers work not only in Italy but also in other parts of Europe and the United States as well. Marxist art scholars in contemporary Germany include Inge Fleischer, B. Hinz, R. Mattausch, and others, whose *Caspar David Friedrich und die deutsche Nachwelt; Aspekte zum Verhältnis von Mensch und Natur in der bürgerlichen Gesellschaft,* examines the ideological basis of Caspar David Friedrich's reputation in Germany during the nineteenth and twentieth centuries. These writers draw attention to the novelty in Friedrich's works and isolate them from the wider European context. Adolph Menzel, a nineteenth-century German painter, has been evaluated from a Marxist point of view by Werner Schmidt (b. 1902) and Konrad Kaiser (b. 1914) in *Adolf Menzel.*

The English painter, novelist, and art critic John Berger (b. 1926) has written on the visual arts from an independent Marxist point of view, notwithstanding the fact that Frederick Antal was Berger's mentor in questions of method and critical judgment. After beginning his career as a painter and teacher of drawing and exhibiting art in London, Berger began publishing art criticism in various journals. From 1951 to 1961 he was the regular art critic of the *New Statesman* and contributed to Marxist, Communist, and non-Marxist periodicals in England and the United States. Two early books dealt with Communist painters, *Renato Guttuso* and *Fernand Léger.*

In 1960 Berger published *Permanent Red: Essays in Seeing,* which

appeared in the United States in 1962 as *Toward Reality*. This book, an anthology of Berger's articles, reveals his debt to Antal and his independence from Marxism and the Communist party. His essays verge on populism; his emphasis on realism in art is Marxist and he upholds the belief that art should be fundamentally representational. In *The Success and Failure of Picasso,* Berger praises Picasso but admonishes him for failing to realize his potential as a realist. As a critic sympathetic to Marxist realism, Berger disdains formalism in art, just as Antal in his later writings had criticized the formalism of Wölfflin. Though Berger identifies subject matter as the basis of content in art, he never approves of the Soviet doctrine of making naturalism the exclusive and universal style of socialist art. If he had been writing in the Soviet Union, Berger would have been called a revisionist. His recent volumes include *Art and Revolution: Ernst Neizvestny and the Role of the Artist in the U.S.S.R.,* a study on the Soviet sculptor Ernst Neizvestny, and a collection of writings entitled *The Moment of Cubism and Other Essays.* When Berger's contributions to the *New Statesman* ceased in 1961, his influence as an art critic began to wane in England. He has never been important in the United States.

David Kunzle, trained by Gombrich in England, seems to take a Marxist-inspired stance. His most important publication is *The History of the Comic Strip,* which is projected to appear in three volumes. The first volume, *The Early Comic Strip: Narrative Strips and Picture Stories in the European Broadsheet from c. 1450 to 1825,* is primarily a corpus of reproductions of all the broadsheets which are classed by the author as picture stories and thus as antecedents of the modern strip up to 1826. The book is based on research in twenty-three print collections. Kunzle seeks to tie these prints together by means of a historical commentary; his analysis incorporates the techniques of history, art history, literature, folklore, and criminology. Of Hogarth, Kunzle says: "The Hogarthian picture story is the most perfect moral expression of the progressive bourgeoisie in the age of the Enlightenment." He declares that Hogarth condemns society so completely that his works are a call for radical change.

In *The Absolute Bourgeois: Artists and Politics in France, 1848– 1851* and *Image of the People: Gustave Courbet and the Second French Republic 1848–1851,* the English art historian Timothy J. Clark investigates the "actual, complex links which bind together art and politics in this period," and "tries to reconstruct the conditions in which art was, for a time, a disputed, even an effective, part of the historical process." His partially Marxist-inspired social history of

art seeks to interpret "the connecting links between artistic form, the available systems of visual representation, the current theories of art, other ideologies, social classes, and more general historical structures and processes." Unlike previous scholars who viewed art in Paris between 1848 and 1851 as the work of an avant-garde or as a movement away from literary and historical subject matter towards an art of pure sensation, Clark examines it from several perspectives: the dominance of classicism in nineteenth-century art; the progress of individualism in French art, "whether to sanctify the newly dominant classes or to look for a means to subvert their power"; the problem of popular imagery; and what he terms the "withering away of art." Clark strives to illuminate the situational context of the artist and his work. He finds that some works by Millet, Daumier, and Courbet go against the grain of their time in their fusion of traditional forms with obdurate subject matter, and are founded on a particular knowledge of politics. He goes on to say that the work of these artists is not equally political and revolutionary because some of them (e.g., Millet and Baudelaire) took a more or less independent approach to politics.

Although Clark's books cannot be called Marxist, their author belongs to a group of self-proclaimed Marxist historians of French art that meets in Paris once a year to exchange their views. This group is international in background and includes, among others, Michel Melot of Paris, Klaus Herding of Hamburg, Nicos Hadjinicolaou of Greece, and Linda Nochlin of the United States. The group publishes *Histoire et critique des arts* (Paris).

Another Marxist-inspired writing by a member of this group is Nicos Hadjinicolaou's *Art History and Class Struggle*. In this book Hadjinicolaou sets out to describe and demolish "bourgeois art history" and to lay out the framework for a "scientific" (i.e., dialectical materialist) art history. He objects to traditional art history (i.e., art history as a history of artists, as a history of works of art, as part of the history of civilization), because it is itself ideological, in that it fails to recognize picture making as "visual ideology." "Ideology" and "scientific" are central terms in Hadjinicolaou's argument. They are adapted from the work of the French Marxist philosopher Louis Althusser, and, more specifically, from his work *Pour Marx*, in which Althusser holds that ideology is, as it were, the rationalization of the lived experience of a social formation, while science, which is the product of dialectical materialist theory, gives us knowledge of social formations. Hadjinicolaou replaces the term "style" with "vis-

ual ideology." Rather than analyze works of art to any depth, he adduces a work's patrons and commentators to establish its class ideology. For instance, Masaccio's *The Tribute Money* is "Florentine merchant bourgeoisie" and Rembrandt's *Rape of Ganymede* "ideology of the Calvinist or Mennonite Dutch bourgeoisie." Hadjinicolaou's method fails to establish a "scientific" method by describing the actual work. His book is more reminiscent of Antal's work than of an application of Althusserian methodology to art history.

The little book by Hadjinicolaou is far more rigid and programmatic in its outlook than the bulk of writings by this international group of Marxists. More representative of its outlook is the work of the Ulmer Verein. As a group these Marxists claim to have progressed far beyond Antal's and Hauser's simple causal sociological explanations of the arts by acknowledging the complexity of the conditions that shape the genesis of art. Upholding the well-known Marxist tenet that the meaning of art lies in its relationship to its immediate sociopolitical environment, these writers strive to interpret the work of art through the lens of contemporary responses. They tend to present more detailed formal analyses of individual works of art and adduce more pertinent texts to support their points of view than had a Hauser or an Antal. For example, in Clark's article on Manet's *Bar at the Folies-Bergère,* the ambiguities of the surface and space in the canvas are viewed as signs for the class uncertainties of the cafe-concert environment.

In short, Marxist art historians and critics are numerous today, but their books and essays have found no wide acceptance in the profession. Like non-Marxist social historians of art, these writers generally overlook the limitations of sociological explanations; they fail to recognize the impossibility of accounting for stylistic features by simple sociological recipes, the possibility of time lags between stylistic and social changes, and the existence of different stages of development in different artistic media. Their comparisons between social structures and the stylistic characteristics of works of art are too facile: enticing, but on the whole undocumented, and thus incorrect. Contemporary Marxists tend to obstruct rather than to aid our understanding of works of art. As Meyer Schapiro has observed in his article "Style," "the [Marxist] theory has rarely been applied systematically in a true spirit of investigation, such as we see in Marx's economic writings. Marxist writing on art has suffered from schematic and premature formulations and from crude judgments imposed by loyalty to a political line."

This judgment is not to minimize the significant contribution that Marxism and Marxists have made to the discipline of art history; they have opened up new avenues of thought by posing fresh questions about the causes of art. Economic factors have surely played a role in the genesis of many works of art, but they do not constitute the only cause. One is reminded of what the cultural historian Peter Gay has said: "a historical event is always the product of numerous causes, immediate and remote, public and private, patent and concealed" *(Art and Act)*. The same judgment surely applies to works of art.

Althusser, Louis. *Pour Marx*. Paris: F. Maspero, 1965.

Antal, Frederick. *Classicism and Romanticism, with Other Studies in Art History*. New York: Basic Books, 1961. (This volume reprints Antal's five "Reflections on Classicism and Romanticism" articles from *Burlington Magazine* [1935–41].)

————. *Florentine Painting and Its Social Background; the Bourgeois Republic before Cosimo de'Medici's Advent to Power: Fourteenth and Early Fifteenth Centuries*. London: Paul, 1948.

————. *Fuseli Studies*. London: Routledge & Paul, 1956.

————. *Hogarth and His Place in European Art*. London: Routledge & Paul, 1962.

————. "Klassizismus, Romantik und Realismus in der französischen Malerei von der Mitte des XVIII. Jahrhunderts bis zum auftreten Géricault." Ph.D. dissertation, Vienna University, 1914.

Argan, Giulio Carlo. *Die Kunst des 20. Jahrhunderts, 1880–1940*. Vol. 12 in the series *Propyläen Kunstgeschichte*. Berlin: Propyläen-Verlag, 1977.

————. *Marcel Breuer, disegno industriale e architettura*. Milan: Görlich, 1957.

————. *Storia dell'arte italiana*. 3v. Florence: Sansoni, 1968–69.

————. *Umberto Boccioni*. Rome: De Luca, 1953.

Art Front. Ed. by Ben Shahn and Stuart Davis. New York: Artist's Union of New York, 1934–37.

Barr, Alfred Hamilton, Jr. *Cubism and Abstract Art*. New York: Museum of Modern Art, 1936.

Berger, John. *Art and Revolution: Ernst Neizvestny and the Role of the Artist in the U.S.S.R.* London: Weidenfeld & Nicolson, 1969.

————. *Fernand Léger*. Dresden: VEB Verlag der Kunst, 1967.

————. *The Moment of Cubism and Other Essays*. London: Weidenfeld & Nicolson, 1969.

————. *Permanent Red: Essays in Seeing*. London: Methuen, 1960. (Pub. in the United States as *Toward Reality*. New York: Knopf, 1962.)

————. *Renato Guttuso*. Dresden: Verlag der Kunst, 1957.

————. *The Success and Failure of Picasso*. Baltimore: Penguin, 1965.

Bianchi Bandinelli, Ranuccio. *Roma: La fine dell'arte antica*. Milan: Feltrinelli, 1970. *Rome: The Late Empire; Roman Art A.D. 200–400*. Tr. by Peter Green. New York: Braziller, 1971.

————. *Roma: L'arte romana nel centro del potere.* Milan: Feltrinelli, 1969. *Rome, The Center of Power, 500 B.C. to A.D. 200.* Tr. by Peter Green. New York: Braziller, 1970.

————. *Storicità dell'arte classica.* New ed. 2v. Florence: Flecta, 1950.

Brown, Milton Wolf. *The Painting of the French Revolution.* New York: Critics Group, 1938.

Clark, Timothy J. *The Absolute Bourgeois: Artists and Politics in France 1848–1851.* London: Thames & Hudson, 1973.

————. *Image of the People: Gustave Courbet and the Second French Republic 1848–1851.* London: Thames & Hudson, 1973.

————. "Manet's *Bar at the Folies-Bergère.*" In *The Wolf and the Lamb: Popular Culture in France, from the Old Régime to the Twentieth Century,* pp. 233–52. Ed. by Jacques Beauroy et al. Saratoga: Anma Libri, 1977.

Fleischer, I.; B. Hinz; R. Mattausch; et al. *Caspar David Friedrich und die deutsche Nachwelt; Aspekte zum Verhältnis von Mensch und Natur in der bürgerlichen Gesellschaft.* Ed. by W. Hofmann. Frankfurt am Main: Suhrkamp, 1974.

Gay, Peter. *Art and Act: On Causes in History—Manet, Gropius, Mondrian.* New York: Harper & Row, 1976.

Guyau, Jean Marie. *L'Art au point de vue sociologique.* Paris: F. Alcan, 1889.

————. *Les Problèmes de l'esthétique contemporaine.* Paris: F. Alcan, 1884. *Problems of Contemporary Aesthetics.* Tr. by Helen Laurence Mathews. Los Angeles: De Vorss, 1947.

Hadjinicolaou, Nicos. *Histoire de l'art et lutte des classes.* Paris: F. Maspero, 1973. *Art History and Class Struggle.* Tr. by Louise Asmal. London: Pluto Pr., 1978.

Hausenstein, Wilhelm. *Der nackte Mensch in der Kunst aller Zeiten und Völker.* Munich: R. Piper, 1911.

Hauser, Arnold. *Philosophie der Kunstgeschichte.* Munich: Beck, 1958. *The Philosophy of Art History.* New York: Knopf, 1959.

————. *The Social History of Art.* 2v. London: Routledge & Paul, 1951.

————. *The Sociology of Art.* Tr. by Kenneth J. Northcott. Chicago: Univ. of Chicago Pr., 1982.

Hicks, Granville. *The Great Tradition: An Interpretation of American Literature since the Civil War.* New York: Macmillan, 1933.

Histoire et critique des arts. Paris: Association histoire et critique des arts, 1977–.

Hook, Sidney. *From Hegel to Marx: Studies in the Intellectual Development of Karl Marx.* New York: Reynal & Hitchcock, 1936.

————. *Towards the Understanding of Karl Marx: A Revolutionary Interpretation.* New York: John Day, 1933.

Husserl, Edmund. *The Idea of Phenomenology.* Tr. by William P. Alston and George Nakhnikian. The Hague: Nijhoff, 1964.

Kaiser, Konrad. *Adolf Menzel.* Berlin, GDR: Henschelverlag, 1956.

Klingender, Francis Donald. *Animals in Art and Thought to the End of the Middle Ages.* Ed. by Evelyn Antal and John Harthan. London: Routledge & Paul, 1971.

————. *Art and Industrial Revolution.* London: N. Carrington, 1947.

————. *Goya; In the Democratic Tradition.* London: Sidgwick & Jackson, 1948.

————. *Marxism and Modern Art: An Approach to Social Realism.* London: International Publishers, 1945.

Kunzle, David. *The Early Comic Strip: Narrative Strips and Picture Stories in the European Broadsheet from c. 1450 to 1825.* Berkeley: Univ. of California Pr., 1973. (Vol. 1 of projected 3v. series *The History of the Comic Strip.*)

Lifshitz, Mikhail. *The Philosophy of Art of Karl Marx.* New York: Critics Group, 1938.

Mannheim, Karl. *Ideologie und Utopie.* Bonn: F. Cohen, 1929. *Ideology and Utopia: Introduction to the Sociology of Knowledge.* Tr. by Louis Wirth and Edward Shils. New York: Harcourt, Brace, 1936.

Marx, Karl. *A Contribution to the Critique of Political Economy.* Intro. by Maurice Dobb. Tr. by S. W. Ryazanskaya. Ed. Maurice Dobb. New York: International Pubs., 1970. (Originally published as *Zur Kritik der politischen Ökonomie. Erstes Heft.* Berlin: Franz Duncker, 1859.)

————. *Über religiose Kunst* (1842). (For a reconstruction of the main ideas of this lost writing, see Mikhail Lifshitz, *The Philosophy of Art of Karl Marx,* pp. 33–39. Tr. by Ralph B. Winn. London: Pluto Press, 1973.)

Mehring, Franz. *Aus dem literarischen Nachlass von Karl Marx, Friedrich Engels und Ferdinand Lassalle.* 4v. Stuttgart: J. H. W. Dietz Nachf., 1912.

————. *Karl Marx: Geschichte seines Lebens.* Leipzig: Leipziger Buchdruckerei Aktiengesellschaft, 1918.

Plekhanov, Georgi. *Art and Society.* Tr. by Paul S. Leitner, et al. New York: Critics Group, 1936.

Schapiro, Meyer, "From Mozarabic to Romanesque in Silos." *Art Bulletin* 21:312–74 (1939).

————. "Nature of Abstract Art." *Marxist Quarterly* 1:77–98 (1937).

————. "Style." In *Anthropology Today.* Ed. by Alfred Louis Kroeber. Chicago: Univ. of Chicago Pr., 1953.

Schmidt, Werner. *Adolf Menzel, 1815–1905.* Leipzig: E. A. Seemann, 1958.

Taine, Hippolyte. *Philosophie de l'art; leçons professées à l'École des Beaux Arts.* Paris: G. Baillière; New York: Bailliere Bros., 1865.

[Ulmer Verein]. *Kunstgeschichte gegen den Strich gebürstet? 10 Jahre Verein.* Giessen: Anabas-Verlag, 1969.

Werckmeister, Otto Karl. "Review of Meyer Schapiro's *Romanesque Art"* (*Selected Papers, 1;* New York: Braziller, 1977). *Art Quarterly* 2:211–18 (Spring 1979).

CULTURAL HISTORY

When art historians regard the visual arts as a manifestation of culture and interpret them in relation to all human activity and thought, they intrude upon cultural history. If they reconstruct cultural life in a historical period, by analyzing and synthesizing human

institutions, attitudes, motives, and products, they become cultural historians. In the past century, it has sometimes been difficult to separate art history and cultural history, as the two fields have often overlapped.

Cultural history reached a peak in the work of Jacob Burckhardt (1818–97), a Swiss historian and art historian acknowledged as the greatest cultural historian. His *Die Cultur der Renaissance in Italien: Ein Versuch* elevated cultural history to a position of authority among historical genres. Burckhardt marshaled and synthesized a vast amount of historical data pertaining to the Italian Renaissance from 1300 to 1600 and advanced an original interpretation of this period: "The fifteenth century is, above all, that of the many-sided man." His interpretation takes into account social and political institutions, individualism, the revival of antiquity, morality, and religion; the individual is his focal point. The visual arts are virtually ignored in this work. He dealt with them in *Die Zeit Constantin's des Grossen;* in *Der Cicerone: Eine Anleitung zum Genuss der Kunstwerke Italiens,* a 1,000-page guidebook to the art treasures of Italy; and in a subsequent study (with Wilhelm Lúbke) on modern architecture, *Geschichte der neueren Baukunst.*

Because Burckhardt identified the visual arts as the highest of all creative activities, his work attracted art critics and scholars of different nationalities. Renewed interest in the Italian Renaissance during the third quarter of the nineteenth century is exemplified by the art criticism in Hippolyte Taine's (1828–93) *Philosophie de l'art en Italie; leçons professées à l'École des Beaux Arts* and Walter Pater's *Studies in the History of the Renaissance.* In the late nineteenth century, the two most influential interpretations of Italian Renaissance art in the Burckhardt tradition are one volume of John Addington Symonds's (1840–93) seven-volume work, *Renaissance in Italy,* and the three-volume *Histoire de l'art pendant la Renaissance* by the French art historian Eugene Müntz (1845–1902). While Symonds's conception of the Renaissance was directly influenced by Burckhardt, his writing is more recreative art criticism or literature than Burckhardt's objective history. Müntz's views, however, closely approach the cultural perspectives of Burckhardt. His volumes on Renaissance art history, and his monographs on Raphael, Donatello, and Leonardo da Vinci provide what Burkhardt omitted. Müntz's comprehensive work has not been superseded in the twentieth century.

Other studies in the Burckhardt tradition have been more restricted in scope. *Die Gesellschaft der Renaissance in Italien und die*

Kunst by Hubert Janitschek (1846–93) investigates aspects of the Renaissance, such as art patronage, while Karl Justi (1832–1912) deals with artistic biography in the light of the cultural milieu: *Diego Velazquez und sein Jahrhundert*. Burckhardt's thesis of the rise of individualism in the Renaissance led to a wide interest in biography, and Justi and many other art historians and historians of the late nineteenth century avidly pursued this. Thus, Müntz edited *Les Artistes célèbres,* which appeared in fifty-seven volumes between 1886 and 1906. The cultural interpretations of Burckhardt, Janitschek, and Justi were the single most persuasive influence on Aby Warburg, who interpreted art history as cultural history, or *Geisteswissenschaft*. Warburg had studied under Janitschek and Justi and greatly admired Burckhardt. Warburg confined his area of inquiry to the fifteenth century.

Burckhardt created interest in other periods. In the study of the Middle Ages, his heir was the Dutch cultural historian Johan Huizinga (1872–1945). Like Burckhardt, Huizinga identified the visual arts and literature as the main sources for the investigation of humanity's past and emphasized the intellectual and creative rather than the material aspects of civilization. Huizinga differed from Burckhardt in that he refrained from attributing a few dominating ideas to a single culture. His *Herfsttij der Middeleeuwen; Studie over Levens- en Gedachtenvormen der Veertiende en Vijftiende eeuw in Frankrijk en de Nederlanden* regards the fourteenth and fifteenth centuries as the end of the Middle Ages rather than the transition to the Renaissance, and views the art of the brothers Van Eyck and their contemporaries "in connection with the entire life of their times."

One reason why the field of Italian Renaissance art history has been so thoroughly studied in our century is the tenacious survival of the Burckhardt tradition. This field of inquiry has also witnessed the appearance of studies that are far more limited in scope or methodology. Scholars no longer wish to recreate Burckhardt's panorama; time has caused aspirations and points of view to change. Scholars today seldom interpret art as a creation of a national spirit. There are, however, some notable exceptions.

In his explorative and penetrating book *The Formation of Islamic Art,* Oleg Grabar investigates the possible ramifications of sociological, political, economic, historical, psychological, ecological, and archaeological influences upon the early arts of Islam. Seeing new cultural attitudes toward visual expression, rather than a heavy in-

debtedness to the past, Grabar examines these attitudes as manifestations in, for example, the symbolic appropriation of land, doctrines on art, and Islamic monuments with no specifically Islamic function. He concludes that the originality and unity of early Islamic art derive from the new signifying power that its forms acquired.

The economic and cultural historian Georges Duby, in *The Age of Cathedrals: Art and Society, 980–1420,* shows how the re-emergence of the princely state, from a rural economy to an urban one, from a community of lords and serfs to one of citizens—that is, the social, political, and religious upheavals of medieval Europe—occurred and how they were reflected in major works of art, such as the façade sculptures of St. Denis and Chartres Cathedral and the paintings of Giotto and Jan Van Eyck.

Werner Hofmann has investigated the works of Gustav Klimt within their context—the city of Vienna during the Indian summer of the declining Habsburg Empire—and offers an interpretation of the intellectual forces at work in that place at the turn of the century. In *Gustav Klimt und die Wiener Jahrhundertwende* Hofmann treats the problem of the artist in society. He describes Klimt's patronage and how the Viennese upper middle classes tried to lend a sense of elitist style to an emerging democratic society on the basis of a unity of art, society, and culture. Klimt emerges as "the most notable exponent of a concept of art and culture which the bourgeoisie used in a last effort to arrange the way of life of a democratic society on an elite basis." Hofmann suggests that the ornate world view of Vienna at that time was in harmony with the current political policy of white-washing social ills. Like other "stylists" of the Vienna Secession, Klimt held an almost naive belief in a natural and national *Kunstwollen,* a "will-to-form" that encouraged a harmonious interaction of the arts with life. To demonstrate his point of view, Hofmann quotes such critics of the Jugendstil facade as Karl Kraus, editor of *Die Fackel,* and the architect Adolf Loos. In this way Hofmann tries to account for why Klimt craved such an adornment of reality. He defines the underlying philosophical and social impulses that led to this reality.

About a decade after he set up the first teaching department of anthropology in the United States at Columbia University in 1899, German-born Franz Boas (1858–1943) evolved his cultural anthropology, in which he strongly influenced the growing discipline toward a natural historical approach in the examination of native customs. Deductive reasoning and generalization were to be set aside for

painstaking induction from limited bodies of carefully controlled data. Thus he established no general laws of cultural development. Boas's approach continued to World War II at Columbia University and the University of California at Berkeley, where two of his students, Alfred L. Kroeber (1876–1960) and Robert H. Lowie (1883–1957) continued their mentor's positivistic approach. In *Configurations of Culture Growth* and *Style and Civilization* Kroeber explores various cultural achievements in human history and confines himself to theoretical views. Under the influence of Kroeber and Henri Focillon, George Kubler (b. 1912) has researched *Mexican Architecture of the Sixteenth Century* by fusing the techniques of demography and ecology with an analysis of social, economic, and political phenomena. About a decade later, Kubler prepared *The Shape of Time*, his major theoretical treatise on change in the arts. Along with other scholars (e.g., Roy Sieber), these writers have also been responsible for making the tribal arts a legitimate field of inquiry in the discipline of art history.

Oliver W. Larkin's *Art and Life in America*, a history of the cultural and intellectual development of the United States as shown in its works of art, attempts to demonstrate how the arts "have expressed American ways of living and how they have been related to the development of American ideas, particularly the idea of democracy." More perceptive and imaginative is John McCoubrey's *American Tradition in Painting*, which advances the thesis that American "art is possessed by the spaciousness and emptiness of the land itself." His interpretation of the development of American painting would seem to derive largely from the thesis of *Frontier in American History* by Frederick Jackson Turner (1861–1932), a prominent Harvard University historian. In *America as Art* (1976), Joshua C. Taylor (1917–81) and John G. Cawelti examine some of the ways in which certain ideas and attitudes of and about America became inseparable from the art of the country and how in some cases American art reflects salient aspects of America.

In a related study, *Nature and Culture: American Landscape and Painting, 1825–1875*, art historian Barbara Novak has attempted to place American landscape painting from 1825 to 1875 in its cultural context, and to explore that context—philosophical, spiritual, and scientific—in the hope of disclosing what formed and gave sustenance to the art which, in turn, contributed to that context. Rather than a chronological or biographical presentation of painters and oeuvres, or an incisive examination of individual works of art, her

study deals with groups of paintings by interpreting texts by leading American writers—essayists, poets, and critics contemporary with the painters she discusses, for the sake of discovering in those texts a point of view representative of the "mind" of the era. Her method is somewhat reminiscent of Erwin Panofsky's iconology, in that she tries to establish the intellectual context in which painters worked, and thereby the meaning of their landscapes. In her examination of paintings of natural phenomena, such as rocks, plants, and clouds, as bearers of specific meanings, she investigates theories of creation in nineteenth-century America. She finds that landscape painters, geologists and botanists, explorers and clergymen, shared the same objectives. For example, to elucidate the stated aspirations of the artist Frederick Church, she cites the journals of the explorer Alexander von Humboldt.

In short, Novak strives to reconstruct the intellectual and philosophical background of American culture for the purpose of understanding landscape painting in the United States. She probes religion, philosophy, and the history of science. Great stress is laid on texts—journals, periodicals, contemporary letters, and criticism. She proceeds from the assumption that ideas have a life of their own, an assumption that has its origins in twentieth-century structuralism. She also relies on the "American mind" method of historians such as Perry Miller, Henry Nash Smith, and Leo Marx who, writing in the 1950s and 1960s and maintaining that there was *an* American culture in the nineteenth century, assumed that the American mind was more or less a single, definable entity, most clearly evident in the writings of the country's leading thinkers. Fully acknowledging the difficulties that this approach poses, including the generalities that it tends to yield, Novak does not assert that there was a direct cause-and-effect relationship between artists and writers. As for the parallels she discerns between European and American landscapes of the last century, she finds them coincidental; the analogous formal qualities are accounted for by cultures with parallel attitudes. Although her study may be criticized for its lack of specific observations on individual works of art, it presents a bold attempt to relate American painting and ideas in the last century.

Boas, Franz. *The Mind of Primitive Man.* New York: Macmillan, 1911.
Burckhardt, Jacob. *Der Cicerone: Eine Anleitung zum Genuss der Kunstwerke Italiens.* Basel: Schweighauser'sche Verlagsbuchhandlung, 1855.

The Cicerone: An Art Guide to Painting in Italy for the Use of Travellers and Students. Tr. by A. A. Clough. New ed. London: J. Murray, 1879.

―――. *Die Cultur der Renaissance in Italien: Ein Versuch.* Basel: Schweighauser, 1860. *The Civilization of the Renaissance: An Essay.* Tr. by S. G. C. Middlemore. New York: Modern Library, 1954.

―――. *Die Zeit Constantin's des Grossen.* Basel: Schweighauser'sche Verlagsbuchhandlung, 1853.

―――, and Wilhelm Lübke. *Geschichte der neueren Baukunst.* Stuttgart: Ebner & Seubert, 1868.

Duby, Georges. *The Age of Cathedrals: Art and Society, 980–1420.* Tr. by Eleanor Levieux and Barbara Thompson. Chicago: Univ. of Chicago Pr., 1981.

Grabar, Oleg. *The Formation of Islamic Art.* New Haven, Conn.: Yale Univ. Pr., 1973.

Hofmann, Werner. *Gustav Klimt und die Wiener Jahrhundertwende.* Salzburg: Verlag Galetie Welz, 1970. *Gustav Klimt.* Tr. by Inge Goodwin. Greenwich, Conn.: New York Graphic Soc., 1972.

Huizinga, Johan. *Herfsttij der Middleeuwen; Studie over Levens- en Gedachtenvormen der Veertiende en Vijftiende eeuw in Frankrijk en de Nederlanden.* Haarlem: H. D. Tjeenk Willink, 1919. *The Waning of the Middle Ages, a Study of the Forms of Life, Thought, and Art in France and the Netherlands in the XIVth and XVth Centuries.* Tr. by F. Heiman. London: E. Arnold, 1924.

Janitschek, Hubert. *Die Gesellschaft der Renaissance in Italien und die Kunst.* Stuttgart: W. Spemann, 1879.

Justi, Karl. *Diego Velasquez und sein Jahrhundert.* Bonn: M. Cohen, 1888. *Diego Velazquez and His Times.* Tr. by A. H. Keane. Philadelphia: Lippincott, 1889.

Krautheimer, Richard. *Rome: Profile of a City, 312–1308.* Princeton, N.J.: Princeton Univ. Pr., 1980.

Kroeber, Alfred Louis. *Configurations of Culture Growth.* Berkeley and Los Angeles: Univ. of California Pr., 1944.

―――. *Style and Civilization.* Ithaca, N.Y.: Cornell Univ. Pr., 1957.

Kubler, George. *Mexican Architecture of the Sixteenth Century.* 2v. New Haven, Conn.: Yale Univ. Pr., 1948.

―――. *The Shape of Time: Remarks on the History of Things.* New Haven, Conn.: Yale Univ. Pr., 1962.

Larkin, Oliver W. *Art and Life in America.* New York: Rinehart, 1949.

McCoubrey, John. *American Tradition in Painting.* New York: Braziller, 1963.

Müntz, Eugene. *Donatello.* Paris: Librairie de l'art, 1885.

―――. *Histoire de l'art pendant la Renaissance.* 3v. Paris: Hachette, 1889–95.

―――. *Léonard da Vinci, l'artiste, le penseur, le savant.* Paris: Hachette, 1899. *Leonardo da Vinci: Artist, Thinker, and Man of Science.* 2v. London: Heinemann, 1898.

―――. *Raphaël, biographie critique.* Paris: H. Laurens [1881]. *Raphael: His Life, Works and Time.* Tr. by Walter Armsbry. London: Chapman & Hall, 1882.

————, ed. *Les Artistes célèbres*. 57v. Paris: Librairie de l'art, 1886–1906.

Novak, Barbara. *Nature and Culture: American Landscape and Painting, 1825–1875*. New York: Oxford Univ. Pr., 1980.

Pater, Walter. *Studies in the History of the Renaissance*. London: Macmillan, 1873.

Sieber, Roy. *African Furniture and Household Objects*. Bloomington: Indiana Univ. Pr., 1980.

————. *African Textiles and Decorative Arts*. New York: Museum of Modern Art; distrib. by New York Graphic Soc., 1977.

Symonds, John Addington. *Renaissance in Italy*. 7v. London: Smith, Elder, 1875–86.

Taine, Hippolyte. *Philosophie de l'art en Italie; leçons profesées à l'École des Beaux Arts*. Paris: G. Baillière; New York: Baillière Brothers, 1866.

Taylor, Joshua C. and John G. Cawelti. *America as Art*. Washington, D.C.: Smithsonian Inst. Pr., for the National Collection of Fine Arts, 1976.

Turner, Frederick Jackson. *Frontier in American History*. New York: Holt, 1920.

GEISTESGESCHICHTE

Max Dvořák (1874–1921), the Czech successor in Vienna to Alois Riegl, was the first art historian to establish *Geistesgeschichte* as a branch of study in his discipline. Author of fundamental studies on the arts of early Christianity, the Middle Ages, the Van Eyck brothers, and mannerism, Dvořák interpreted the history of art as *Geistesgeschichte* in his major work, "Idealismus und Naturalismus in der gotischen Skulptur und Malerei," written between 1915 and 1917 and published in 1918. This essay followed Dvořák's research on the Van Eyck brothers and their respective shares in the execution of the Ghent Altarpiece. In "Das Rätsel der Kunst der Brüder Van Eyck" Dvořák places the art of the Van Eycks within a larger context and shows a continuous evolutionary development from the Early Renaissance to impressionism. He contends that greater naturalism was achieved from about 1400 to the later nineteenth century owing to ever-increasing technical skill and the assimilation of the formal values of Italian trecento art into Northern manuscript illumination about 1400.

In the second decade of this century, Dvořák began to reformulate his thinking. To him, World War I portended the demise of materialistic culture and naturalism in painting. He predicted that from it would emerge a new spiritualism, typified by the expressionism of Oskar Kokoschka. His scholarly thought expanded to include idealism; that is, the expressive spiritual qualities that lend shape to the creative process. In "Idealismus und Naturalismus," he proceeds

from analogies drawn between the visual arts of the Gothic age and other contemporary phenomena, and finds the basis of the arts in the *Weltanschauung* of medieval Christianity that lies beyond material experience. Gothic painting and sculpture thus reflect a purely spiritual and transcendental global outlook. Rather than explain the arts as causally determined by events in the development of new economic, social, or religious thought, and maintaining that the spiritual qualities of medieval art cannot be extrapolated from the writings of the major theologians of the period, Dvorák finds parallels between the visual arts and these other phenomena. Gothic art and Gothic philosophy, for example, are not caused by each other, but are the product of the total framework of a global outlook. For Dvorák, Gothic art both derives from and reflects the outlook. The brilliance of this interpretive study resulted from Dvorák's training in cultural and intellectual history and in medieval theology.

Dvorák lectured in Vienna and his papers gave him a position of great authority in European art history, a position rivaled only by that of Heinrich Wölfflin in Germany. Dvorák's work has had little influence in the United States because it cannot be easily translated. With Dvorák's example guiding their work, many art historians, especially those in Vienna and East Europe, looked for analogies between the visual arts and other expressions of thought. They proceeded from the assumption that discoverable relationships must exist among contemporary works of art on the one hand, and literature, music, philosophy, religion, science, economics, and other branches of human endeavor, on the other. Some of them produced nothing more concrete than an "intuitive morphology." Examples include Richard Hamann's (1879–1961) *Der Impressionismus in Leben und Kunst* and Wilhelm Hausenstein's (1882–1957) *Vom Geist des Barock*. Herman Nohl's (1879–1960) *Die Weltanschauungen der Malerei* is more successful. Nohl applies Dilthey's types of *Weltanschauung* to music and painting and adopts a physiognomic theory of art history in which the *Weltanschauungen* of works of art can be read directly from them.

Other scholars have arrived at interpretations of art history either as *Geistesgeschichte* or viewed in terms of the prevailing *Weltanschauung* of a period or culture. Frederick Antal and Arnold Hauser wrote social histories of the arts; both studied under Dvorák in Vienna, but their contributions are often distinguished from those of their mentor by their interaction of Marxism and *Geistesgeschichte*. Dvorák's point of view is reflected primarily in Hauser's *Der Manier-*

ismus: Die Krise der Renaissance und der Ursprung der modernen Kunst. Dealing with mannerism (the subject of a lecture that Dvořák delivered in 1920), Hauser postulates a coherence and unity of the experience of a given period. From this experience he tries to extrapolate the attitudes that can be seen in its art forms. The noted Rembrandt scholar Otto Benesch (1896–1964), who also studied under Dvořák, has endeavored to follow up his teacher's interpretation of art history. Dagobert Frey (1883–1962), another pupil of Dvořák, has also interpreted art history as cultural and intellectual history. Werner Weisbach (1873–1953) sees baroque art as *Geistesgeschichte* in *Der Barock als Kunst der Gegenreformation.* Weisbach has written that Romanesque art represents "the ideas, concepts and precepts which were *leitmotifs* of the reform" of the Cluniac order and related movements. Robert Hedicke's *Methodenlehre der Kunstgeschichte* attempts to formulate a concrete art historical methodology under the influence of Dvořák's thought.

Dvořák's influence is also seen in studies by Erwin Rosenthal (b. 1889) and Georg Weise. Sir Nikolaus Pevsner's "The Architecture of Mannerism" seeks parallels between the formal and emotional character of several sixteenth-century Italian buildings and contemporary "thought and feeling." Pevsner's interpretation appears to have been inspired by Dvořák and Wilhelm Pinder. Another recent examination of mannerist art, Gustav René Hocke's *Die Welt als Labyrinth: Manier und Manie in der europäischen Kunst,* attempts to document analogies (*Ur-Ausdruckszwänge,* or basic underlying modes of artistic expression) between sixteenth-century Italian painting and twentieth-century dada and surrealism. Dvořák's *Geistesgeschichte* has also influenced the art critic, art historian, essayist, and novelist Josef Paul Hodin (b. 1905). Hodin, a native of Prague and English by adoption, has focused on expressionist painting (which is ignored in Hocke's book), especially that of contemporary artists such as Munch and Kokoschka, with whom he made direct personal contact. Hodin bases his search for the philosophical meaning of the art work on a *Weltanschauung,* a global point of view shaped by the writings of Goethe, and on his interviews with living major artists and with Karl Jaspers (1883–1969) and Carl Gustav Jung.

The Norwegian scholar Hans Peter L'Orange (b. 1903) has made an interpretation of art works that is analogous to Dvořák's in *Fra Principat til Dominat.* L'Orange seeks to relate the salient formal qualities of the architecture and sculpture of the tetrarchy to the social and intellectual tenor of the age. He identifies parallel patterns

of strict regularity and symmetry, uniformity and immobility in both the arts and the social structure of this time, and finds that the parallelisms point to the "spiritual mentality of the period," the causes of which he leaves unexplained. While he seems to allude to a "time-spirit" or *Zeitgeist,* he avoids the temptation to uncover principles or laws in the anecdotal parallelisms he has described.

Benesch, Otto. *Artistic and Intellectual Trends from Rubens to Daumier as Shown in Book Illustration.* Cambridge, Mass.: Dept. of Printing and Graphic Arts, Harvard College Lib., 1943.

──────. *The Art of the Renaissance in Northern Europe: Its Relation to the Contemporary Spiritual and Intellectual Movements.* Cambridge, Mass.: Harvard Univ. Pr., 1945.

Dvořák, Max. "Idealismus und Naturalismus in der gotischen Skulptur und Malerei." *Historische Zeitschrift* 119:1–62, 185–246 (1918). Also published in *Kunstgeschichte als Geistesgeschichte; Studien zur abendländischen Kunstentwicklung.* Ed. by Karl Maria Swoboda and Julius Wilde. Munich: R. Piper, 1924.

──────. "Das Rätsel der Kunst der Brüder Van Eyck." *Jahrbuch der Kunsthistorischen Sammlungen des Allerhöchsten Kaiserhauses* 24:161–317 (1904).

Frey, Dagobert. *Gotik und Renaissance als Grundlagen der modernen Weltanschauung.* Augsburg: B. Filser, 1929.

Hamann, Richard. *Der Impressionismus in Leben und Kunst.* 2d ed. Marburg: Verlag des Kunstgeschichtlichen Seminars, 1923.

Hausenstein, Wilhelm. *Vom Geist des Barock.* Munich: Piper, 1920.

Hauser, Arnold. *Der Manierismus: Die Krise der Renaissance und der Ursprung der modernen Kunst.* Munich: Beck, 1964. *Mannerism: The Crisis of the Renaissance and the Origin of Modern Art.* 2v. Tr. by Eric Mosbecher. London: Routledge & Paul, 1965; New York: Knopf, 1965.

Hedicke, Robert. *Methodenlehre der Kunstgeschichte.* Strasbourg: Heitz, 1924.

Hocke, Gustav René. *Die Welt als Labyrinth: Manier und Manie in der europäischen Kunst.* Hamburg: Rowohlt, 1957.

Hodin, Josef Paul. *Edvard Munch, Nordensgenius.* Stockholm: Ljus, 1948.

──────. *Modern Art and the Modern Mind.* Cleveland and London: Pr. of Case Western Reserve Univ., 1972.

──────. *Oskar Kokoschka, the Artist and His Time; A Biographical Study.* Greenwich, Conn.: New York Graphic Soc., 1966.

L'Orange, Hans Peter. *Fra Principat til Dominat.* Oslo: H. Aschehoug, 1958. *Art Forms and Civic Life in the Late Roman Empire.* Tr. by Dr. and Mrs. Kunt Berg. Princeton, N.J.: Princeton Univ. Pr., 1965.

Nohl, Herman. *Die Weltanschauungen der Malerei.* Leipzig: Wigand, 1908.

Pevsner, Sir Nikolaus. "The Architecture of Mannerism." *The Mint: A Miscellany of Literature, Art and Criticism* 1:116–38 (1946).

Rosenthal, Erwin. *The Changing Concept of Reality in Art.* New York: Wittenborn, 1962.

————. *Contemporary Art in the Light of History*. London: Lund Humphries, 1971.

————. *Giotto in der mittelalterlichen Geistesentwicklung*. Augsburg: B. Filser, 1924.

Weisbach, Werner. *Der Barock als Kunst der Gegenreformation*. Berlin: P. Cassirer, 1921.

————. *Religiöse Reform und mittelalterliche Kunst*. Zurich: Benziger, 1945.

Weise, Georg. *Die geistige Welt der Gotik und ihre Bedeutung für Italien*. Halle: Salle, M. Niemeyer, 1939.

ALTERNATIVE INTELLECTUAL APPROACHES

The relation between art and ideas can be understood in many ways. Art can be interpreted as "ideas" contained in forms; it can be analyzed to produce "leading ideas." Writers interested in such relations treat art as a document in the history of ideas, for art history parallels and reflects intellectual history. Sometimes either direct statements or allusions show the allegiance of an artist to a specific philosophy, establish that he or she has had some direct acquaintance with philosophies once well known, or at least that he or she is familiar with their general assumptions. While more common in the study of literature than of art, this approach is basically a specific approach to the general history of thought and artistic creativity, employing art only as document and illustration. While it cannot aspire to a full comprehension of the uniqueness of a work of art and its connections with other art works, artists, and general creative developments, it certainly helps to place the work of art more firmly in the crucible of the ideas in which it was generated. Thus its exegetic value cannot be overestimated.

In his *Painting and Reality*, Étienne Gilson (1884–1978), the philosopher and historian, tries to establish the relation between painting and the realm of being, to ground painting in reality. In order to develop his thesis that painting seeks to add new beings to those already found in nature—and not merely to represent them—he distinguishes painting from the art of picturing. For Gilson, "a painting has its own rules, its own justification within itself. A picture has its criterion outside itself, in the external reality it imitates." Picturing, unlike painting, merely produces images of actual or possible beings—but not of new beings. Whatever the importance of pictures, he concludes, they do not belong to the art of painting. This

distinction allows Gilson to account for the development of modern painting, including abstract painting.

Erwin Panofsky was, among other things, interested in the Renaissance as a static concept of style. In his fundamental paper, "Renaissance and Renascences," Panofsky sees a new historical consciousness, a trend toward individualism, an increasing preoccupation with a scientific approach to nature, and a dissolution of the compartmentalization characteristic of the later Middle Ages in the art and thought of the Italian Renaissance as early as the first half of the fourteenth century. In the Renaissance, he finds a reintegration of classical form and content that was "total and permanent." These qualities, Panofsky writes, distinguish the Renaissance from the Carolingian age and the twelfth century, which were marked by renascences that lacked a total and enduring reintegration of form and content. In other words, Panofsky affirmed Burckhardt's distinction between the Renaissance and the Middle Ages; this traditional view is widely accepted by art historians today.

In *Gothic Architecture and Scholasticism,* Panofsky examines the problem of the parallelisms between Gothic architecture and scholasticism. He investigates the alleged interdependence in far greater depth than previous scholars and concludes that the step-by-step development of scholastic thinking is integrally correlated with the step-by-step development of Gothic cathedrals built in the Île-de-France between about 1130 and 1270. Panofsky seeks to demonstrate that "at least some of the French thirteenth-century architects did think and act in strictly scholastic terms" and assimilated the "controlling principles" (identified as *manifestatio* and *concordantia*) and methods of procedure of scholasticism and then expressed these principles and methods in the style and structure of their buildings. Panofsky shows a "genuine cause and effect" relationship rather than parallelism or coincidental simultaneity.

Gerhart Ladner's *Ad Imaginem Dei: The Image of Man in Mediaeval Art* employs the same essential method of investigation. Ladner (b. 1905) writes that the Christian doctrine of man's image-likeness with God, as interpreted by medieval theologians, may be reflected in the representation of man in medieval sculpture and painting from the third and fourth centuries A.D. to the High Gothic period. Fully aware that "a direct causal nexus between such theological views and the practice of art cannot be established," Ladner contends "that these views and their vicissitudes represent attitudes of the mind

which among other things nourished the conception of the human image which can be perceived in the works of art themselves." A related interpretation of the history of the image of God incarnate and of the individual in medieval Christianity appears in Wolfgang Schöne's "Die Bildgeschichte der christlichen Gottesgestalten in der abendländischen Kunst."

The French scholar André Chastel (b. 1912) has written several studies of the relation of intellectual history to the visual arts in the Italian Renaissance. *Marsile Ficin et l'art* examines the relationship between the art and the philosophical movements of the age, especially the neoplatonism of Marsilio Ficino. Chastel's *Art et humanisme à Florence au temps de Laurent le Magnifique; études sur la renaissance et l'humanisme platonicien* interprets Florentine art and ideas in the generation 1470–1500 in the light of the intellectual events of the time. Chastel adopts Henri Focillon's motto that "the history of art is the history of the human spirit through forms."

In "The Renaissance Concept of Artistic Progress and Its Consequences," Sir Ernst H. Gombrich describes the Renaissance concept of artistic progress and its effect on artists. At that time, Gombrich writes, "the artist had not only to think of his commission but of his mission . . . this mission was to add to the glory of the age through the progress of art." Gombrich shows how this idea penetrated into the very fabric of individual artists' works. He has expanded his theories in *The Ideas of Progress and Their Impact on Art*.

Historian Hugh Trevor-Roper (b. 1914) describes the art patronage of the Hapsburg courts and the history of ideas in *Princes and Artists: Patronage and Ideology at Four Hapsburg Courts, 1517–1633*. Believing that four successive courts vividly illustrate the distinct phases of the great ideological crisis of the time, Trevor-Roper tries to show that each of the four rulers reflects the changing European *Weltanschauung* by the pattern of his patronage. He declares that "the artists whom these rulers patronised reflect these changing attitudes; and a consideration of those artists and that patronage, in their historical context, may . . . illustrate a crisis of society and a chapter in the history of ideas." Some of the ideas represented in works commissioned by these patrons were the dream of universal empire, the glory of a particular dynasty, the crusade for religious unity, military triumph against the infidel, and the presentation of European peace.

In his inquiry into the naturalism of seventeenth-century art, James S. Ackerman finds no exact parallels between the visual arts and the

scientific revolution of Galileo, Descartes, and Kepler. Painting was not responsive, as literature was, to scientific images of nature. The cultural unity of the seventeenth century, Ackerman writes, was "due less to the influence of scientific discovery on the artist than to the influence of aesthetic and ethical traditions on the scientist."

Charles de Tolnay (b. 1899), on the other hand, has interpreted some works by Pieter Bruegel the Elder as evidence of a pantheistic monism like that of Cusanus or Paracelsus. Although it contains valuable insights, de Tolnay's study has not been widely accepted. Studies by Rudolf Wittkower examine the relations between the visual arts and the concepts of individualism, genius, and loneliness. Donald Drew Egbert has investigated "The Idea of Organic Expression and American Architecture" and found that the "idea of organic expression as a philosophical and scientific doctrine has significant implications for the history of American architecture as well as of American life in general . . . and this despite the fact that it is primarily a biological concept, naturalistic in tendency, whose complete validity for art has justly been questioned, especially by those critics whose philosophy of art has either a humanistic or a supernaturalistic basis."

The idea of the avant-garde, one of the most popular concepts discussed by critics of contemporary art, has been investigated by art scholars including Donald Drew Egbert and Horst W. Janson. In a monograph on Manet, Anne Coffin Hanson writes that Manet was the modern artist par excellence of his time. Hanson says that Manet's contemporaries were urging an art for the modern world and shows how Manet tried to assimilate these views in his work.

The architectural historian Peter Collins investigates American and European buildings of the past two centuries in terms of the history of ideas in his *Changing Ideals in Modern Architecture, 1750–1950.* He tells what revivalism, rationalism, eclecticism, and functionalism meant to the architects who followed these styles, and describes how different ideas of the arts and sciences influenced architectural theory.

Ackerman, James S. "Science and Visual Art." In Stephen Toulmin et al. *Seventeenth Century Science and Arts.* Ed. by Hedley H. Rhys. Princeton, N.J.: Princeton Univ. Pr., 1961.

Bazin, Germain. *Histoire de l'avant-garde en peinture de XIIIe au XXe siècle.* Paris: Hathette, 1969. *The Avant-Garde in Painting.* Tr. by Simon Watson Taylor. New York: Simon & Schuster, 1969.

Chastel, André. *Art et humanisme à Florence au temps de Laurent le Magni-*

fique; études sur la renaissance et l'humanisme platonicien. Paris: Pr. Univ. de France, 1959.

———. *Marsile Ficin et l'art.* Geneva: E. Droz, 1954.

Collins, Peter. *Changing Ideals in Modern Architecture, 1750–1950.* Montreal: McGill Univ. Pr., 1965.

Egbert, Donald Drew. "The Idea of 'Avant-garde' in Art and Politics." *American Historical Review* 73:339–66 (1967).

———. "The Idea of Organic Expression and American Architecture." In *Evolutionary Thought in America.* Ed. by Stow Persons. New Haven, Conn.: Yale Univ. Pr., 1950.

Gilson, Etienne. *Painting and Reality.* New York: Pantheon, 1957.

Gombrich, Sir Ernst H. *The Ideas of Progress and Their Impact on Art.* New York: Cooper Union School of Art and Architecture, 1971.

———. "The Renaissance Concept of Artistic Progress and Its Consequences." In *Actes du XVIIme Congrès International d'Histoire de l'Art.* The Hague: 1955. Reprinted in Sir Ernst H. Gombrich. *Norm and Form: Studies in the Art of the Renaissance.* London: Phaidon, 1966.

Hanson, Anne Coffin. *Manet and the Modern Tradition.* New Haven, Conn. and London: Yale Univ. Pr., 1977.

Janson, Horst W. "The Myth of the Avant-Garde" in *Art Studies for an Editor: 25 Essays in Memory of Milton S. Fox,* pp. 167–75. New York: Abrams, 1975.

Ladner, Gerhart. *Ad Imaginem Dei: The Image of Man in Mediaeval Art.* Latrobe, Pa.: Archabbey Pr., 1965.

Lovejoy, A. O. *The Great Chain of Being; A Study in the History of an Idea.* Cambridge, Mass.: Harvard Univ. Pr., 1936.

Panofsky, Erwin. *Gothic Architecture and Scholasticism.* Latrobe, Pa.: Archabbey Pr., 1951.

———. "Renaissance and Renascences." *Kenyon Review* 6:201–36 (1944).

———. *Renaissance and Renascences in Western Art.* 2d ed. Stockholm: Almquist & Wiksell, 1965.

Poggioli, Renato. *Teoria dell'arte d'avanguardia.* Bologna: Il Mulino, 1962. *The Theory of the Avant-Garde.* Tr. by Gerald Fitzgerald. Cambridge, Mass.: Harvard Univ. Pr., 1968.

Schöne, Wolfgang. "Die Bildgeschichte der christlichen Gottesgestalten in der abendländischen Kunst." In Wolfgang Schöne, et al. *Das Gottesbild im Abendland.* Witten: Eckart-Verlag, 1959.

Tolnay, Charles de. *Pierre Bruegel l'ancien.* 2v. Brussels: Nouvelle société d'éditions, 1935.

Trevor-Roper, Hugh. *Princes and Artists: Patronage and Ideology at Four Hapsburg Courts, 1517–1633.* New York: Harper & Row, 1976.

Wittkower, Rudolf. *The Artist and the Liberal Arts.* London: H. K. Lewis, 1952.

———. "Individualism in Art and Artists." *Journal of the History of Ideas* 22:291–302 (1961).

———, and Margot Wittkower. *Born under Saturn: The Character and Conduct of Artists.* London: Weidenfeld & Nicolson, 1963.

PART II

REFERENCE WORKS

General Works

ABSTRACTS AND INDEXES

The Architectural Index. Boulder, Colo., 1950– .
Annual subject index to ten architectural periodicals.

Architectural Periodicals Index. London: Royal Institute of British Architects, 1973– .
Annual subject index to architectural periodical literature. About one-third of the several hundred periodicals indexed are British; the others are published in Europe, Asia, and the Americas. All titles are indexed in English; the language of each article and the nature of its illustrations are indicated. There is an index of authors and architects.

Art and Archaeology Technical Abstracts. New York: Institute of Fine Arts, New York Univ., 1955– . v.1– .
This publication first appeared under the title *Studies in Conservation* and then as *IIC Abstracts*. It is sponsored by the International Institute for Conservation of Historic and Artistic Works. The series is now published semiannually; the second issue contains a cumulative index for the year. The works summarized are of international provenance and include articles, books, news items, and reports that deal with preservation, restoration, analysis, and documentation of artistic and/or historic works. Each issue is divided into sections on specific materials, such as paper, fibers, and glass and a section on general methods and techniques. Many of the abstracts are initialed. Translations of titles not in English are provided, as well as the original titles.

Art Index. New York: H. W. Wilson, 1929– .
Author and subject index to domestic and foreign museum bulletins and art periodicals with bibliographical information on archaeology, architecture, art history, arts and crafts, city planning, fine arts, graphic arts, industrial design, interior design, landscape design, photography and film, and related fields.

Art/Kunst. International Bibliography of Art Books. Basel: Helbing & Lichtenhahn, 1972– .
Annual international list of published works on art. Works are listed alphabetically by author or editor under subject, chronological, and form divisions. Catalogs and guides are listed separately. Brief annotations are frequently provided. Prices are noted when known. Prefatory material and

headings appear in English, French, and German. A personal name index is included.

Chicago. Art Institute. Ryerson Library. *Index to Art Periodicals*. Boston: G. K. Hall, 1962. 11v.
————.————. First Supplement. 1975.
Art indexing at the Ryerson Library began in 1907; this set lists much periodical material that antedates and/or supplements the *Art Index*. Materials are grouped by subject.

Clapp, Jane. *Sculpture Index*. Metuchen, N.J.: Scarecrow Pr., 1970– .
Guide to pictures of sculpture in about 950 publications. Volume 1 covers the sculpture of Europe and the contemporary Middle East; volume 2 covers the sculpture of the Americas, the Orient, Africa, the Pacific Area, and the classical world.
The index covers three-dimensional works in a variety of materials and three-dimensional portraits, architectural elements, furniture, and decorative and utilitarian objects. It lists sculptors, locations, titles of works, and subjects.
Sculptures are listed by artist, title, and subject. For each listed work, the following information is normally given: artist, original location, material dimensions, locations, and reproductions in books.

Columbia University Libraries. Avery Architectural Library. *Avery Index to Architectural Periodicals*. Boston: G. K. Hall, 1963. 12v.
————.————. Supplements. 1965, 1966, 1967, 1968, 1970.
Reproduces, in one alphabetical order, the author, subject, and title cards for the periodical articles indexed by the Avery Library. The periodicals included are those with articles written in the roman alphabet or with summaries in English. The subject scope includes archaeology, decorative arts and interior design, furniture, landscape architecture, and urban planning and housing.

Havlice, Patricia Pate. *World Painting Index*. Metuchen, N.J.: Scarecrow, 1977. 2v. 2,130p.
A three-part index consisting of a bibliography of 1,161 books and catalogs published between 1940 and early 1975; an index of paintings by unknown artists arranged by title; and an index of painters and their works. The numbered code following the entries in each index refers the reader to the bibliography citation that contains an illustration of the work. Includes works in oil, tempera, gouache, acrylic, fresco, pastel, watercolor, and collage.

RILA (Répertoire International de la Littérature de l'Art). *International Repertory of the Literature of Art*. n.p.: College Art Assn. of America, 1975– .
Sponsored by several international organizations, RILA is a guide to the literature on post-classical European and on post-Columbian American art.

Each issue is divided into two sections. The first contains abstracts cited alphabetically by author under a number of form, period, and subject headings. Books, periodical and newspaper articles, Festschriften, congress reports, exhibition catalogs, museum publications, and dissertations are included. The second section is an author-subject index. When the subject is an artist, dates, nationality, and medium are given.

BIBLIOGRAPHY

Arntzen, Etta, and Robert Rainwater. *Guide to the Literature of Art History.* Chicago: American Library Assn.; London: Art Book Co., 1980. 616p.

Describes and evaluates resources for graduate students and art historians. The emphasis is on books that will give background to advanced researchers.

Chapters on art history in general cover bibliography, directories, sales records, visual resources, dictionaries and encyclopedias, iconography, historiography, sources and documents, and histories and handbooks. Individual chapters treat books on architecture, sculpture, drawing, painting, prints, photography, and decorative and applied arts; the books are arranged by forms of works about them and by geographic and chronological subdivisions. Descriptions of periodicals and series are included.

Besterman, Theodore. *Art and Architecture: A Bibliography of Bibliographies.* Totowa, N.J.: Rowman & Littlefield, 1971. 216p.

Contains major sections for art, archaeology, architecture, towns and town planning, ceramics, painting, posters, cinematography, and special subjects. Within each of these are geographic, form, chronological, and/or subject divisions. Within each subdivision, the arrangement is chronological by the date of publication. The author does not provide extensive annotations, but notes the number of items included in each bibliography and provides some explanatory comments regarding titles, series, and editions.

Bibliographic Guide to Art and Architecture, 1975– . Boston: G. K. Hall, 1976–.

Annual supplement to the *Dictionary Catalog of the Art and Architecture Division* of the Research Libraries of the New York Public Library; provides an international, computer-produced listing of items relating to art and architecture cataloged by the library during the year. Materials are listed by author, title, and subject in a single alphabet and include monographs, serials, and nonbook resources on the visual, plastic, and decorative arts, as well as printmaking and engraving, art history and criticism, and city planning.

Columbia University Libraries. Avery Architectural Library. *Catalog of the Avery Memorial Architectural Library of Columbia University.* 2nd ed., enl. Boston: G. K. Hall, 1968. 19v.
———.———. First Supplement. 1972. 4v.

Reproduces, in one alphabetical order, the author, subject, and selective title cards for all the art and architecture books in the Columbia University Library system. Also catalogs roughly 10,000 original drawings in the Avery

Library. The supplement lists works acquired since the second edition of the main set was published.

Dove, Jack. *Fine Arts*. London: Clive Bingley, 1966. 88p.
A series of bibliographic essays that present an introductory survey of major works in the fine arts. The ten chapters treat general works, history of art, painters and painting, sculpture, architecture, glass, ceramics, and furniture, miscellanea, costume and stage design, crafts, and museums and galleries. Author-title and subject indexes are included.

Ehresmann, Donald L. *Fine Arts: A Bibliographic Guide to Basic Reference Works, Histories, and Handbooks*. Littleton, Colo.: Libraries Unlimited, 1975. 283p.
Bibliography cites and annotates over 1,100 works on art history of interest to the general reader, beginning students, and advanced students. The first part covers reference tools and the second histories and handbooks. Works published since 1958 are emphasized, since earlier publications are listed in other bibliographies. The listings are divided by geography, period, and form. An appendix lists and extracts those books most appropriate for small and moderate-sized libraries. Includes author-title and subject indexes.

Freer Gallery of Art. Smithsonian Institution. *Dictionary Catalog of the Library*. Boston: G. K. Hall, 1967. 6v.
Reproduces the cards from the Freer Gallery collection of Oriental, Near Eastern, and nineteenth-century American art. The author, subject, and title cards are divided into two sections, each with one integrated alphabetical listing. The first section comprises books in Western languages and the second those in Chinese and Japanese.

Goldman, Bernard. *Reading and Writing in the Arts. A Handbook*. Detroit: Wayne State Univ. Pr., 1972. 163p.
Guide to selected bibliographies and other basic tools and methods used in art history and related disciplines. Intended for the general public and beginning and advanced students. The volume consists primarily of annotated citations of reference books and periodicals arranged by form and subjects. There are chapters on dictionaries, catalogs, iconography, and so forth. English-language works are emphasized; foreign titles are included when nothing of the same type and caliber has been published in English. An alphabetical index or reference key by subject precedes the annotated bibliography. The volume concludes with essays on writing research papers; on library, museum, and art history literature; and on writing for publication.

Hall, Robert de Zouche. *A Bibliography on Vernacular Architecture*. Newton Abbot, Devon: David & Charles, 1972. 191p.
Unannotated bibliography of books and articles on the vernacular architecture of the British Isles. (Vernacular architecture develops naturally in a region without attention to national or international style and without professional designers.) The bibliography is divided into chapters on types of

buildings, construction and materials, regional and local studies, and economic and social background; it is further subdivided geographically and chronologically. There is an author index.

Harvard University Graduate School of Design. *Catalog of the Library.* Boston: G. K. Hall, 1968. 44v.
———.———. First Supplement. 1970. 2v.
———.———. Second Supplement. 1974. 5v.
Lists, in alphabetical order, the books, periodicals, and periodical articles on architecture, landscape architecture, and city and regional planning in the Graduate School of Design collection. The two supplements have a dictionary arrangement but contain separate sequences for books and pamphlets and for periodical literature.

Harvard University Library. Fine Arts Library. *Catalogue of the Harvard University Fine Arts Library.* The Fogg Art Museum. Boston: G. K. Hall, 1971. 15v.
———.———. First Supplement. 1976. 3v.
Reproduces the cards—with author, subject, and added entries interfiled—of books and sales catalog holdings in the fine arts collections of Harvard and associated libraries. Auction sales catalogs are listed separately, arranged alphabetically by dealer and chronologically by date of sale. The supplement indexes new acquisitions.

Kiell, Norman, comp. and ed. *Psychiatry and Psychology in the Visual Arts and Aesthetics: A Bibliography.* Madison: Univ. of Wisconsin Pr., 1965. 250p.
Cites books and articles that relate art to psychology and psychiatry. Book is arranged alphabetically by author under such subject headings as architecture, art therapy, color, tests, and primitive and prehistoric art. Includes an author index.

Lucas, E. Louise. *Art Books: A Basic Bibliography on the Fine Arts.* Greenwich, Conn.: New York Graphic Soc., 1968. 245p.
Addressed to persons compiling and using a collection suitable for a four-year undergraduate college. The major divisions are dictionaries, indexes, and encyclopedias; iconography; history and theory; architecture; sculpture; painting; graphic arts; minor arts; and monographs on artists. Period, geographical, and subject subdivisions are frequent. Each section is arranged alphabetically by author. There is an index of personal names.

Mayer, Leo Avery. *Bibliography of Jewish Art.* Ed. by Otto Kurz. Jerusalem: Magnes Pr., Hebrew Univ., 1967. 374p.
Lists published writings about Jewish art works produced between 70 A.D. and 1830 A.D. The numbered items in the bibliography are arranged alphabetically and are not annotated, though brief descriptions of the contents are given where the title is not self-explanatory. There is an author, title, and subject index.

New York. Metropolitan Museum of Art. *Library Catalog.* Boston: G. K. Hall, 1960. 25v.
————.————. Supplements. 1962, 1965, 1968, 1970, 1973, 1975.
The first twenty-three volumes of this set reproduce, in one alphabetical order, the author, subject, and title cards of the museum's library. The last two volumes reproduce cards for sales catalogs. The one-volume supplements contain separate listings for books/journals and sales catalogs.

New York Public Library. Art and Architecture Division. *Bibliographic Guide to Art and Architecture: 1976.* Boston: G. K. Hall, 1977. 766p.
This guide, a supplement to the Dictionary Catalog of the Art and Architecture Division of the Research Libraries of the New York Public Library, provides complete cataloging information on books and nonbook materials cataloged between September 1975 and August 1976 on fine and applied art, urban planning, architecture, printmaking and engraving, costume and metalwork, and manuscript illumination. Works in all languages are included. Main entry, added entry, series titles, and subject headings are listed alphabetically.

Ottawa. National Gallery. Library. *Catalog of the Library of the National Gallery of Canada.* Boston: G. K. Hall, 1973. 8v.
Reproduces, in one alphabetical order, the author, title, and subject cards from the National Gallery Library.

Pacey, Philip. *Art Library Manual. A Guide to Resources and Practice.* New York: Bowker, 1977. 423p.
Addressed to the professional librarian, this volume contains twenty-four essays on art library materials and their acquisition, care, and organization. Typical chapters cover quick reference material, museum and gallery publications, standards and patents, periodicals and serials, theses, reprints, sound recordings, video, film, and book design and illustration. Appendixes describe other libraries and organizations as sources of information and conservation. There is a general index.

Phillips, Margaret. *Guide to Architectural Information.* Lansdale, Pa.: Design Data Ctr., 1971. 89p.
Annotated guide to architectural reference books, emphasizing works related to the art and science of building. Some materials on environmental design and planning are listed. Works are arranged alphabetically by title under form headings with subject, title, and author indexes appended.

Rath, Frederick L., Jr., and Merrilyn Rogers O'Connell, comps. *Guide to Historic Preservation, Historical Agencies, and Museum Practices: A Selective Bibliography.* Cooperstown, N.Y.: New York State Historical Assn., 1970. 369p.
Cites books, articles, and pamphlets dealing with historic preservation with emphasis on publications since 1945. The work is divided into seven major sections on preservation organizations, general reference materials,

preservation principles and practices, administration, the study and care of collections, research, and interpretation. The first section contains background information on the organizations. There is a general index.

World Wide Art Book Bibliography. Boston: Worldwide Books, 1966–71.

An international bibliography published twice a year with each number devoted to a special topic or period, such as the decorative arts or ancient and medieval art. Only books in print at the time of publication are listed. Includes annotations and price and size information. All issues have author indexes; title indexes appear in the more recent issues.

BIOGRAPHY

Bachmann, Donna G., and Sherry Piland. *Women Artists: An Historical, Contemporary and Feminist Bibliography.* Metuchen, N.J.: Scarecrow, 1978. 323p.

Cites the works of 161 women artists from pre-1500 to the twentieth century in three sections. Although the emphasis is on historical contributions, the contemporary scene is included in a critical survey of women in art. Minor artists, even a few whose works are not extant, are listed. Section 1 lists general works including books, periodicals, and catalogs. Microfilm collections, slide sets, and dissertations are included under books. Full citations are given. Some evaluative annotations are included. Section 2 classifies citations by century and section 3 is a selected bibliography on needlework. The 59 black-and-white illustrations in the book are listed with notes on their current locations.

Bryan's Dictionary of Painters and Engravers. New ed., rev. & enl. under the supervision of George C. Williamson. Port Washington, N.Y.: Kennikat Pr., 1964. 5v.

Illustrated biographical sketches of the careers and major works of Western painters and engravers. The final volume reproduces the monograms of the artists.

Canaday, John. *The Lives of the Painters.* London: Thames & Hudson, 1969. 4v.

The first three volumes of this set contain several hundred biographies, linked by a running text, of painters from Giotto through the impressionists. The sketches deal primarily with the painters' styles and contributions. The fourth volume contains plates and an index.

Havlice, Patricia Pate. *Index to Artistic Biography.* Metuchen, N.J.: Scarecrow, 1973. 2v.

Indexes sixty-four biographical works in ten languages dealing with artists from all over the world. Arranged in alphabetical order by the artist's name, the entries provide dates, medium, nationality, and a letter code keyed to a

biographical bibliography. Pseudonyms and variant spellings of names or forms of entry are cross-referenced.

Mallett, Daniel Trowbridge. *Mallett's Index of Arts, International-Biographical Including Painters, Sculptors, Illustrators, Engravers and Etchers of the Past and Present.* New York: R. R. Bowker, 1935. 493p.
————.————. Supplement. 1940. 319p.
Provides basic data on 27,000 artists and a key to further information. The index gives name, pseudonym, maiden name, nationality, place and year of birth and death, active years, and place of residence.

Who's Who in Architecture from 1400 to the Present Day. Ed. by J. M. Richards. London: Weidenfeld & Nicolson, 1977. 368p.
Entries emphasize the architectural achievements rather than the personal lives of the subjects. Some biographical entries include photographs or floor plans of the subjects' work, and cite book-length biographies.

CATALOGS OF COLLECTIONS

Boston. Museum of Fine Arts. *Illustrated Handbook.* Boston: Museum of Fine Arts, 1976. 433p.
A guide to and partial catalog of the Boston Museum collections, organized according to the nine departments of American decorative arts and sculpture, Asiatic art, classical art, contemporary art, Egyptian art, European decorative arts and sculpture, paintings, prints and drawings, and textiles. The sections contain photographs of the objects, mostly black and white, with descriptions of physical characteristics and provenance and brief analyses of importance, styles, and themes. Floor plans are included.

New York. The Frick Collection. *The Frick Collection: An Illustrated Catalogue.* New York: Frick Coll., 1968. 9v.
Photographs of works in the Frick Collection, physical and exhibition details, historical background, and select bibliography. There are brief biographical sketches of the artists. The volumes deal separately with painting, sculpture, furniture, porcelains, enamels, carpets, drawings, and prints.

U.S. Library of Congress. Reference Department. *Guide to the Special Collections of Prints and Photographs in the Library of Congress.* Washington, D.C.: Library of Congress, 1955. 200p.
Describes the origin, nature, and scope of over 800 collections of pictures in the Library of Congress. Entries are arranged alphabetically, normally by the name of the person or institution that began the collection. The term "picture" is broadly defined, and the scope of inclusions and exclusions is detailed in the preface. There is an index to proper names and subjects.

DICTIONARIES AND ENCYCLOPEDIAS

The Book of Art: A Pictorial Encyclopedia of Painting, Drawing, and Sculpture. New York: Grolier, 1965. 10v.
Addressed to the nonspecialist reader, these volumes survey the visual arts worldwide. The emphasis is on Western art with some material on Oriental and primitive art. The ten volumes describe the origins of Western art, Italian art to 1850, Flemish and Dutch art, German and Spanish art to 1900, French art from 1350 to 1850, British and North American art to 1900, impressionists and post-impressionists, modern art, Chinese and Japanese art, and how to look at art. The text surveys works, themes, and biography, but accords primacy to the photographic illustrations. There is a general glossary and index.

Briggs, Martin S. *Everyman's Concise Encyclopedia of Architecture.* New York: Dutton, 1959. 372p.
Composed of brief illustrated articles, this encyclopedia has a long article on "Architecture, Periods of," which is a history of the subject. It also has articles on national architectures.

Encyclopedia of World Art. New York: McGraw-Hill, 1959–68. 15v.
Covers all forms of art in all times and places. The entries are illustrated, monographic studies of art; it is necessary to use the index to locate much of the material. Contributors include both Eastern and Western scholars.

Gaunt, William, comp. *Everyman's Dictionary of Pictorial Art.* London: Dent, 1962. 2v.
These volumes include 1,200 biographical sketches and illustrated entries for forms, media, and technical terms, famous works, periods, schools, styles, and theories from all periods and countries. The entries are alphabetical, arranged with a classified list in the first volume. The second volume contains supplementary lists of British and American artists and an index of illustrations.

Haggar, Reginald G. *A Dictionary of Art Terms: Painting, Sculpture, Architecture, Engraving and Etching, Lithography and Other Art Processes, Heraldry.* New York: Hawthorn, 1962. 416p.
Lists and defines ancient and modern terms from art practice and the literature of art criticism. Line drawings supplement the text. A glossary provides English equivalents of French, German, and Italian terms in three separate lists. There is a classified bibliography.

Harper's Encyclopedia of Art: Architecture, Sculpture, Painting, Decorative Arts. New York: Harper, 1937. 2v.
Long and short illustrated articles on persons, monuments, artistic forms and motifs, places, movements, and styles, arranged in alphabetical rather than chronological or geographical order. Some articles provide general information while others concentrate on particular works. Many articles have bibliographies.

Harris, John, and Jill Lever. *Illustrated Glossary of Architecture 850–1830*. New York: Potter, 1966. 78p. of text, 224p. of plates.

An illustrated two-part dictionary. The first part defines terms relating to the study of British architecture over a 1,000-year period. Most definitions contain plate number references. The second part consists of plates that are arranged according to architectural units and forms. There is a brief bibliography between the two parts.

Mayer, Ralph. *A Dictionary of Art Terms and Techniques*. New York: Crowell, 1969. 447p.

Defines and illustrates a wide range of artistic terms and techniques related primarily to Western ceramics, drawing, painting, printmaking, sculpture and associated arts. There is a bibliography.

McGraw-Hill Dictionary of Art. Ed. by Bernard S. Myers. New York: McGraw-Hill, 1969. 5v.

The 15,000 entries cover art of all nations and periods, and include articles on styles, periods, cities, buildings, and museums. The work includes much information on Oriental and primitive art. Many articles have bibliographies. Considerable space is devoted to biographies of painters, sculptors, architects, industrial designers, and decorative artists of all times and places.

Mollett, J. W. *An Illustrated Dictionary of Art and Archaeology, Including Terms Used in Architecture, Jewelry, Heraldry, Costume, Music, Ornament, Weaving, Furniture, Pottery, Ecclesiastical Ritual with over 700 illustrations*. New York: American Archives of World Art, 1966. 350p.

The scope of this volume is well indicated by its expanded title. Originally published in 1883 and revised in 1966, this work covers terms up to the end of the nineteenth century. The illustrated entries define and frequently provide etymologies and the symbolic meanings of words and the objects they describe.

Murray, Peter, and Linda Murray. *Dictionary of Art and Artists*. London: Thames & Hudson, 1966. 464p.

Covers artists and technical terms, including movements and processes, with emphasis on Western Europe and styles in other countries growing out of that tradition. Coverage begins in 1300 and encompasses only painting, drawing, sculpture, and other graphic arts. The biographies provide dates, describe the artists' distinguishing characteristics, and locate major works. At least one illustration is provided for each entry. These entries range in length from a few lines to a column or more. There are many cross-references, in small capitals, a classified bibliography, and an alphabetical bibliography on persons and subjects.

Myers, Bernard S., et al., eds. *Encyclopedia of Painting*. 3rd ed. New York: Crown, 1970. 511p.

Illustrated biographies, articles on regional painting, movements, and techniques for Eastern and Western art. Italian painters are alphabetized by their first names.

The Penguin Dictionary of Architecture. Ed. by John Fleming, Hugh Honour, and Nikolaus Pevsner. 2d ed. Harmondsworth, England: Penguin, 1972. 315p.

Biographical entries, definitions of technical terms, and brief articles on national architectures and architectural movements. There are a few black and white drawings. The coverage is worldwide, but with a Western emphasis.

Pevsner, Nikolaus; John Fleming; and Hugh Honour. *A Dictionary of Architecture.* Rev. & enl. Woodstock, N.Y.: Overlook, 1976. 556p.

Illustrated biographical sketches, national surveys, and descriptions of architectural forms, styles, and physical appurtenances. Bibliographies accompany some of the articles. This dictionary updates the *Penguin Dictionary of Architecture,* first published in 1966.

Praeger Encyclopedia of Art. New York: Praeger, 1971. 5v.

Almost 4,000 entries and 5,000 illustrations (of which roughly one-third are in color), this encyclopedia surveys the art and architecture of all periods and regions. Most of the articles are signed and include bibliographies. Entries cover biography, national and civilization surveys, periods, styles, schools, and movements. The work is indexed.

Saylor, Henry H. *Dictionary of Architecture.* New York: Wiley, 1952. 221p.

Concise definitions and phonetic pronunciations for architectural terms and styles, including terms from related disciplines. Some well-known architectural monuments, such as the Elgin Marbles, are included. Illustrations are grouped under such categories as arches, columns, and brickwork bonds.

The Thames and Hudson Encyclopedia of the Arts. Herbert Read, consulting ed. London: Thames & Hudson, 1966. 966p.

More than 10,000 entries and 3,500 color and black-and-white illustrations cover people, schools, genres, styles, movements, technical terms, and individual works. Painting, sculpture, architecture, the graphic and applied arts, literature, cinema, theater, and music are described.

A Visual Dictionary of Art. Greenwich, Conn.: New York Graphic Soc., 1974. 640p.

Addressed to the educated layperson, this illustrated dictionary has a large number of brief entries that cover Eastern and Western art with emphasis on painting and sculpture. The first portion contains introductory essays on the art of periods and regions with many cross-references to dictionary entries. The dictionary portion contains concise entries on persons, sites, works and monuments, schools, movements, techniques, and terminology. For each work illustrated, size, location, title, and date are provided. There is a bibliography and an index.

White, Norval. *The Architecture Book.* New York: Knopf, 1976. 343p.

Defines and describes roughly 1,400 persons, architectural elements, types of structures, styles, and other technical terms. A rather informal illustrated dictionary that reflects the author's knowledge, attitudes, and opinions.

DIRECTORIES

American Art Directory. New York: R. R. Bowker, 1952– .
 Lists museums, art organizations, universities and colleges with art departments and museums, art schools and classes in the United States, Canada, and abroad. There are also lists of art councils, magazines, newspapers with art notes and their critics, traveling exhibitions, scholarships, and supervisors and directors of art education in American school systems.

Cummings, Paul, ed. *Fine Arts Market Place*. New York: R. R. Bowker, 1973–74.
 Directory of art dealers, print publishers and wholesalers, auction houses, art presses, art book and museum stores, art book publishers, photographers, packers and movers, restorers and conservators, insurers, custom brokers, advertising and public relations agencies, publishers' representatives, fine art printers, founders and fabricators, framing sources, retail art materials, wholesale art materials, gallery equipment, organizations and associations, and exhibitions. Entries list individuals involved in the trade, their locations, specialties, products and activities, addresses, and telephone numbers.

Rauschenbusch, Helmut. *International Directory of Arts*. Berlin: Deutsche Zentraldruckerei Ag, 1952/53– .
 Lists public institutions, associations, artists, collectors, and staff members of museums, galleries, libraries, archives, universities, and schools.

GUIDES TO REPRODUCTIONS

American Library Color Slide Company. *The American Library Compendium and Index of World Art*. New York: American Archives of World Art, 1961. 465p.
 Lists slides available through the American Library Color Slide Company but does not reproduce them. The first four sections of the book cover architecture, sculpture, painting, and the minor arts; they are divided geographically and chronologically. When known, the artist's dates, and the date, medium, country of origin, and present location of the art work are given. The final three sections list historically compiled survey sets of slides; contents of the five basic world art libraries; and a basic lecture series. There is an extensive index of proper nouns including artists, works, and schools.

Bartran, Margaret. *A Guide to Color Reproductions*. 2d ed. Metuchen, N.J.: Scarecrow, 1971. 625p.
 Addressed primarily to retail print dealers, this guide lists color prints produced on paper in sheet form and available in the United States from publishers and/or wholesale distributors. The first section is arranged alphabetically by artist, with the artist's dates provided. For each reproduction, the size, source, and price are quoted. The second part is a title listing

and refers to the artist and the reproduction identification number for full information.

Clapp, Jane. *Art Reproductions.* New York: Scarecrow, 1961. 350p.
Indicates which reproductions of art works, including paintings, graphic arts, drawings, sculpture, and decorative art pieces, are available from museums in the United States and Canada. The arrangement is first by media and then by location and period, with artists and their works listed in alphabetical order. For each available reproduction, the size, price, format, and vending library are given. The index includes artists and their subjects, such as the names of persons and locales portrayed or general topics.

Havlice, Patricia Pate. *World Painting Index.* Metuchen, N.J.: Scarecrow, 1977. 2v.
Indexes reproductions in more than 1,100 art books published since 1940. It overlaps the books by the Monros only where new editions have appeared. The index has four sections. Part 1 is a bibliography of the books indexed; part 2 is a title listing of anonymous paintings; part 3 is the main entry index, by artist and subclassified by painting title. Parts 2 and 3 have citations to the bibliography. Part 4, however, is a title index to part 2, which means that two steps are required to locate paintings when only the title is known. Parts 2 and 3 indicate whether each reproduction is in color or black and white and whether it shows the entire work or a detail.

Hewlett-Woodmere Public Library. *Index to Art Reproductions.* Metuchen, N.J.: Scarecrow, 1974. 372p.
A guide to reproductions of paintings, sculpture, graphic art, photography, stage design, and architecture published in sixty-five selected books between 1956 and 1971. Reproductions are listed by the artist's name and by the title of the work with the latter keyed to the former. Artist listings give dates when available; notes for each work include symbols for the book(s) in which a reproduction appears, the page, measurements of the reproduction, and whether it is in color or black and white. Cross-references to other names by which an artist is known are provided.

Monro, Isabel Stevenson, and Kate M. Monro. *Index to Reproductions of European Paintings: A Guide to Pictures in More than Three Hundred Books.* New York: H. W. Wilson, 1956. 668p.
A guide to reproductions in 328 books with paintings listed by the artist's name, title, and some subjects. The books indexed are found in most art libraries. The guide excludes books on individual painters, lists few exhibition catalogs, and few foreign language books. Many paintings are located.

New York Graphic Society. *Fine Art Reproductions of Old and Modern Masters. A Comprehensive Illustrated Catalog of Art through the Ages.* Greenwich, Conn.: New York Graphic Soc., 1980. 550p.
Provides color photographs of prints available through the New York Graphic Society. Includes the name of the artist, title and location of the original, and size and cost of the print. Recommended framing styles are

described. The prints are divided into geographic, chronological, and subject sections. There is an index and brief biographical sketches of some 400 artists.

Thomson, Elizabeth. *Index to Art Reproductions in Books*. Metuchen, N.J.: Scarecrow, 1974. 372p.
 Indexes art works reproduced in sixty-five books published between 1956 and 1971. Includes painting, sculpture, graphic art, photographs, stage design, and architecture. The work is arranged by artist, with works listed alphabetically under each. A separate title index refers to the book authors. For each reproduction, the book indicates size and whether it is in color or black and white.

Unesco. *Catalog of Reproductions of Paintings Prior to 1860*. Paris: Unesco, 1972. 501p.
 Guide to high-quality reproductions of important works produced before 1860 by major painters. Explanatory material appears in English, French, and Spanish. The arrangement is alphabetical by the artist's name or, in the case of anonymous works, by the French name of the country or school. Each entry includes a small photograph of the reproduction; the dates and places of the painter's birth and death; the title and date of the painting and its medium, size, and location; the process employed in printing the reproduction and its size; Unesco archives number; publisher; and price. Also included is an index of artists and lists of publishers and printers.

HISTORIES AND HANDBOOKS

Brunskill, R. W. *Illustrated Handbook of Vernacular Architecture*. London: Faber & Faber, 1970. 230p.
 Describes domestic, agricultural, and industrial buildings designed by non-professionals and constructed from common materials and according to common forms of a geographic area. The illustrated chapters describe walling, roofing, and architectural details, primarily in the British Isles. There is a small glossary, an annotated bibliography, and an index.

Caplan, H. H. *The Classified Directory of Artists Signatures, Symbols, and Monograms*. London: Prior, 1976. 738p.
 Guide composed of six sections with the first and largest being an alphabetical listing of artists together with facsimiles of the signatures they employed. The second section shows monograms in alphabetical order. First, uppermost, or predominating letters are used in alphabetizing this portion; cross-references are employed when necessary. Unclassified monograms are appended in a separate section. The fourth and fifth sections show illegible and misleading signatures filed according to the first legible letter and in an unclassified section. The final section shows symbols grouped by form. All sections provide birth and death dates and place of birth, and types and locations of works.

Eichenberg, Fritz. *The Art of the Print: Masterpieces, History, Techniques.*
New York: Abrams, 1976. 611p.
Addressed to the working artist, the collector, and the general public, this
book surveys developments in Western and Eastern relief, intaglio, lithogra-
phy, silkscreen, and monotype prints. There are chapters on antecedents of
the print and on workshops and paper. Each section is normally comprised
of essays by scholars and notes by prominent artists working in the medium
under discussion. There are many color and black-and-white photographs, a
glossary, a bibliography, and an index.

Fletcher, Banister F. *A History of Architecture on the Comparative Method,*
17th ed. Rev. by R. A. Cordingley. New York: Scribner's, 1961. 1,366p.
Surveys Western and Eastern architecture in chapters on particular styles
and countries. Each chapter is illustrated and contains five major sections.
The first describes the geographic, climatic, social, geologic, religious, and
historical influences on a given style. The second deals with the architectural
character or appearance and special features of the buildings of the period
under review. The third provides illustrative examples with brief textual
notes. The fourth section comparatively analyzes such features as plans,
walls, and ornaments. The fifth lists reference books. A general bibliography,
a glossary, and an index are included.

Osborne, Harold, ed. *The Oxford Companion to Art.* Oxford: Clarendon
Pr., 1970. 1,277p.
Designed for the general public, this illustrated work covers the visual arts
primarily. Biographical entries provide dates, locate major works, and have
bibliographic appendices.
The selective bibliography, which lists over 3,000 volumes, is divided into
five sections: (1) reference materials; (2) general works on art theory and
criticism; (3) general works on the arts in the nineteenth and twentieth
centuries; (4) works on materials and techniques; and (5) books with a
special bearing on individual articles or groups of articles. The entries in the
last section are numbered alphabetically, and the numbers of the titles per-
taining to certain articles are printed at the end of the articles.

Pierce, James Smith. *From Abacus to Zeus: A Handbook of Art History.*
Englewood Cliffs, N.J.: Prentice-Hall, 1968. 131p.
More a glossary than a handbook, this work provides information on
Western art, especially Christian art. Chapter 1, which comprises half the
volume, briefly explains and illustrates terms from art and architecture.
Chapter 2 identifies gods and other mythological beings and provides a chart
of corresponding Greek and Roman gods. Chapters 3, 4, and 5 deal with
Christian subjects of art, saints and their attributes, and Christian symbols.
Each chapter is arranged alphabetically, except for the one on Christian
subjects, which groups entries in broad categories. Pronunciations are in-
cluded where appropriate. The work provides many references to the illus-
trations and plates of the Jansons' *History of Art.*

ICONOGRAPHY

Cirlot, J. E. *A Dictionary of Symbols.* 2d ed. London: Routledge & Paul, 1971.
Describes symbols from every nation and the interpretations and uses of the same symbol in different cultures. The author prefaces the dictionary with an essay on the symbol, its origin, symbolism in dreams and alchemy, definitions, analysis, and interpretation. The text is illustrated with historic and contemporary drawings and black-and-white plates. There are two bibliographies, one of principal sources and the other of additional sources, and an index.

Daniel, Howard. *Encyclopedia of Themes and Subjects in Painting. Mythological, Biblical, Historical, Literary, Allegorical, and Topical.* New York: Abrams, 1971. 252p.
Deals primarily with themes employed by European artists from the Renaissance to the 1950s. Many paintings illustrating the themes are reproduced.

De Vries, Ad. *Dictionary of Symbols and Imagery.* Amsterdam: North-Holland Publishing, 1974. 515p.
A dictionary-form guide to the verbal and pictorial symbols used in Western arts and life. There are many multiple definitions or insights.

Ferguson, George. *Signs and Symbols in Christian Art.* New York: Oxford Univ. Pr., 1959. 123p.
This volume is a topical treatment of Christian symbolism with the following chapters: animals, birds and insects; flowers, trees, and plants; earth and sky; the human body; the Old Testament; Saint John the Baptist; the Virgin Mary; Jesus Christ; the Trinity; the Madonna and angels; the saints; radiances, letters, colors, and numbers; religious dress; religious objects; and artifacts. Within each chapter are alphabetically arranged entries for subdivisions of the subject, and the work closes with a list of plates and a general index.

Hall, James. *Dictionary of Subjects and Symbols in Art.* New York: Harper & Row, 1974. 345p.
Defines and describes persons, personifications, objects, events, and activities that are the subject of artistic themes or that symbolize some other object or occurrence. The book emphasizes dominant Christian and classical themes that have been conventional in Western art since the beginning of the Renaissance. Individual art works are rarely referenced or described. The book includes an annotated list of ancient sources and a bibliography.

Schiller, Gertrud. *Iconography of Christian Art.* London: Lund Humphries, 1971. 2v.
Describes the origins and development of pictorial themes and forms, with emphasis on their relationship to the Bible, Christian dogma and liturgy, and other religious writings. Each volume is divided almost equally into textual analysis and plates. The first volume covers Christ's incarnation, childhood,

baptism, temptation, transfiguration, and works and miracles while the second explores the theme of the passion of Christ. Both volumes contain bibliographies and indexes of biblical and legendary texts cited. The second volume has a thematic index for the entire work.

Ancient

Huyghe, René, ed. *Larousse Encyclopedia of Prehistoric and Ancient Art.* London: Hamlyn, 1966. 415p.

Each section begins with an introductory essay on art forms and society and continues with signed articles on, and historical summaries of, art in the classical and ancient Middle Eastern civilizations, the Orient, Africa, Oceania, pre-Columbian America, India, and prehistoric Europe. The book is illustrated in color and black and white. A general index is included.

Rowland, Benjamin, Jr. *The Classical Tradition in Western Art.* Cambridge, Mass.: Harvard Univ. Pr., 1963. 379p.

This historical survey of Western art begins in the Greek period and ends with entries for Maillol, Picasso, Henry Moore, and DeChirico. There are 229 black-and-white plates listed before the text and contained at the end of the entries. Preceding the plates are a section devoted to notes and a general index.

Winckelmann, Johann Joachim. *History of Ancient Art.* New York: Frederick Unger, 1968. 4 vols.

This work, translated from the German by Alexander Gode, discusses the following topics: the origin of art, Egyptian art, Phoenician and Persian art, Etruscan art, Greek art, and Greek art among the Romans. There are black-and-white drawings within the text and each volume closes with an extensive section of notes.

Byzantine and Medieval

Allen, Jelisaveta, S., ed. *Literature on Byzantine Art, 1892–1967.* London: Mansell for Dumbarton Oaks Ctr. for Byzantine Studies, 1973– .

Series presents annotated bibliographies of classified topographic and cumulative literature on the history of Byzantine art, taken from volumes 1 through 60 of *Byzantinische Zeitschrift* (1892–1967). Volume 1, divided into two parts, is arranged alphabetically by geographical units. Part 1 includes Africa, Asia, and European countries from Albania to Ireland. Part 2 includes European countries from Italy to Yugoslavia. Within each country, entries are arranged by geographical region and site. The book includes bibliographies of general works, architecture, mosaics, paintings, icons and panels, sculpture, and sarcophagi. Critical annotations are reproduced from the *Byzantinische Zeitschrift,* III. Abteilung, "Bibliographische Notizen und Mitteilungen."

Volume 2 lists classified works arranged by media, such as bibliographies, general works, architecture, sculpture, mosaics, painting, illuminated manuscripts, and iconography. The minor arts, such as amulets, bookbinding, ceramics, ivory and bone carving, and woodwork are also covered. Volume 1 contains place name and author indexes. Volume 2 has a general index and an author index.

Beckwith, John. *Early Medieval Art.* New York: Praeger, 1964. 270p.
This historical survey of medieval art in the three centuries after Charlemagne's reign contains black-and-white and color plates as well as floor plans for significant buildings. A map of Frankish lands is contained before the text and the volume concludes with a section of notes, a bibliography, and a general index.

Hubert, Jean; J. Porcher; and W. F. Volbach. *The Carolingian Renaissance.* New York: Braziller, 1970. 378p.
This work is translated from the French and contains signed chapters devoted to architecture, book painting, and sculpture. Following these essays are sections devoted to black-and-white illustrations, plans, a chronological table, a bibliography, a list of illustrations, a glossary-index, and maps. There are also color and black-and-white illustrations throughout the text.

Huyghe, René, ed. *Larousse Encyclopedia of Byzantine and Medieval Art.* London: Hamlyn, 1963. 416p.
Five major sections deal respectively with the first centuries of the Christian era; the great invasions and the fall of Byzantium; the development of Oriental art; the flowering of medieval art in the West; and the Gothic Middle Ages. Each section contains an essay on art forms and society, signed articles on periods and places, and a chronological summary of political events and art works. The book is illustrated in color and black and white with numbered references that link the illustrations to the text. An index is included.

Rice, David Talbot. *Art of the Byzantine Era.* London: Thames & Hudson, 1963. 286p.
This survey of Byzantine art contains chapters devoted to the Christian East before Islam, the art of Constantinople 550–1204, the Balkans, and the revival under the Palaeologae emperors. There are color and black-and-white illustrations in the text and the volume concludes with a bibliography, a list of illustrations, a chronological table, and a general index.

Renaissance and Baroque

Avery, Catherine B. *The New Century Italian Renaissance Encyclopedia.* New York: Appleton-Century-Crofts, 1972. 978p.
This dictionary covers the Italian Renaissance with a wide scope containing, in addition to more obvious articles, entries for Thomas Cranmer, Mar-

tin Luther, and Elizabeth I of England. Preceding the entries is a list of photographs and the volume closes with over twenty-five pages of black-and-white plates relating to some of the articles.

Coulton, G. G. *Art and the Reformation.* Cambridge: Univ. Pr., 1953. 622p.
This volume contains chapter divisions arranged chronologically from monastic arts through the end of the Reformation. There are thirty-four topical appendixes covering such topics as art and the black death, artists' prices, St. Nicholas, and the choice of patron saints. Preceding the text is a list of illustrations and a list of abbreviations for cited sources. The volume concludes with an index of names and places.

Huyghe, René, ed. *Larousse Encyclopedia of Renaissance and Baroque Art.* New York: Prometheus, 1964. 444p.
This work contains signed articles under the headings: "The End of the Middle Ages and the Growth of Realism," "The Italian Renaissance and the Ideal of Beauty," "The Later Renaissance," and "Baroque Art." Each article has color and black-and-white plates and the volume concludes with a general index. The authors are curators, professors, and other scholars from Italy, Spain, France, and Belgium.

Jacobs, Alan. *17th Century Dutch and Flemish Painters.* Amsterdam: Van Gorcun, Assen, 1976. 297p.
In this work artists are treated under thirty-three headings ranging from landscapes, battles and skirmishes, and field sports to religious, mythological, and interiors of churches. Artists are separately listed and their treatment of the subject is discussed with cross-references to their treatment of other subjects. Preceding the sections on the subjects are general chapters devoted to historical and critical matters and the volume closes with a short general bibliography and an index.

Modern

BIBLIOGRAPHY

American Association of Architectural Bibliographers. *Papers.* v. 1– , 1965– . Charlottesville: Univ. Pr. of Virginia, 1965– .
Each annual volume contains one or more signed bibliographies of works by and about notable architects from Thomas Jefferson to Antonio Gaudi. Brief essays introduce the bibliographies. A cumulative author-title index to the series was published in 1974.

Art Bibliographies Modern. Santa Barbara, Calif.: American Bibliographical Center and Clio Pr., 1973– . (Supersedes LOMA. *Literature on Modern Art: An Annual Bibliography.* 1969– . Boston: Worldwide Books, 1971– .)
An annual bibliography divided into two sections, the first listing artists and the second, subjects. Includes late nineteenth- and twentieth-century

painting, sculpture, drawing, prints, ceramics, textiles, graphic design, pho-
tography, and selections from other disciplines as they relate to the fine arts.
Books, articles, exhibition catalogs, and ephemeral publications of interna-
tional provenance are indexed; each citation contains a code letter identify-
ing the publication format. Some illustrations from indexed works are pro-
vided. There are subject, author, and title indexes.

Art Design Photo, 1972– . London: Idea Books, 1974– .
 Annual bibliography of art books, exhibition and sale catalogs, periodi-
cals, newspapers, and other art publications published during the preceding
year. Covers late nineteenth- and twentieth-century art and artists, photogra-
phy and graphic design, ceramics, textiles, jewelry, and fashion. Comics,
posters, children's books, and symbols are included. Each volume is divided
into artist and subject sections. The artist section includes painters, sculptors,
printmakers, photographers, jewelers, potters, textile artists, fashion de-
signers, stage designers, graphic designers, illustrators, and cartoonists. The
subject section lists movements and subjects alphabetically, some grouped
under generic headings such as photography, museums, or expressionism.
Includes a subject and author index.

Mason, Lauris, comp. *Print Reference Sources: A Select Bibliography, 18th–*
 20th Centuries. Millwood, N.Y.: Kraus-Thomson, 1975. 246p.
 Bibliography of books, articles, catalogs, and museum and dealer publica-
tions relating to 1,300 printmakers and their work. The printmakers are
arranged alphabetically; the publications about them appear in chronological
order. Currently available and out of print sources are included in this guide
for librarians, collectors, dealers, curators, auction catalogers, and print col-
lectors.

Sharp, Dennis, compiler. *Sources of Modern Architecture: A Bibliography.*
 Architectural Association (London) Paper no. 2. New York: Wittenborn,
 1967. 56p.
 Lists more than 1,000 books and articles on the lives and works of over
100 influential architects of the past century. Arranged alphabetically, the
entries include biographical and career details followed by a bibliography of
works by or about the architect. Subject and national bibliographies, a select
list of periodicals concerned with the modern movement, and subject and
author indexes, are included.

BIOGRAPHY

Berman, Esmé. *Art and Artists of South Africa.* Cape Town: A. A. Balkema,
 1970. 369p.
 This volume contains an alphabetical directory of artists and artistic move-
ments in South Africa with entries listing background data on the individual
or significant individuals in the movement, exhibitions, public collections,
and, in some articles, a short bibliography. The entries are preceded by a
historical table and survey and the work contains lists of artists as appen-
dixes as well as a bibliography and a general index.

Fisher, Stanley E. *A Dictionary of Water Colour Painters, 1750–1900*. London: Foulsham, 1972. 245p.

Alphabetically lists watercolor artists who were born in Britain, or who worked in Britain at some time during their lives. Each entry provides biographical details if known, notes on the artist's career, memberships, subjects, and exhibitions. The entries locate major works. There are a general introduction, a bibliography, lists of catalogs and periodicals, and illustrations.

The Index of Twentieth Century Artists. New York: Research Inst. of the College Art Assn., 1933–37.

Published monthly for five years, this index contained biographical sketches of twentieth century artists with detailed information on awards, honors, affiliations, exhibitions, and galleries. The series included bibliographies and indices.

Maillard, Robert, gen. ed. *New Dictionary of Modern Sculpture*. New York: Tudor, 1971. 328p.

An illustrated international dictionary of sculptors that contains no articles on terms, movements, and schools but does describe them in the biographical entries. The biographies provide a few personal details but concentrate on tracing the artists' development, contributions, and theories.

Naylor, Colin, and Genesis P. Orridge, eds. *Contemporary Artists*. New York: St. Martin's Pr., 1977. 1,077p.

Biobibliography of 1,300 internationally known artists who worked professionally for at least five years. No artist who died before 1930 is included. Biographical sketches list individual shows, selected group shows, collections, and publications about the artist. Comments by the artist on his or her work are often included.

Who's Who in Art. Havant, Hants, England: Art Trade Pr., 1927– .

Brief biographical sketches principally of living British artists and art critics, writers, and teachers. Each entry lists dates, education, medium, exhibitions, awards, address, and publications. The work describes the purposes and activities of artistic academies, groups, and societies in Great Britain. Appendixes reproduce monograms and signatures and list obituaries and abbreviations.

Wood, Christopher. *Dictionary of Victorian Painters; With Guide to Auction Prices, 300 Illustrations, and Index to Artists' Monograms*. Woodbridge, England: Antique Collectors' Club, 1971. 435p.

Enlarges upon earlier art dictionaries such as Bénézit and Thieme-Becker with a select international list of major and minor Victorian artists. Each entry includes biographical information, titles of important works, critical comments, recent auction prices for some works, and bibliographies where available. The book also contains a list of exhibitions and galleries that show Victorian work, a key to letters after the artists' names, 212 black-and-white plates, and a monogram index.

DICTIONARIES AND ENCYCLOPEDIAS

Charmet, Raymond. *Concise Encyclopedia of Modern Art.* Ed. by Roger Brunyate. Glasgow: Collins, 1972. 256p.
Describes twentieth-century painting and sculpture and some nineteenth-century precursor artists and styles. There are illustrated, cross-referenced entries for artists, movements, styles, institutions, and some associated technical terms. The editor locates many major works.

Fifty Years of Modern Art. New York: Praeger, 1959. 335p.
This work contains chapters devoted to fauvism, cubism, futurism, expressionism, constructivism and suprematism, metaphysical art, dada and surrealism, naive painting, socialist realism, the independents, and nonrepresentational art. There are numerous color and black-and-white plates contained in the articles and the volume concludes with a biographical section with entries for over 200 artists of the modern era. Each entry contains biographical data and a list of the artist's works contained in the volume.

Hatje, Gerd. *Encyclopaedia of Modern Architecture.* London: Thames & Hudson, 1963. 336p.
Signed, illustrated articles on schools, countries and individual architects, arranged alphabetically. There is a long introduction.

Huyghe, René, gen. ed. *Larousse Encyclopedia of Modern Art from 1800 to the Present Day.* New York: Prometheus, 1965. 444p.
The signed articles in this encyclopedia are international in scope and oriented to periods and movements. The surveys mention specific artists and their work; photographs illustrate the text. A general index is included.

Lake, Carlton, and Robert Maillard, eds. *Dictionary of Modern Painting.* New York: Tudor, n.d. 416p.
This volume deals with painting beginning with the impressionists and ending with those artists who, though still alive in 1950, had made their major contribution before World War II. There are initialed entries for artists, movements, and significant places in the history of modern art. The articles are cross-referenced and contain black-and-white and color illustrations. A list of contributors and their initials begins the work.

Norman, Geraldine. *Nineteenth-Century Painters and Painting: A Dictionary.* Berkeley: Univ. of California Pr., 1977. 204p.
Illustrated articles, alphabetically arranged, on artistic schools, movements, styles and approximately 700 artists, including those considered important at the time, those who have become noted since, and lesser known personalities. An introductory chapter presents a descriptive artistic survey of the nineteenth century. There are brief bibliographies in the entries and a more extensive classified bibliography.

Pehnt, Wolfgang, ed. *Encyclopedia of Modern Architecture.* New York: Abrams, 1964. 336p.

Signed, illustrated articles on persons, styles, movements, manifestos, national surveys, schools, organizations, and some materials and design elements. Some articles have bibliographies. There is an index of names.

Phaidon Dictionary of Twentieth-Century Art. London: Phaidon, 1973. 420p. 66 plates.

Covers persons and terms. The biographies include established artists who have made their major creative contributions during this century and a few major nineteenth-century figures who influenced twentieth century art. The term entries define concepts, groups, organizations, techniques, and schools. There are some brief bibliographies and almost seventy black-and-white reproductions.

GUIDES TO REPRODUCTIONS

Parry, Pamela Jeffcott. *Contemporary Art and Artists: An Index to Reproductions.* Westport, Conn.: Greenwood Pr., 1978. 327p.

Restricted to artists active between 1940 and the mid-1970s, this international guide indexes more than sixty books and exhibition catalogs that would be available in most museum, college, and public libraries with art collections. Covers all media except architecture. The index is divided into two parts: an artist index with full information and a subject and title index.

Unesco. *Catalog of Reproductions of Paintings 1860–1973, with Fifteen Projects for Exhibitions.* Paris: Unesco, 1974. 343p.

Guide to high quality reproductions of important works produced after 1860 by major painters. Explanatory material appears in English, French, and Spanish. Alphabetically arranged by the artists' names, the entries include a small photograph of the reproduction; the dates and places of the painter's birth and death; the title and date of the painting and medium, size, and location; the process employed in printing the reproduction and its size; Unesco archives number; publisher; and price. The book includes suggestions for fifteen exhibitions on such themes as impressionism, neofigurative art, and informalism; an index of artists; and lists of publishers and printers.

MOVEMENTS

ABSTRACT ART

Berckelaers, Ferdinand Louis. *A Dictionary of Abstract Painting Preceded By a History of Abstract Painting.* London: Methuen, 1958. 205p.

The first third of this volume is an historical survey of abstract painting. Three appendixes present the views on painting of Severini, Malevitch, and Mondrian. A geographical chronology covering France, Russia, Germany, Switzerland, Holland, and the United States follows. The major portion of

the work contains illustrated biographical sketches of abstract artists, many of which have brief bibliographies. There is a general bibliography.

ART NOUVEAU

Kempton, Richard. *Art Nouveau: An Annotated Bibliography.* v.1– . Los Angeles: Hennessey & Ingalls, 1977– .
Lists books and periodical articles relating to art nouveau with brief, critical annotations. Includes writings from the time of the art nouveau movement and more recent evaluations; the coverage extends to the fine and the decorative arts. The book has a classified subject arrangement with an author index. A large proportion of the items are in French, German, and other languages.

Walker, John A. *Glossary of Art, Architecture and Design Since 1945. Terms and Labels Describing Movements, Styles and Groups Derived from the Vocabulary of Artists and Critics.* London: Clive Bingley, 1973. 240p.
Emphasizes Anglo-American terms in painting, sculpture, ceramics, architecture, graphic and industrial design, and urban planning, especially those of recent coinage. Tools and technical processes are generally ignored. Most entries include short bibliographies. There is a general bibliography and an index.

DADAISM

Motherwell, Robert, ed. *The Dada Painters and Poets: An Anthology.* New York: Wittenban, 1967. 403p.
This anthology contains selections from 1914 to 1948 by personalities associated with the dada movement. There are several relevant documents contained as appendixes that are followed by a bibliography of sixty pages, an index to the bibliography, and a copy of the "Dada Manifesto of 1949" by Richard Huelsenbeck.

Pierre, José. *Futurism and Dadaism.* London: Heron Books, 1969. 207p.
This volume contains narrative introductions to futurism and dadaism followed by sections on evidence and documents, chronology, museums, the principal pictorial movements, and principal exhibitions. The work has extensive color illustrations and concludes with a glossary, bibliography, and a list of illustrations.

SURREALISM

Dali, Salvador. *Dali on Modern Art.* New York: Dial, 1957. 156p.
This volume contains an essay by Dali on art translated by Haakon M. Chevalier with the French original following. The work gives Dali's views on many subjects and is illustrated with black-and-white plates from numerous artists and relevant quotations from other authors.

Nadeau, Maurice. *The History of Surrealism*. London: Jonathan Cape, 1968. 351p.

This historical survey contains a bibliography of literature on surrealism, copies of manifesto and other documents, a list of surrealist periodicals, tracts, catalogs, films, and critical works. It closes with a general index.

Pierre, José. *A Dictionary of Surrealism*. London: Methuen, 1974. 168p.

After a historical introduction the main body of the work is a dictionary of the subject with entries for individuals, phrases, and techniques, as well as national entries. The volume is illustrated with black-and-white and color photographs of the artists' works; foreign terms in the articles are translated into English.

United States and Canadian Art

ARCHIVES

McCoy, Garnett. *Archives of American Art. A Directory of Resources*. New York: R. R. Bowker, 1972. 163p.

A guide to the Archives of American Art, a bureau of the Smithsonian Institution. The archives were collected for researchers and comprise the papers of individual artists and records of galleries, organizations, critics, and collectors. Some 555 groups of papers are described. The directory is arranged alphabetically by the name of the collection. Each collection has a number that is referenced in an index to proper names. Each entry tells the source of the collection and date of acquisition, the forms and numbers of documents held, and the dates covered by the collection. A brief, descriptive note follows.

BIBLIOGRAPHY

Olana's Guide to American Artists: A Contribution toward a Bibliography. Riverdale, N.Y.: Olana Gallery, 1978. 227p.

First volume of a projected series, this book is an unannotated list of materials relating to American artists. Most listed items are exhibition catalogs; biographical and critical works, and a few periodical articles are included. The number of illustrations is given for each entry. Most of the book is arranged alphabetically by artist; catalogs of two-person, three-person, and group shows are separately listed.

BIOGRAPHY

Cederholm, Theresa Dickason. *Afro-American Artists*. Boston: Trustees of the Boston Public Library, 1973. 348p.

The main body of this work is an alphabetical biobibliographical directory of Afro-American artists. Each entry contains biographical data, works of

the artist, dates and locations of exhibitions, location of collections, awards, society memberships, and sources for further information on the artist. The volume concludes with a bibliography containing subdivisions for books, magazine and journal articles, newspaper articles and catalogs.

Collins, J. L. *Women Artists in America*. Chattanooga, Tenn.: The Author, 1975. 2 vols.
This work contains an alphabetical biographical directory and illustrations of many of the artists' work. Each entry contains an artist's educational background, awards, collections, and a notation if a photo of her work is contained in the volume. Each volume is a complete alphabetic arrangement and the second volume updates but does not duplicate the entries in the first.

Croce, George C., and David H. Wallace. *The New York Historical Society's Dictionary of Artists in America 1564–1860*. New Haven, Conn.: Yale Univ. Pr., 1957. 759p.
Provides personal and career information on painters, sculptors, engravers, lithographers, and other artists who lived and/or worked in the United States from 1564 to 1860. Important works and themes of the artists are noted but no critical assessment is made. Cites sources for further information and provides full bibliographic information.

Cummings, Paul. *A Dictionary of Contemporary American Artists*. 3rd ed. New York: St Martin's Pr., 1977. 545p.
Roughly 900 illustrated biographical sketches of artists including education, teaching experience, participation in the Federal Art Project, scholarships, awards, commissions, address and dealer(s) of record, and major exhibitions. The volume includes a bibliography, an index, and a pronunciation guide. The dictionary is revised approximately every four years.

Dawdy, Doris Ostrander. *Artists of the American West. A Biographical Dictionary*. Chicago: Swallow Pr., 1974. 275p.
Biographical data and citations to entries in biographical dictionaries for 1,350 artists who were born before 1900 and portrayed life in the seventeen states west of the 95th meridian. There are brief biographical sketches for 300 major artists, and a bibliography.

Fielding, Mantle. *Dictionary of American Painters, Sculptors and Engravers*. Ed. by Genevieve C. Doran. Greens Farms, Conn.: Modern Books and Crafts, 1926, 1974.
Mantle Fielding compiled a dictionary on approximately 6,400 American artists. Doran added information on more than 2,500 seventeenth- through nineteenth-century artists. The two listings are in separate sections, each arranged alphabetically by the artist's name. The brief entries provide dates, old addresses (of historical interest only), medium, education, awards, exhibits, and memberships.

Macdonald, Colin S. *A Dictionary of Canadian Artists*. Ottawa: Canadian Paperbacks, 1967. 3v.
Biographical information on artists, critical comments on their work, ma-

jor works, locations of some works, and bibliographies where appropriate. Entries vary from a few lines to several pages.

Samuels, Peggy, and Harold Samuels. *The Illustrated Biographical Encyclopedia of Artists of the American West.* Garden City, N.Y.: Doubleday, 1976. 549p.
Lists more than 1,700 artists of the American West with eighty-eight pages of half-tone reproductions. Entries give the artist's name, brief biographical data, medium, locations of some works, recent auction prices if known, and where the artist's signature may be verified. This is followed by a biographical sketch of the artist. Entries range from a few lines to more than half a page.

Wodehouse, Lawrence. *American Architects from the Civil War to the First World War: A Guide to Information Sources.* Detroit: Gale, 1976. 343p.
Cites and annotates historical and/or critical books and articles. The guide provides some biographical information. The guide's first section lists general reference works; the second describes individual architects. The third section provides some information on significant architects about whom little has been written. There are general and building location indexes.

————. *American Architects from the First World War to the Present. A Guide to Information Sources.* Detroit: Gale, 1977. 305p.
Annotated bibliography of books, periodical articles, and some newspaper articles on almost 175 American architects, including some foreigners who practiced in the United States. Brief biographical notes are provided for many of the architects. The book is divided into two major sections. The first lists general reference works, and the second describes individual architects. The publications are arranged by architect and alphabetically by author. An appendix provides biographical information on the critic Ada Louise Huxtable and a guide to her articles. There are general and building location indexes.

Young, William, ed. and comp. *A Dictionary of American Artists, Sculptors and Engravers from the Beginning through the Turn of the Twentieth Century.* Cambridge, Mass.: Young, 1968. 515p.
Includes artists who were born or who gained American citizenship and who produced most of their work in the United States. Brief entries provide dates, medium, education, exhibitions, and awards.

CATALOGS OF COLLECTIONS

Boston. Museum of Fine Arts. *American Paintings in the Museum of Fine Arts, Boston.* Boston: Museum of Fine Arts, 1969. 2v.
The first volume of this catalog contains text and the second, pictures. The text volume is arranged alphabetically by the artist's name. After a brief biographical sketch, the catalog provides historical background material for the paintings, lists dates and locations of exhibitions and collections of which

the paintings have been part, and gives additional references. The book includes titles and collection indexes. The reproductions in the second volume are loosely arranged in chronological order with all paintings by a given artist grouped together.

New York. Metropolitan Museum of Art. *American Paintings. A Catalogue of the Collection of the Metropolitan Museum of Art, 1965– . 1965– . v.1–.*
Projected as a three-volume set, this catalog presents, in chronological order by birth date, biographical sketches of American artists represented in the collection and illustrated descriptions and analyses of their works held there. The catalog provides the exhibition locations and dates of the paintings and bibliographic references. There are name and title indexes.

U.S. Library of Congress. Prints and Photographs Division. *American Prints in the Library of Congress. A Catalog of the Collection.* Baltimore: Johns Hopkins Pr., 1970. 568p.
Lists prints by American artists in the Library of Congress. The arrangement is alphabetical by artist; each entry has brief identifying information and bibliographic references. The print is then named, classed, and physically described. Many of the prints are reproduced. There are bibliography and indexes for places, names, sets, and societies.

DICTIONARIES AND ENCYCLOPEDIAS

Baigell, Matthew. *Dictionary of American Art.* New York: Harper & Row, 1979. 390p.
The volume begins with a list of articles to be found in the dictionary arrangement in addition to those on individuals and a list of abbreviations. Biographical articles contain data on the artist's career, as well as critical comments on his or her works, location of papers and works, and some bibliographical references.

The Britannica Encyclopedia of American Art. Chicago: Encyclopaedia Britannica Educational Corp., n.d. 669p.
Signed articles on American arts, crafts, and architecture from colonial times to the present. Includes biographical sketches and many black-and-white and color photographs. The book has a classified list of entries, a guide to museums and public collections, a glossary, and a bibliography.

GUIDES TO REPRODUCTIONS

Monro, Isabel Stevenson, and Kate M. Monro. *Index to Reproductions of American Paintings, a Guide to Pictures Occurring in More than Eight Hundred Books.* New York: H. W. Wilson, 1948. 731p.
————.————. Supplement. 1964. 480p.
Lists works of artists in 520 books and in more than 300 exhibition

catalogs. The paintings are entered under author, title, and some subjects. Many are located. The index includes many references to portraits.

The supplement lists paintings in more than 500 general books on art, books on individual artists, and museums and exhibition catalogs.

Pierson, William H., and Martha Davidson, eds. *Arts of the United States: A Pictorial Survey.* New York: McGraw-Hill, 1960. 452p.

Two-part guide for teachers of art history, librarians, and museum personnel. The first part contains brief essays on periods and aspects of American art; e.g., seventeenth- and eighteenth-century architecture, costume design, Indian arts and artifacts, and twentieth-century painting. The second part is an illustrated catalog of available color slides related to the development of American art. The catalog is classified according to the subjects of the essays; an index of artists and works is included.

Smith, Lyn Wall, and Nancy Dustin Wall Moure. *Index to Reproductions of American Paintings Appearing in More than 400 Books, Mostly Published since 1960.* Metuchen, N.J.: Scarecrow, 1977. 931p.

Indexes reproductions in recent art books that are not restricted to a single painter. The index alphabetically lists artists and their paintings, with reference to books with reproductions. Works in permanent collections of public galleries or museums are located. There is a broad subject index to the reproductions that makes it possible, for example, to locate paintings of animals, Indians or portraits of individuals. The book's introduction has scope notes for these subject headings.

HISTORIES AND HANDBOOKS

Whiffen, Marcus. *American Architecture since 1780: A Guide to the Styles.* Cambridge, Mass.: M.I.T. Pr., 1969. 313p.

Directed to laypersons, this illustrated guide describes American building exteriors. It is divided into sections on such styles as Queen Anne, Egyptian revival, prairie, and brutalism, which are grouped chronologically. A bibliography, a glossary, and an index are included.

AUTHOR-TITLE INDEX

Compiled by Dickerson-Redd Indexing Systems

193

SUBJECT INDEX

Compiled by G. Fay Dickerson

221